The English Seaside

Peter Williams

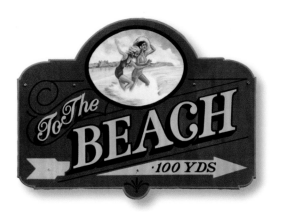

ENGLISH HERITAGE

Published by English Heritage, The Engine House, Fire Fly Avenue, Swindon, SN2 2EH
www.english-heritage.org.uk
English Heritage is the Government's lead body for the historic environment.

The views expressed in this book are those of the author and not necessarily those of English Heritage.

First published 2005, ISBN 1 85074 939 6
Published in paperback 2006, ISBN 978 1 905624 02 7
Second edition published 2013

ISBN 978 1 84802 125 9
Product code 51754

British Library Cataloguing in Publication data
A CIP catalogue record for this book is available from the British Library.

For more information about images from the English Heritage Archive, contact Archives Services Team, The Engine House, Fire Fly Avenue, Swindon SN2 2EH; telephone (01793) 414600.

Brought to publication by Jess Ward, Publishing, English Heritage.

Typeset in Gill Sans Light 10pt

Edited by Susan Kelleher
Indexed by Christopher Phipps
Cover design by Hybert Design
Page design and layout by Pauline Hull

Printed in UK by Butler Tanner and Dennis

COVER Evening light at Cleethorpes beach, Lincolnshire.

HALF TITLE PAGE (P1) Plaque at Bognor Regis, West Sussex.

FRONTISPIECE Deckchairs at Scarborough, this image was used on the 69p stamp.

TITLE PAGE (P3) Beach sign at Scarborough.

The English Seaside

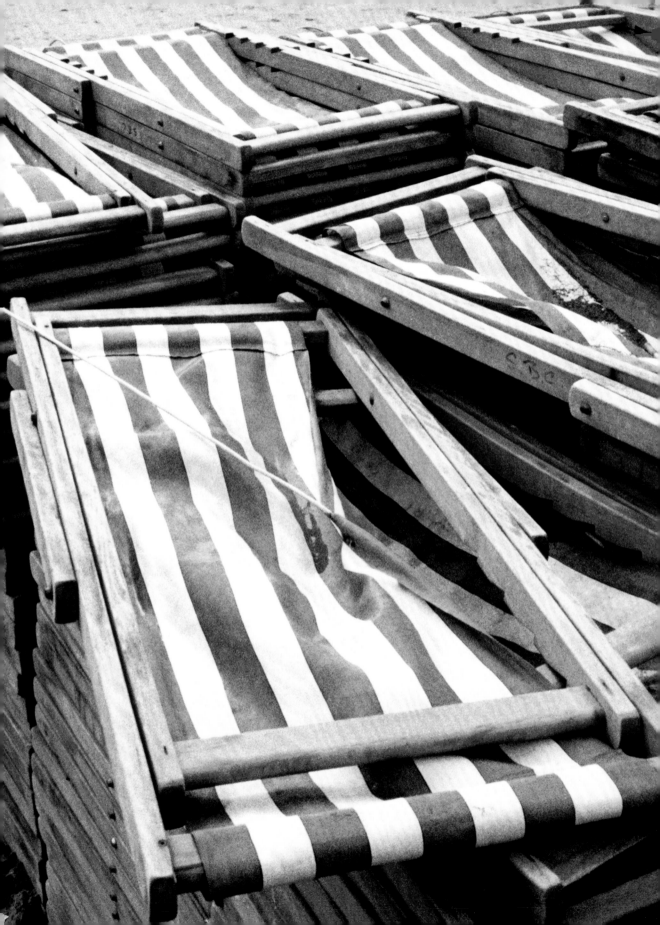

Contents

Foreword

The English invented the seaside holiday in the 18th century, but they do not quite know what to do with its legacy, or how to appreciate its continuing vitality. This entrancing collection of photographs illustrates the dilemma as well as the delights. It is much too easy to write off such celebrations of living seaside heritage as exercises in nostalgia, but such a criticism (if to be nostalgic is to deserve chastisement) is not applicable here. Peter Williams is well aware of the current problems of the English seaside, whether economic, cultural or presentational, but he has found, framed and presented an array of quirky, distinctive, vivid and arresting images which bring out exactly why the seaside deserves better than to be consigned to the margins of metropolitan condescension. He found the main exception, Brighton, which has been 'London by the sea' since it became the maritime retreat of the Prince Regent, to be unmanageably large. However, he does justice to the smaller, more 'artistic' cultural outposts of the metropolis, such as Aldeburgh, Southwold and St Ives. Such metropolitan outliers are exceptional, and the present writer was once asked how he could possibly propose comparing St Ives with somewhere as 'remote', presumably from London, as Whitby. On current road journey calculations the former is 32 miles further from London than the latter, but perception was all. As part of this process of selective vision, since the late 20th century the English seaside holiday (and most of its resorts) has suffered from parallel but mutually reinforcing media narratives, combining assumptions of outdated monochrome dullness and unremitting, inevitable decline with cloying, trivialising retrospective celebrations of an imagined past, of lost childhoods and cosy customs. Taken together, these standard stories make it difficult to secure a serious hearing for advocates of the historical and continuing contemporary importance of this enormously influential set of phenomena (Browne and Walton, 2010).

When a BBC journalist asked a marketing consultant in mid-August 2006 about his personal image of the English seaside, it followed the stereotype faithfully – rainy and dreary, grey seas and stony beaches, allied rather strangely with bacon sandwiches, presumably as a telegraphed indication of low catering standards. The strange perception that English beaches were uniformly stony may derive from metropolitan experience of Brighton. Bed and breakfast 'establishments' also featured in this panorama, but to mention them was sufficient. Their imagined deficiencies could be left to the imagination. But the consultant was quick to identify the need for promoters of this apparently unpromising product to organise their story around an ESP, or Emotional Selling Point, which extended the nostalgia and kitsch themes into the more reputable areas of heritage and memory, and to establish the PoD (Point of Difference) which might set each coastal destination apart from all the rest, thereby creating the necessary niche identity to attract the right sort of visitor (Dear, 2006).

This was, in its way, an acute set of observations, although perhaps more by accident than informed design. The sheer diversity of the 'English seaside', even if we focus only on coastal tourism as if it could be abstracted or isolated from its workaday maritime, residential and other urban surroundings, enables it to provide something for (almost) everyone, unless in obsessive search of guaranteed sunshine to the exclusion of all else. Peter Williams is not the first to celebrate this, as the excellent work of Kenneth Lindley (nearly 40 years ago) and Fred Gray on seaside architecture and design has highlighted; but he brings perspectives of his own to bear on this rich field of vision and experience (Lindley, 1973; Gray, 2006). Awareness of a generic seaside 'difference', of the positively attractive 'otherness' of beaches, boats and bays, of the enjoyable liminality of coastal settings on the delightfully dangerous transitional threshold between the security of dry land and the turbulent, unpredictable sea, and of the holiday suspension of conventions and taboos on this unstable, intermediate territory, brings unity and coherence to this otherwise diverse collection of seaside images, and helps to explain the resilience of (to express it in the most mundane of wording) the seaside economy.

What do we mean by 'English seaside'?

But how, in the English context, should 'seaside' be defined? For present purposes 'English' means 'on the English coastline'. From the late 18th century onwards, and especially as the railway network extended in the mid-19th century, many English seaside visitors went to the Welsh coast, from Penarth and Tenby to Rhyl, Colwyn Bay or Llandudno, not forgetting Aberystwyth, Barmouth or Pwllheli (Borsay and Walton, 2011). Penarth and Tenby were part of a Bristol Channel tourism economy. Aberystwyth developed strong links, originally railway based, with Birmingham, Wolverhampton and the Black Country, while the popular resorts of North Wales were nourished by Liverpool and industrial Lancashire as well as the Potteries and West Midlands. But here the grafting of English commercial popular culture alongside Welsh-speaking, often Sabbatarian, local societies created distinctive tensions which lacked parallels within England itself, although the resorts themselves looked similar (Parry, 2002). Few English people went to the Scottish seaside, whether 'gulf stream' in the west or 'golf stream' in the east. English destinations in Scotland involved grouse moors, the Highlands and the literary landscapes associated with Sir Walter Scott, and the arrows for coastal holidaymakers pointed the other way, especially during and after the First World War, as Scots from Glasgow and the industrial belt discovered Blackpool, Morecambe, Whitley Bay and Scarborough (Durie, 1997, 2003). The Isle of Man pulled together popular holidaymakers from industrial Lancashire as well as Clydeside in its own distinctive coastal culture, although it never fully recovered from the requisitioning of its steamers and the loss of key Scottish markets during the First World War (Belchem, 2000; Beckerson, 2007). Irish coastal tourism danced to a different drum, affected for most of the 20th century by political conflict (Cusack, 2010). Visitors to the English seaside from beyond the British Isles have always been few and far between, and attempts to attract them have been isolated and ineffectual (Beckerson, 2002). But there is plenty of rich, idiosyncratic material along the extensive diversity of the English coastline to sustain this book, with well over a hundred coastal resorts of all shapes and sizes (from villages to conurbations adding up to half a million residents) to provide material, and with no need to draw on adjacent British coastal cultures.

But the question remains: what is distinctively 'seaside' about 'the seaside' in England? Peter Williams has focused on coastal health and pleasure resorts, although he has occasionally strayed into more specialised dock, seaport and naval towns; and this association is consistent with the general usage of the word. Some of these photographs capture a quirky edginess which underlines the peculiarities of the seaside as a place of holiday escape, where (for a short time) conventions may be ignored or defied, and 'things done differently'. That very edginess has sometimes provoked reactive attempts at tighter restrictions and control: the vulgarity of comic postcards generated repeated and equally comic attempts at censorship, culminating in the prosecutions of Donald McGill for obscenity in the mid-1950s (Buckland, 1984). The English seaside has provided, and still provides, spaces in which behaviour which elsewhere might be challenging or even threatening (such as undressing in public) can be normalised or even domesticated, although this kind of distinctiveness has been undermined since the late 20th century by the spread of areas of tolerated license and misrule in other English settings. This forms part of a general challenge to notions of what makes the seaside special when leisure industries reproduce important aspects of it inland, as illustrated in a particularly direct way by Peter Williams' picture of the 'urban beach' in front of Birmingham Town Hall (Urry, 1997). But there is also a countervailing cosiness about aspects of the seaside, as illustrated through the 'nice cup of tea' or 'something to sit on' themes, a good example of an aspect of general 'Englishness' which has its own coastal incarnation in the beach hut or seaside café.

The seaside certainly distils certain conventional aspects of Englishness, but it does so within a wider frame of specific expectations of what an English coastal resort might contain that would set it apart from other 'English' experiences. Paul Theroux, casting a resident outsider's gaze along the coastline in the early 1980s, knew enough to pull a lot of these together. He remarked that a generic English seaside

resort would have an esplanade with a bandstand, a prominent war memorial, a rose garden with memorial benches, a lifeboat station, a lighthouse (Costa, 2012), a pier, genteel sporting equipment in the form of putting and bowling greens and a boating lake, a golf course, a church whose architectural and historical attributes featured prominently in the local guidebook, a newsagent selling both kitsch and sexually suggestive postcards, a souvenir shop selling what he called 'rock candy', a lugubrious funfair, public conveniences (with a man hovering outside, hopefully trying to catch the eye of the 'customers'), a caravan park, associations with literature and historic scandal, past connections with smuggling, and prominent landmarks in the ownership of the National Trust and the Ministry of Defence (Theroux, 1983, 341).

This collage represents a small to medium-sized resort with a mixed visitor economy, in the early stages of what often proved to be a long decline. The attributes Theroux presents are skewed towards southern England, but a similar inventory could also be compiled for many resorts in northern England, and indeed Wales and Scotland. If we are looking for 'Englishness', however, we immediately note that most of these attributes would not be found on the leisure coastlines of continental Europe. Theroux tilts the balance between the edgy and the cosy towards the latter, as befits his marginalisation (in this particular summary) of the larger and more popular coastal centres, but even in this little catalogue the cosy is often subverted by hints of deviance or vice, as befits the liminality of the coast. Theroux also reminds his readers of the proximate immensity and drama of the sea itself, inviting visitors to the coast to contemplate infinity – but from the shelter of their cars, in the windswept car parks that are also part of the equipment of the universal resort, taking refuge behind closed windows and unfurled newspapers, and taking comfort from a flask of tea. Shortly before Theroux was writing, Douglas Adams' *The Hitch-Hiker's Guide to the Galaxy* had already tapped into a similar vein of bewildered, defensive, downbeat Englishness (Adams, 1995). Peter Williams' photographs pick up on a remarkably high proportion of Theroux's seaside themes: lighthouses, lifeboats, naval and military interventions (with their

archaeology, memorabilia and commemorations) (Payne, 2012), religion (often manifested in diverse and unusual ways in coastal settings, including Whitby's 'Penny Hedge' custom and perhaps its gentle Goths on Walpurgis Eve and at Hallowe'en, as well as the multitude of churches Williams lists), piers, seats, public conveniences (without their hopeful hangers-on), amusements, associations with 'famous people', golf (but not bowls, cricket or putting greens, or indeed boating lakes), smugglers (reinforced by pirates and wreckers), and, indeed, people gazing out to sea (but without the protection of a steel carapace or the shelter provided by a windscreen). There is a lot of intersection between these Venn diagrams.

The English seaside also looks different from other kinds of place, even if we leave aside the beach, estuary and seafront, the paraphernalia of fishing, docks, harbours, maritime impedimenta, inviting alleys and curious vernacular cottages which are still to be found in every location that combines the history and heritage of seaport activity with catering for summer visitors. Herring gulls and other run-of-the-mill seabirds may now be commonplace inland, but there are plenty of dedicated and attractive shore birds to catch the educated eye. The same applies to vegetation, which is also more likely to be supplemented by exotic shrubs and, where climate allows (as at Torquay, since at least the 1920s), the promotional use of the iconic palm tree (Morgan and Pritchard, 2000, 114–15, 136, 140). Above all, the architecture of the seaside holiday can be eccentric, emphasising the role of the coast as marginal place, exempt from the usual conventions and constraints. The defensive backlash of terraces and bungalows which could be anywhere can dilute but not disguise the extravagant delights of seaside orientalism and eclecticism, from Brighton's Royal Pavilion onwards, on piers and pavilions, theatres and Winter Gardens, aquaria, amusement parks and hotels. It is not that similar kinds of (mainly Victorian) confection do not exist inland, but they are irresistibly drawn to congregate on the pleasure periphery of the tourist coastline. This book is not an architectural survey, but it does emphasise, rightly, the contribution of 1930s modernist architecture at the coast; sometimes in explicitly 'nautical moderne' form with bridges and

portholes, sometimes aiming at the full 'ocean liner' effect (as at Hastings and Brighton), to the profile of seaside towns from Brighton, Hastings, Bexhill (and not forgetting Frinton) to Blackpool and Morecambe, spanning imagined divides of social class and cultural geography (Gray, 2006; Chase, 2005). But most of the extensive coastal building development of the inter-war (and post-war) years took the form of standard semi-detached houses and bungalows taken unimaginatively from builders' catalogues, and the exciting modernist buildings stand out like beacons from the surrounding greyness. It is ironic that the bungalow was originally, in the 1880s, an exotic import from the Imperial East to the East Kent coast, soon to be domesticated and endlessly replicated in reduced form as the global culture of which it formed part became localised according to invented English conventions (King, 1984). It is also interesting that there is no section here on seaside architecture between the Second World War and the regeneration projects of the new millennium. This absence reflects a lack of confidence, innovation or positive affirmation of identity at the post-war seaside, beginning with the failure to adapt a Festival of Britain aesthetic to the seaside resort, a generation before the discourses of decline began in earnest (Walton, 2007b). The occasional appearance in this book of buildings from this period (the concrete cliff lift at Shanklin, the post-war beach huts and the occasional surviving coffee bar or fish and chip restaurant with 1950s décor) merely emphasises the shortage of usable subjects. The apparent lacuna in the book reflects a real lacuna on the ground.

This helps to explain the persistent grounding of English seaside imaginaries in the Victorian and Edwardian pasts, and to some extent that of the inter-war years, in the latter case especially through the celebration of (thriving and diverse) clusters of beach huts and (largely but not entirely lost) public swimming pools and lidos, reflecting the rise of sunbathing in conjunction with more relaxed, informal beach and bathing regimes (Walton, 2007a; Ferry, 2009; Smith, 2005). The reduction of outdoor popular entertainment to Punch and Judy (and donkey riding) in these pages faithfully reflects the disappearance of generations of minstrels, itinerant 'German bands',

pierrots and concert parties into the mists of nostalgia (and nostalgia publications), and of heritage survival or revival (Chapman and Chapman, 1988). Mr Punch, together with the palmists and clairvoyants who are illustrated here and are integral to the popular seaside's defiance of the usual rules of both science and common sense, is the only survivor from the rainbow of alfresco, informal live entertainments which used to be scattered along the shorelines of historic English resorts. They are no longer there to be photographed. Seaside illuminations, transforming autumn evenings with fairy lights and magical tableaux, combining popular art with technical craftsmanship, have likewise vanished almost everywhere. The great surviving festival of fantasy at Blackpool, originating in 1912, is (understandably) relegated here to a single photograph in the 'Time and Tide' section (Gray and Walton, 2012). The 'end of the pier show', a little more resilient in its contrasting incarnations at nostalgic Cromer or risqué Blackpool, is beyond the open-air gaze of the present project, as are other aspects of live seaside entertainment on a larger scale, in Winter Gardens and similar settings. However distinctive, and indeed innovative and risqué, this may continue to be (especially at Blackpool, under the challenging recent auspices of Vanessa Toulmin with *Showzam!* and *Admission All Classes*, and Basil Newby with *Funny Girls*, deploying 'neo-variety', burlesque and drag), seaside entertainment has almost completed its journey indoors. The association between the English seaside and edgy entertainment goes beyond the remit of this book, but it remains strong enough to reinforce the message communicated by these photographs that the seaside is still 'different', in exciting as well as cosy and nostalgic ways. It is also economically resilient, as recent research in very different idioms has demonstrated.

Resilience and regeneration

Research during the first decade of the 21st century has overturned easy assumptions about the inevitable and terminal decline of English seaside tourism, and of the broader seaside economy. The work of Christina Beatty and Steve Fothergill underlines the importance of seaside towns whose economies are dominated by tourism, retirement and commuting:

put together, their populations are equivalent to that of Wales, or to North-East England, although this is obscured by dilution by other kinds of place within conventional regions, counties and local government boundaries (Beatty and Fothergill, 2003, 2004). A recent attempt to calculate tourism's importance as an employer found that in 2011 9.1 per cent of the British labour force worked in the industry, with London leading the way numerically; but the most important concentration of tourism workers was in Torbay, described as a 'traditional' coastal resort, where it employed one in six of the workforce. Cornwall, with major coastal tourism industries, came third, while Blackpool, with more than one in eight of the labour force in tourism (despite substantial retired, commuter and administrative populations), came sixth. The labelling of some occupations in this difficult area was bound to be questionable at the margins, especially in seasonal economies, but the orders of magnitude are convincing (Office of National Statistics, 2012).

But despite its obvious importance, the coastal, unlike the rural, has never been a distinctive category in government planning at any level beyond the local, and it has suffered from a persisting lack of official understanding of or receptivity to its peculiarities and needs. Definitions also present problems, especially when highly seasonal resorts are embedded in complex local economies. Even so, there is clearly plenty of life in these coastal towns, many of which are positively attractive to desirable migrants and capable of generating new employment. Some are more buoyant than others, and certain towns, or parts of towns, show persisting and unattractive symptoms of decline, deprivation and decay, with boarded-up shops, high levels of local unemployment and dependence on long-term disability benefit (in many cases a product of migration by retired miners from the former coalfields), and problems of drug dependency, vandalism and crime. The conversion of unviable boarding houses into multiple bedsitter occupation, for housing benefit recipients who promise landlords a guaranteed year-round income, has been a particular bugbear. Government policies for the dispersal of various categories of inconvenient people, over several parliaments, have worsened the damage. But it would be deeply misleading to generalise from this minority of examples, mainly drawn from old provincial popular resorts which have lost their tourist markets to changes in demand flows over the last 40 years, to the English seaside as a whole (Beatty and Fothergill, 2003, 2004; Beatty, Fothergill, Gore and Wilson, 2010; Browne and Walton, 2010). The widespread (though far from universal) success of seaside regeneration initiatives, and the high visibility and popularity of artistic interventions in coastal settings, underlines this point. The value of seaside history as a distinctive set of experiences which can be used to tell an attractive story, backed up by surviving evidence 'on the ground', is increasingly being appreciated, due not least to the continuing work of English Heritage itself (English Heritage, 2007; Brodie and Winter, 2007; Commission for Architecture and the Built Environment, 2003). There is plenty of supporting material for this argument in the photographs that follow, especially through the association between the seaside and genuinely popular contemporary art, a theme which deservedly attracts extended illustration here.

Seaside resorts have been attractive to proponents of urban regeneration. This is not surprising, as the persisting allure of coastal environments remains apparent: the positive sea change in attitudes to seaside scenery and ambience which set in during the 18th century shows no signs of having run its course, even though many of its consequences have been displaced to sunnier climes (Corbin, 1994). Preena Shah has developed the concept of 'coastification' to reflect those aspects of gentrification through regeneration which are particularly associated with coastal settings, although one of their dangerous side effects can be to leach out the eccentric and unusual (unless 'iconic' and legally protected, and especially when low-key, much-loved but under-valued) and introduce the standardised, one-size-fits-all 'blandscapes' which have become the signifiers of 'clone town Britain' (Shah, 2011; Browne and Walton, 2010).

Peter Williams is alert to not only to surviving eccentricities, but also to aspects of the coastal regeneration agenda. This is illustrated by his section on the new art galleries and museums which have sought to achieve a seaside 'Guggenheim effect', akin

to the urban revival of the Basque city of Bilbao, in troubled settings like Hastings or Margate as well as more fashionable locations like St Ives or Falmouth. He has also picked up on the splendid competition at Mablethorpe, on the deeply unfashionable Lincolnshire coast, to re-imagine the traditional beach hut, and on various innovative approaches to seaside art and architecture, while his photographs of contemporary seaside sculpture flag up another aspect of the regeneration agenda, which sometimes celebrates seaside traditions in quirky ways. Blackpool's wonderful tide organ deserves to be mentioned here, but seaside soundscapes are another, overlapping story. The English seaside may not always be in the most robust of health, but this photographic sampling underlines that there is still plenty of life in it.

The seaside as unappreciated English invention

Coastal regeneration builds on, and sometimes makes use of, a quarter of a millennium of history and industrial archaeology. The English origins of coastal tourism can be traced to Lancashire and North Yorkshire in the early 18th century. Liverpool seems to have provided the first commercial sea-bathing facilities, followed by Whitby and Scarborough. The latter has strong claims to being the world's first sea-bathing resort, although in the 17th century Scheveningen, in the Netherlands, was already attracting artists and tourists who enjoyed the quaintness and the newly appreciated scenic beauties of the coastal environment (Brodie and Winter, 2007; Brodie, 2012; J H Furnée, in Borsay and Walton, 2011). The origins of commercial sea bathing as something around which a summer holiday season could be organised, in these cold, turbid northern waters, was no accident. It arose from medical capture and systematisation of popular sea-bathing traditions, and from the exaltation of the curative properties of supervised, controlled exposure to chilly seas and bracing waves. On that basis it became, first a complement to, then a substitute for, 'taking the waters' at a mineral spring or 'spa'. By the mid-18th century sea bathing was developing a following among the aristocracy and expanding 'middle ranks' on every English coastline from the Isle of Thanet to the Solway Firth (Walton, 1983). The

bathing machine, a way of privatising access to the sea through the imposition of standards of decency, became an enduring symbol of the peculiarities of the seaside, and the carefully restored early example from Eastbourne is highlighted here, along with the low-key survival of Victorian bathing machines through conversion into static beach huts.

But the most popular images of English seaside history are associated with the Victorian seaside of middle-class families and working-class 'excursionists' during the railway age, which for these purposes began in the 1840s, went into terminal decline in the 1960s, and sputtered out in the 1970s. This is the dimension of the seaside that is most cherished in popular memory, and the Victorian coastal destinations that catered most assiduously for working-class markets are the ones that have suffered most from all kinds of recent competition, from cheap overseas holidays to caravan parks, leisure centres, shopping malls and other new locations, including the new attractions of the inland cities. Before the onset of widespread decline from (usually) the 1970s onwards, English seaside resorts passed through periods of Edwardian modernisation (including a revolution in electricity supply), followed by a pause for breath during and just after the First World War; inter-war prosperity and renewal, with an optimistic focus on sunshine, sport, the open air and the relaxation of taboos and restrictions; widespread closure, damage and dereliction during the Second World War, with Blackpool standing out as a fortunate exception, but universal problems of post-war adjustment with limited resources; and a final surge of popularity in the 1950s and 1960s, when legal backing for paid holidays (at last) made the coast accessible to almost everyone, and enormous crowds accumulated every August on the popular beaches in the autumn of the Victorian industrial economy (Demetriadi, 1997). But this last phase of prosperity was not matched by renewed investment or innovation, and the most prosperous visiting publics were already disappearing to Cornwall, France and increasingly Spain (Walton, 2000). This sequence of layered developments left a palimpsest of survivals from each era, side by side and overlaid one above the other, many of which have survived to be captured by Peter Williams' lens.

Seaside photographers

Peter Williams takes his place in a long line of photographic presenters and interpreters of the popular culture of seaside England. As the holiday industry developed, Victorian photographers were attracted to the tourist areas of coastal towns and each sizeable resort not only had its 'smudgers' or itinerant producers and vendors of happy holiday snaps, but also its more serious recorders and composers of beach scenes and of the quaintness, strangeness and 'difference' of narrow streets, 'fishing quarters', quays and maritime paraphernalia. Frank Meadow Sutcliffe, operating in and around Whitby at the turn of the 19th and 20th century, was unusual only in being particularly successful at producing and marketing attractive photographs, and leaving an accessible archive (Harding, 2008; Hiley, 2005). The Francis Frith collection, also carefully nurtured and marketed, includes a large number of mainly late Victorian seaside scenes, which are clearly a paying proposition in their own right (Sackett, 2000). Humphrey Spender's Blackpool photographs of the later 1930s, taken for the Mass-Observation project which followed Bolton working people to Blackpool at the Wakes holidays, lay claim to greater intimacy and spontaneity (Bolton Worktown 2012; Cross, 1990). Subsequent historic collections include Alfred Gregory's wonderfully observed Blackpool photographs of the 1960s, which focus intimately on individuals and small groups on the beach, in pubs and along the Golden Mile, informally pursuing enjoyment wherever it might be found (Gregory, 1993).

Towards the end of the 20th century Martin Parr produced his controversial images of day-trippers at New Brighton, a rapidly declining resort on the south bank of the Mersey estuary, which divided commentators of all kinds about how (un)sympathetically they should be read, and whether working-class efforts to make the best of unpromising surroundings were being presented only to be mocked; and he then moved to the other end of England to offer a further compilation on Dorset's West Bay. Parr's collaborator Tom Wood was less controversial, and perhaps less abrasive, in presentation and subject matter (Parr, 1986, 1997). Parr's seaside publications coincided with a growing media tendency towards depictions of the popular seaside which ranged from the unsympathetic to the vitriolic, reaching a bilious climax with Charles Jennings' violent and ill-informed denunciation of Blackpool in the 1980s, as part of a generally uncomprehending denunciation of an imagined North of England (Jennings, 1989). But Parr also took an empathetic delight in John Hinde's curiously lit photographs of activities at Butlin's holiday camps during their heyday, and his seaside work is full of interesting ambiguities (Parr, 2002).

This has been the briefest and most selective survey of earlier photographic impressions of the English seaside, its people and (especially) its holidaymakers. In Peter Williams' book his thematic range and geographical coverage are outstandingly broad, for England is a small country with a disproportionately long, varied and variously populated coastline. His grasp of what is worth depicting, presenting and sharing is also unusually, and refreshingly, wide-ranging and eclectic. The subjective comments that follow should be set against this backcloth. We all have our preferences and obsessions, and writing a foreword such as this provides an opportunity for venting them.

Presences and absences

Peter Williams has chosen an impressive range of attractive and evocative themes to illustrate the special nature and diversity of the English seaside. Inevitably, anyone who comments on them will notice apparent absences. The most striking of these, perhaps, is the lack of illustrations of marine promenades (or esplanades, in the terminology adopted by Paul Theroux) and sea defences. These closely related constructions (promenades often ran along the top of sea walls) were essential elements in resort development. The former provided controlled, accessible spaces for exercise, personal display, fashion and flirtation, and even motor racing (before they also came to offer cycling and skateboarding), while the latter safeguarded the lives and property of those who enjoyed and invested in the perilous meeting-point of land and sea. Few things are more 'seaside' than a promenade, although inland versions have a long history, especially at spa resorts (Borsay, 1986). Plenty of their embellishments are featured,

as in the sections on shelters and 'something to sit on'; and piers, which are awarded an appropriately generous amount of attention, have always been for promenading as well as concerts, dancing, amusements and connecting with pleasure craft. Sea defences also offer places to sit when the beach is too crowded, and the groynes which manage the distribution of sand and shingle also offer screening against brisk seaside winds and sand flurries. As increasing attention has been paid to sea-water quality and 'blue flag' status, meanwhile, waste-water treatment plants make increasingly useful contributions to coastal amenity, and the recent investment in new buildings, as at Scarborough, can produce attractive coastal architecture in its own right. Blackpool's black-and-white horizontally striped main sewer ventilator on the central promenade, in the style of a lighthouse, is an older reminder of an ever-present but not always recognised need (Hassan, 2002).

Another important aspect of the seaside experience is the transport arrangements necessary to make the journey. The steam trains and summer railway excursions which were once the lifeblood of the English coastal economy are half a century and more in the past, but several of the preserved heritage railways still bring steam engines to the seaside, as at Whitby and Minehead, conjuring up images from the popular railway poster art of a remembered and communicated past (National Railway Museum, 2012). From the 1920s and especially the 1930s onwards the seaside bus and coach station was also a hub and hive of excursion activity and holiday travel in the summer, generating its own nostalgic associations. When, in the mid-1970s, Kenneth Lindley wrote a short book aimed at stimulating school projects on the seaside, he urged children to seek out their resort's bus station (often an interesting structure from the 1930s), and ask older people about their holiday memories of it; but this, again, is a travel culture that has shrivelled in recent years, swallowed up by the ubiquitous car and its acres of supporting concrete (Lindley, 1975). The car park is essential to the current seaside economy, but it is not generally regarded as a photogenic subject, although Hastings built the first underground example in 1931, and a few years later Blackpool's peculiar problems

led to the building of the first British multi-storey car park, an interesting if not aesthetically pleasing building which survived precariously into the new millennium, across the road from the town's North railway station (Brodie and Winter, 2007, 61). Much more conventionally attractive were the streamlined tram stations at Bispham, Blackpool, built in the same decade, part of the municipal project (which also included a new tram fleet) to modernise, indeed actually streamline, the resort itself (Whitfield, 2012).

Much more important to the contemporary seaside, however, is the miniature railway, which complements the model village (as illustrated here) and miniature or 'crazy' golf course in confirming the seaside as a magical place where shapes can be shifted and normal rules do not apply. Miniature railways, like so many other aspects of the seaside (including the late Victorian and Edwardian cliff lifts, some of which are nicely illustrated here), are not the exclusive property of the coast but tended to gravitate to this favoured habitat. More than 200 have existed on the British coast ('Rails to the Sands', 2010). They range from children's lines in parks, using diesel engines with steam locomotive outlines (as at Saltburn or Scarborough), to the live steam Cleethorpes Coast Light Railway and (since 1927) the Romney, Hythe and Dymchurch line. The latter's 13.5-mile main line gives one form of access to Derek Jarman's Dungeness house and garden, and to the nearby nuclear power stations which form another dimension (vulnerable, intimidating and also out of scale) of characteristic coastal installations, appearing as they do at several points along English shorelines. Nuclear power stations do not feature in these pages, but wind farms do: they are extraneous to the seaside but often visible from it, their measured dancing evolutions graceful or intrusive according to taste, distance and political outlook, provoking similar controversies to those associated with the march of pylons across the English countryside of the 1930s (Luckin, 1990).

Bed and breakfasts are in short supply here, apart from the large Blackpool establishments (entertainingly and aptly classified by the number of lamps they display: 40 years ago the equivalent was the number of tiers on the cakestand), which are almost 'industrial' in their concentration and single-mindedness (though not

in the scale of the individual enterprises), and which are certainly not representative of bed and breakfasts in general. The omission of the gay boarding-house area around Blackpool's North railway station, with its rainbow motifs, putti, garden gnomes, suggestive names and abundant vegetation, is also an opportunity foregone (Walton, 1978; Walton, 1994; Walton, 2000). It is also a shame that no room could be found for places like the enjoyably eccentric Walpole Bay Hotel at Cliftonville, Margate, with its on-site museum; and there must be plenty of other candidates for inclusion in such a category, without taking the negative path of joining the popular searches for the best approximation to Fawlty Towers. But perhaps this might make another book on its own.

Beyond 'the seaside' as represented by coastal holiday towns and villages of a conventional kind, we might also consider the distinctive visual and cultural impact of holiday camps and informal 'plotland settlements', as well as the chalets and caravans that make a brief but interesting appearance here, and the combinations of converted railway carriages that feature in 'Wooden Walls' as isolated examples rather than part of more extensive settlements. Seaside holiday camps had their heyday in the middle decades of the 20th century, but there are important survivors, and in some places evocative remains can be accessed (Hardy and Ward, 1986). The 'plotland settlements', offering cheap self-built accommodation for bohemian families wanting cheap informal holidays outside the conventional resorts, have been tidied up from the often attractive anarchy of the period between the late 19th century and the 1930s, but they still offer character and eccentricity on the fringes of the coastal fringe, despite the current status of Jaywick Sands, near Clacton, as on one measure Britain's most deprived community (Ward and Hardy, 1984; Pendleton, 2012). And caravans and chalets are diverse enough, despite stereotypes of uniformity, to deserve extended study, especially in their post-1950s role of offering access to the seaside to families who could not otherwise afford its most basic pleasures (Beatty, Fothergill with Scott, 2011). Peter Williams'

understandable focus on the conventional seaside town has left these places out in the cold.

We could go on. For example, what of surfing, or sea-front bingo, as contrasting seaside pleasures and demographics, sometimes coexisting in the same resorts? But it is unfair to pick away too assiduously at perceived absence or neglect, when there is so much in these pages to enjoy.

Celebrating the seaside difference

These photographs are a fascinating record in their own right – but they are also valuable for bringing out some paradoxes of the English seaside. It manages to house and display both the deeply conventional and the challengingly eccentric aspects of Englishness. On the wilder (and sometimes tamer) shores of England games are played with size and perspective, time and space, though distorting mirrors, miniaturisation and anachronism. Strange grottos, passages and sculptures abound, and peaceful settlements look outwards and backwards to the relics of maritime conflict and the threat of invasion. Here is a rich field for improvisation and bricolage, and for the celebration of the exotic, in these fringe locations where there is only one way out and the land and sky meet the sea, and visions of infinity are brought back to earth by the transient but alluring physical pleasures of sand and mud, sun cream and lotions, windbreaks and shelters, and greasy or deliquescent food held in the hand and consumed on the hoof. Above all, what is captured here is the informal seaside, not so much the iconic (although that is not absent) but the transient and easily overlooked. The English seaside continues to resist incursions by corporate blandness: despite some aspects of regeneration schemes, it remains a haven for quirky individualism and oddity. Here are some of the advantages that accrue to 'places on the margin'. Long may this continue, and continue to be celebrated.

John K Walton

IKERBASQUE, Instituto Valentín de Foronda, University of the Basque Country UPV/ EHU, Vitoria-Gasteiz, Spain

January 2013

References

Adams, D 1995 *The Hitch-Hiker's Guide to the Galaxy*. London: Del Rey (first published 1979)

Beatty, C and Fothergill, S 2003 *The Seaside Economy*. Sheffield: CRESC, Sheffield Hallam University

Beatty, C and Fothergill, S 2004. 'Economic change and the labour market in Britain's seaside towns'. *Regional Studies* **8**, 461–80

Beatty, C and Fothergill, S with Scott, S 2011 *The Caravan Communities of the Lincolnshire Coast*. Sheffield: CRESC, Sheffield Hallam University

Beatty, C, Fothergill, S, Gore, T and Wilson, I 2010 *The Seaside Tourism Industry in England and Wales*. Sheffield: CRESC, Sheffield Hallam University

Beckerson, J 2002 'Marketing British tourism: Government approaches to the stimulation of a service industry, 1880–1950', *in* Berghoff, H, Korte, B, Schneider, R and Harvie, C (eds) *The Making of Modern Tourism: The Cultural History of the British Experience, 1600–2000*. London: Palgrave, 133–58

Beckerson, J 2007 *Holiday Isle*. Douglas: Manx Heritage Foundation

Belchem, J 2000 '"The playground of Northern England": The Isle of Man, Manxness and the northern working class', *in* Kirk, N (ed) *Northern Identities*. Aldershot: Ashgate, 71–86

Bolton Worktown 2012, Humphrey Spender's Blackpool photographs, http://boltonworktown.co.uk/themes/blackpool/ accessed 8 Dec 2012

Borsay, P 1986 'The rise of the promenade'. *British Journal of Eighteenth-Century Studies* **60**, 125–40

Borsay, P and Walton, J K (eds) 2011 *Resorts and Ports: European Seaside Towns since 1700*. Bristol: Channel View

Brodie, A 2012 'Scarborough in the 1730s: Spa, sea and sex'. *Journal of Tourism History* **4**, 125–53

Brodie, A and Winter, G 2007 *England's Seaside Resorts*. Swindon: English Heritage

Buckland, E 1984 *The World of Donald McGill*. London: Blandford

Chapman, M and Chapman, B 1988 *The Pierrots of the Yorkshire Coast*. Beverley: Hutton Press

Chase, L 2005 'Public beaches and private beach huts', *in* Walton, J K (ed) *Histories of Tourism*. Clevedon: Channel View, 211–27

Commission for Architecture and the Built Environment 2003 *Shifting Sands: Design and the Changing Image of English Seaside Resorts*. London: CABE

Corbin, A 1994 *The Lure of the Sea*. Cambridge: Polity

Costa, T 2012 'To the lighthouse: Sentinels at the water's edge', *in* Cusack, T (ed) *Art and Identity at the Water's Edge*. Farnham: Ashgate, chapter 6

Cross, G (ed) 1990 *Worktowners at Blackpool*. London: Routledge

Cusack, T 2010 '"Enlightened Protestants": The improved shorescape, order and liminality at early seaside resorts in Victorian Ireland'. *Journal of Tourism History* **2**, 161–85

Dear, P 2006 'Reinventing the seaside', *BBC News* 19 Aug 2006, http://news.bbc.co.uk/2/hi/uk_news/4799097.html accessed 26 Nov 2012

Demetriadi, J 1997 'The golden years, 1951–1974', *in* Shaw, G and Williams, A (eds) *The Rise and Fall of British Coastal Resorts*. London: Mansell, 49–74

Durie, A J 1997 'The Scottish seaside resort in peace and war, c. 1880-1960'. *International Journal of Maritime History* **9**, 171–86

Durie, A J 2003 *Scotland for the Holidays*. East Linton: Tuckwell Press

English Heritage 2007 *Regeneration in Historic Coastal Towns*. Swindon: English Heritage

Ferry, K 2009 *Sheds on the Seashore*. Brighton: Indepenpress

Gray, F 2006 *Designing the Seaside*. London: Reaktion

Gray, F and Walton, J K 2012 'Illuminating the seaside', *in* Simonnot, N (ed) *L'Architecture Lumineuse*. Gand/Courtrai: Snoeck, 132–41

Gregory, A 1993 Blackpool: *A Celebration of the 60s*. London: Constable

Harding, C 2008 'Sunny Snaps: Beach and Street Photography in Britain', National Media Museum exhibition

Hardy, D and Ward, C 1984 *Arcadia for All: The Legacy of a Makeshift Landscape*. London: Mansell

Hassan, J 2002 *The Seaside, Health and the Environment in England and Wales since 1800*. Aldershot: Ashgate

Hiley, M 2005 *Frank Sutcliffe: Photographer of Whitby*. Chichester: Phillimore.

Jennings, C 1989 *Up North. Travels Beyond the Watford Gap*. London: Abacus

King, A 1984 *The Bungalow: The Production of a Global Culture*. London: Routledge & Kegan Paul

Lindley, K A 1973 *Seaside Architecture*. London: Hugh Evelyn

Lindley, K A 1975 *Seaside and Seacoast*. London: Routledge & Kegan Paul

Luckin, B 1990 *Questions of Power: Electricity and the Environment in Inter-War Britain*. Manchester: Manchester University Press

Morgan, N and Pritchard, A 1999 *Power and Politics at the Seaside*. Exeter: University of Exeter Press

National Railway Museum 2012 'Railway Posters'. http://www.nrm.org.uk/OurCollection/Posters.aspx?pageNo=5 accessed 8 Dec 2012

Office of National Statistics 2012 'The geography of tourism employment'. http://www.ons.gov.uk/ons/taxonomy/index.html?nscl=Economic+Value+of+Tourism accessed 26 Nov 2012

Parr, M 1986 *The Last Resort*. Wallasey: Promenade Press, reissued 2009, Stockport: Dewi Lewis Publishing

Parr, M 1997 *West Bay*. London: Rocket Press

Parr, M 2002 *Our True Intent is all for Your Delight: The John Hinde Butlin's Photographs*. London: Chris Boot

Parry, G 2002 '"Queen of the Welsh resorts": Tourism and the Welsh language in Llandudno in the nineteenth century'. *Welsh History Review* **21**, 118–48

Payne, C 2012 'Our English coasts: Defence and national identity in nineteenth-century Britain', *in* Cusack, T (ed) *Art and Identity at the Water's Edge*. Farnham: Ashgate, chapter 2

Pendleton, D 2012 'Holidaymaking on the edge: Erosion, marginality and preservation at Skipsea, Yorkshire, U.K.'. *Journal of Tourism History* **4**, 301–19

'Rails to the Sands' 2010 Exhibition opened in Cleethorpes 17 July 2010 by the Miniature Railway Museum Trust. www.seasiderailways.co.uk accessed 8 Dec 2012

Sackett, T 2000 *Victorian Seaside*. Salisbury: Frith Book Co

Shah, P 2011 'Coastal gentrification: The coastification of St Leonard's-on-Sea'. PhD thesis, Loughborough University

Smith, J 2005 *Liquid Assets*. London: English Heritage

Theroux, P 1983 *The Kingdom by the Sea*. London: Penguin

Urry, J 1997 'Cultural change and the seaside resort', *in* Shaw, G and Williams, A *The Rise and Fall of British Coastal Resorts*. London: Mansell, 102–14

Walton, J K 1978 *The Blackpool Landlady: A Social History*. Manchester: Manchester University Press

Walton, J K 1983 *The English Seaside Resort: A Social History, 1750–1914*. Leicester: Leicester University Press

Walton, J K 1994 'The Blackpool landlady revisited'. *Manchester Region History Review* **8**, 23–31

Walton, J K 2000 *The British Seaside: Holidays and Resorts in the Twentieth Century*. Manchester: Manchester University Press

Walton, J K 2007a 'Beaches, bathing and beauty: Health and bodily exposure at the British seaside from the eighteenth century to the twentieth'. *Revue Française de Civilisation Britannique* **14**(2), 119–36

Walton, J K 2007b *Riding on Rainbows: Blackpool Pleasure Beach and its Place in British Popular Culture*. St Albans: Skelter

Walton, J K and Browne, P 2010 *Coastal Regeneration in English Resorts – 2010*. Lincoln: Coastal Communities Alliance

Ward, C and Hardy, D 1986 *Goodnight Campers!: The History of the British Holiday Camp*. London: Mansell

Whitfield, M 2012 'Bispham tram stations, Blackpool'. http://www.c20society.org.uk/botm/bispham-tram-stations-blackpool/ accessed 9 Dec 2012

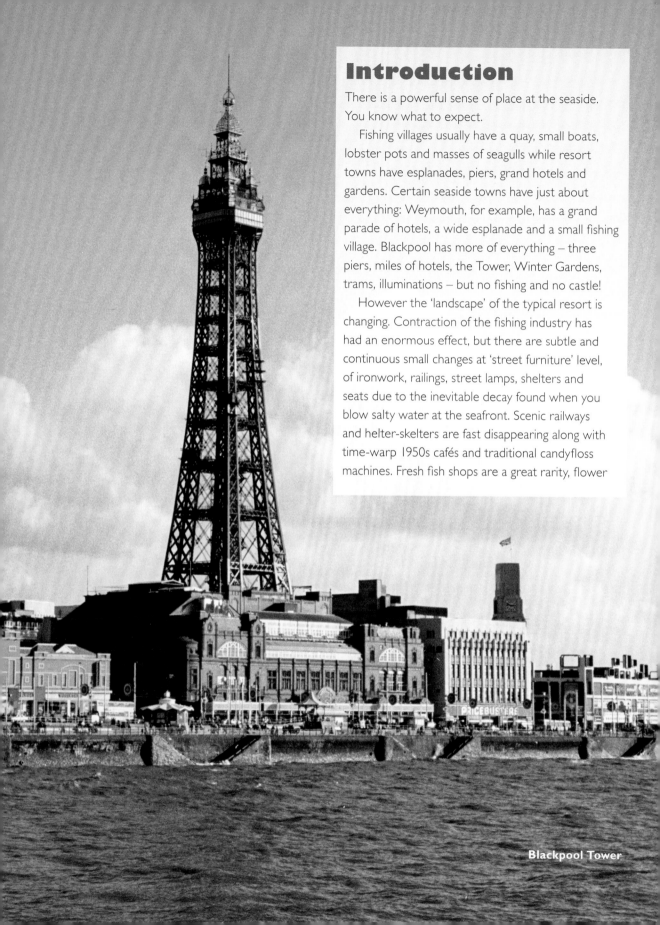

Introduction

There is a powerful sense of place at the seaside. You know what to expect.

Fishing villages usually have a quay, small boats, lobster pots and masses of seagulls while resort towns have esplanades, piers, grand hotels and gardens. Certain seaside towns have just about everything: Weymouth, for example, has a grand parade of hotels, a wide esplanade and a small fishing village. Blackpool has more of everything – three piers, miles of hotels, the Tower, Winter Gardens, trams, illuminations – but no fishing and no castle!

However the 'landscape' of the typical resort is changing. Contraction of the fishing industry has had an enormous effect, but there are subtle and continuous small changes at 'street furniture' level, of ironwork, railings, street lamps, shelters and seats due to the inevitable decay found when you blow salty water at the seafront. Scenic railways and helter-skelters are fast disappearing along with time-warp 1950s cafés and traditional candyfloss machines. Fresh fish shops are a great rarity, flower

Blackpool Tower

beds are decreasing, signwriters have signed off and where oh where can you get 'a pot of tea for the beach'? That stalwart of the hot bank holiday, the grockle with knotted handkerchief hat, rolled-up corduroys and sandals with black socks, is gone forever.

But the changes aren't all bad. A large amount of new stainless-steel street furniture is in evidence and public sculpture has proliferated, some good, some indifferent, some strange, such as Morecambe's birds. Folkestone has made progress with its two-mile sculpture walk. There is continuing regeneration of seafronts under way in resorts all round the coast. Bridlington has led the way with its emphasis on renewal rather than replication and Blackpool, Southport and Dover have exciting new esplanades. The Tate Gallery has revitalised St Ives and a similar effect is beginning to happen in Margate (a town with more than 30 per cent of its shopfronts boarded up), Blyth, Whitehaven, Weston-super-Mare, Bude and Hastings, amongst others, have been transformed by the provision of new railings, seats, car parks and visitor information boards.

Regeneration starts at local level. Don't wait for the bureaucrats to step in, they are there to ensure 'elfansafety' and have a predisposition for 'gentrification' schemes. Whilst Aldeburgh and Southwold are lovely places, they have become the playground for rich Londoners. We all hear with dismay the ridiculous prices paid for beach huts. 'Marinafication' has spread along the south coast. You feel that the yacht owners are less interested in sailing and more interested in the 'sailing lifestyle'. St Ives just about manages to retain a balance between the culture vultures who support the high-end restaurants and the caravan brigade who want decent cheap fish and chips.

What, you might ask, are my qualifications for writing about the seaside? Although born in Derbyshire, my early years were spent in Northern Ireland, where our house was within walking distance of a rocky beach. When I was a teenager, we had a house backing onto sand dunes at Ainsdale, near Southport, and I would often walk or cycle along the old railway line to spend an afternoon at the Pleasureland funhouse. Happy days! I subsequently spent three years living in Blackpool, an interesting contrast to Southport.

It was in the summer of 1992 when I first set forth on my madcap mission to photograph the coast of England. My work took me all over the country and I would often stay at the seaside because that was where there were plentiful, and cheap, hotels. Long summer evenings left me with time to explore, camera in hand. Sometimes the sun shone – but mostly I never minded about the weather. The 'survey' was never meant to be about photographs as art but simply a snapshot of the seaside at a time of great change. I was interested in 'sense of place' and the concept of 'normality' and 'kitsch' and the bizarre.

As the survey progressed I began to rationalise its scope. I realised I would never get to the more remote parts of the coast and that the major port cities were too big and the dockyards difficult of access. However I do include some coverage of port cities here and there, for what are rules for but to be broken. Apologies, also, to Brighton, which I found dauntingly big. Gradually I came to concentrate on 'resorts' and became more willing to venture inland – but only a few streets! Some seaside towns get short shrift due to lack of time and so I apologise to places I didn't have time to visit or cover properly.

For too long the seaside has suffered from bad press. It is accused of being tatty, of being moribund, of being the 'Costa Geriatrica'. Cold, grey, windswept, raining it may be at times and, inevitably, it has all the shortcomings of society at large – alcoholism, gambling, drugs and the rest. But I have found the seaside to be warm-hearted, welcoming and positive. It's not simply the ozone that draws the visitor to the comfort of a hotel with sea views, but some inner need to commune with nature and return to the sea. It's also about having fun – riding the rides for a thrill and a scare, seeing the shows and playing the machines. Above all, it is having the freedom to wander and to build sandcastles, dam streams and bury dad up to his neck in the sand.

Peter Williams
January 2013

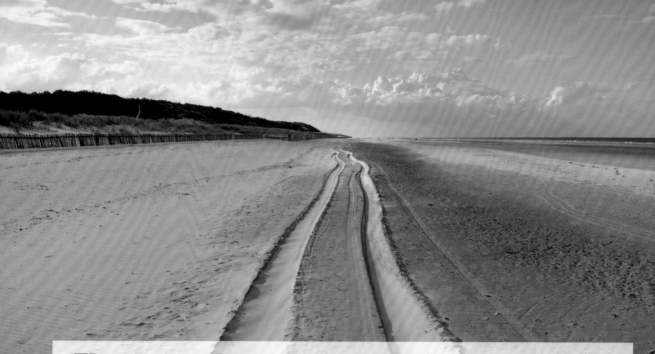

The natural coast

A surprising amount of the English coast is in its natural state, unaltered by harbours, sea walls or works of civil engineering. Outside the major port areas and conurbations, you can walk for miles without seeing anyone.

This solitary, even lonely, aspect of the coast is its chief attraction for many. The combination of big sea and big sky is a powerful spiritual magnet, and there is also something of the desert in an endless beach. It is a place where, whilst we contemplate the infinite grains of sand or gaze out to sea, we can reflect on the meaning of life and our own inner selves. That is, if it doesn't rain.

The question is, just what is 'wild', 'natural' and 'unaltered' and what is carefully and discreetly 'managed'? We like the thought of a natural environment, but at the same time somehow expect the shoreline to be watched over by coastguards, customs and the National Trust. Some management is necessary for safety and to protect rare plants and animals – but let's not be constricted by too many rules and regulations.

Some 'wild' and 'natural' areas are subject to heavy pressure from tourists. The Valley of the Rocks near Lynton and Lynmouth attracted the attention of Gainsborough, Wordsworth, Shelley, Coleridge and Conan Doyle and is still a very real area of outstanding natural beauty. It is now a 'managed' wilderness and you have to park in designated places and keep to the paths. The 'wild' coastal sand dune areas of Upton Towans, Formby Point and Druridge Bay are popular destinations but susceptible to pathway erosion and need constant repair. Pebbly beaches can be at risk from the relentless removal of stones for souvenirs and garden makeovers – Crackington Haven is but one example.

For a real sense of remoteness you could explore the coast at Morecambe Bay, Silloth, or from Amble to Berwick-upon-Tweed. How about Spurn Head, The Wash, Dungeness and Camber, the Isle of Portland, Watchet? Or Start Point, Lizard Point, Hartland Point – in fact all the sticky-out points? Everyone who likes a good remote beach will have their own special place. The thing is not to tell anyone else, or everyone will want to go and the car-park builders will move in.

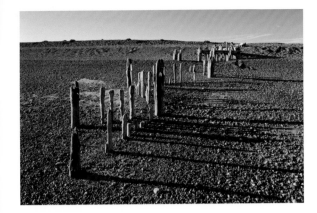

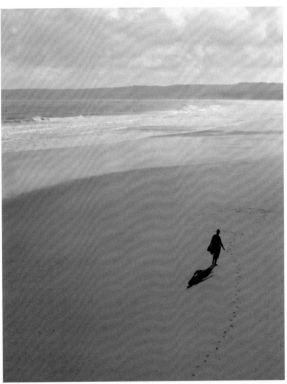

FACING PAGE Vehicle tracks recede into the distance at Mablethorpe beach, Lincolnshire.

ABOVE Old groins catch the evening light at Rye Harbour.

RIGHT A lone figure has a Robinson Crusoe moment as she stumbles upon a line of footprints in the sand at Filey beach, North Yorkshire.

BELOW Atlantic breakers and pebbles at Porth Nanven, Cornwall.

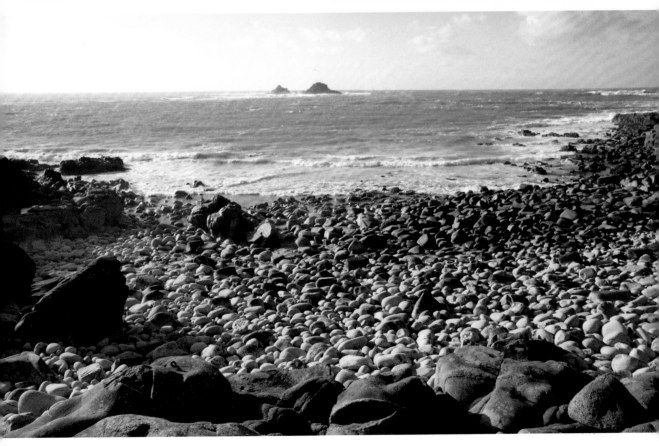

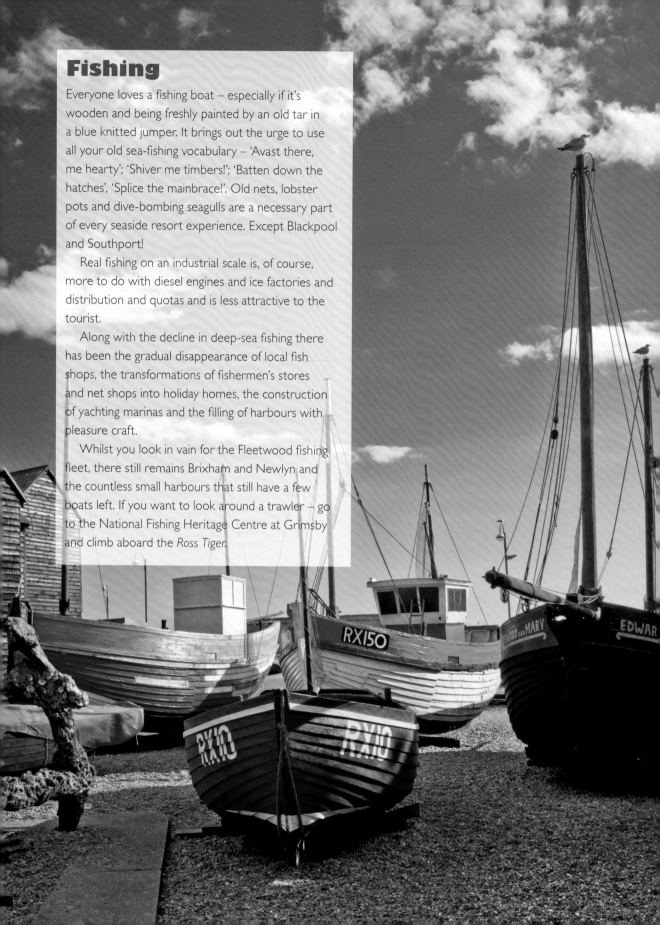

Fishing

Everyone loves a fishing boat – especially if it's wooden and being freshly painted by an old tar in a blue knitted jumper. It brings out the urge to use all your old sea-fishing vocabulary – 'Avast there, me hearty'; 'Shiver me timbers!'; 'Batten down the hatches', 'Splice the mainbrace!'. Old nets, lobster pots and dive-bombing seagulls are a necessary part of every seaside resort experience. Except Blackpool and Southport!

Real fishing on an industrial scale is, of course, more to do with diesel engines and ice factories and distribution and quotas and is less attractive to the tourist.

Along with the decline in deep-sea fishing there has been the gradual disappearance of local fish shops, the transformations of fishermen's stores and net shops into holiday homes, the construction of yachting marinas and the filling of harbours with pleasure craft.

Whilst you look in vain for the Fleetwood fishing fleet, there still remains Brixham and Newlyn and the countless small harbours that still have a few boats left. If you want to look around a trawler – go to the National Fishing Heritage Centre at Grimsby and climb aboard the *Ross Tiger*.

FACING PAGE Fishing boats on the Stade at Hastings.

RIGHT A small fishing boat drawn up on the beach at Worthing, West Sussex.

FAR RIGHT The ubiquitous fibreglass fishermen in their sou'westers. Top one is at North Shields, Tyne and Wear. Bottom one, Whitstable Harbour, Kent.

BELOW Fishing boats on the shingle beach at Dungeness, Lydd, Kent.

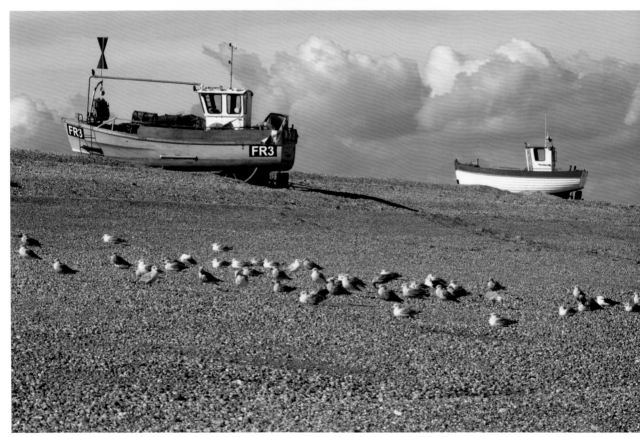

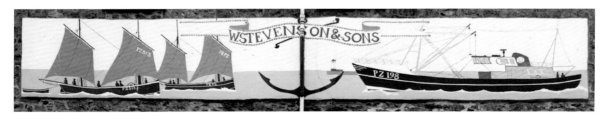

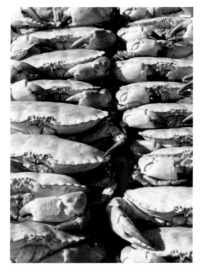

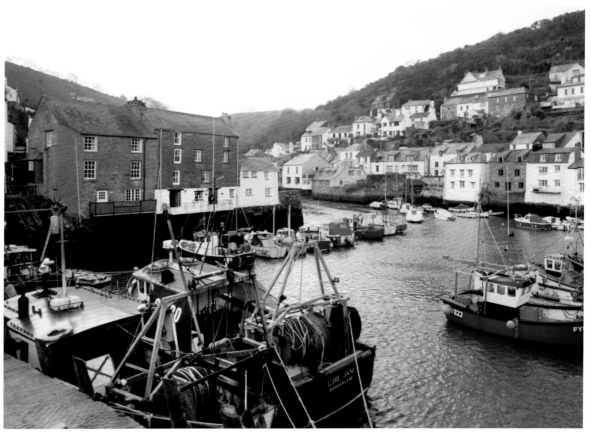

FACING PAGE

TOP A sign on the side of a warehouse in Newlyn, Cornwall. Stevenson's have lovely hand-painted signs dotted about the harbour and even on the sides of their lorries.

CENTRE LEFT Crabs at Hastings.

CENTRE RIGHT Real fishing at the north landing, Flamborough, East Yorkshire.

BELOW Polperro Harbour, Cornwall.

RIGHT Fishing boats, Folkestone Harbour.

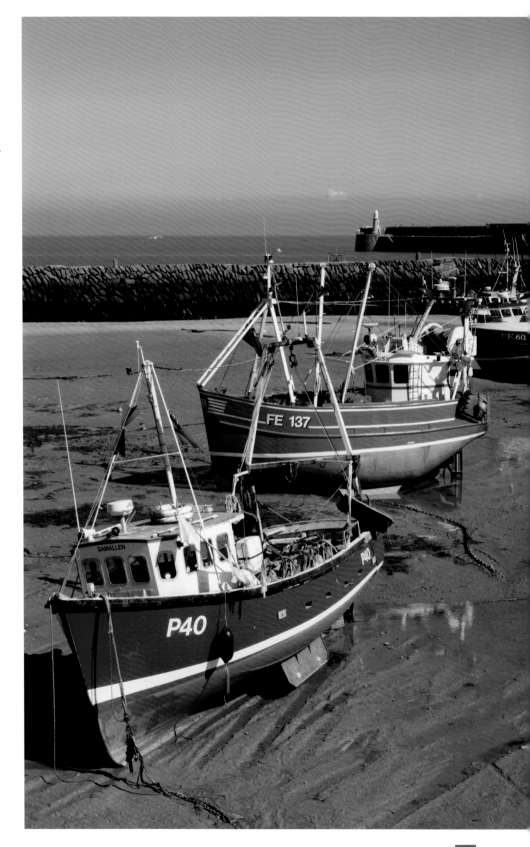

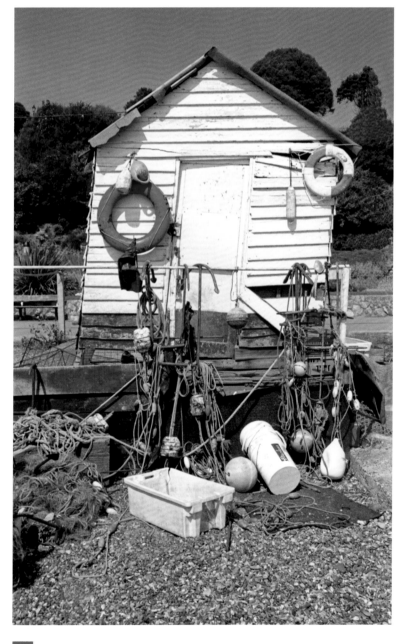

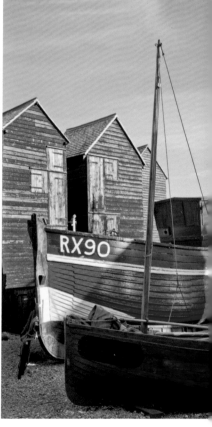

FACING PAGE

TOP LEFT Weatherboarded sail lofts at Brightlingsea, Essex.

TOP RIGHT The Huer's Hut or House, Newquay, Cornwall. Listed as dating from the 18th century, the hut was used as a shelter for the pilchard shoal lookout. The lookout or 'huer' would call out 'Hevva hevva' and wave bushes to direct the boats. Thought to be the origin of the expression 'hue and cry'. But wait, the sign on the building says it dates from the 14th century, was originally a beacon lighthouse and then a hermitage. An interesting enigma!

BOTTOM LEFT The Fryer and Goodall fish shop hut at Felixstowe, Suffolk.

CENTRE RIGHT A sign at Padstow, Cornwall.

BOTTOM RIGHT RX90 *The Valiant*, built in 1953, outside the Fishermen's Museum at Hastings.

TOP RIGHT Fishing boat at Newhaven, East Sussex.

RIGHT A painting of the village displayed at the entrance to Craster, Northumberland.

BELOW Trips to the Farne Islands from Seahouses, Northumberland.

BELOW RIGHT The Fish-slab Gallery, Whitstable, Kent, still retains its typical large wet-fish shop window.

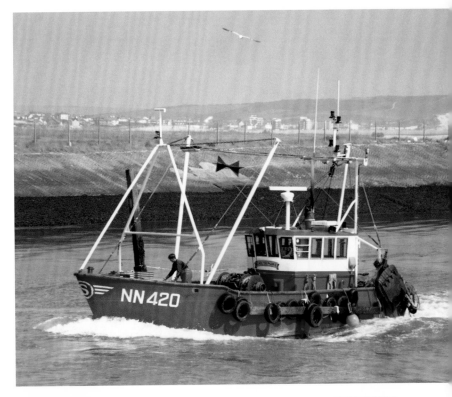

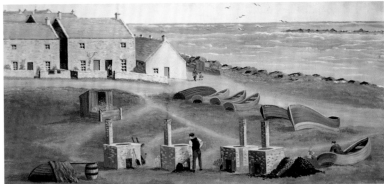

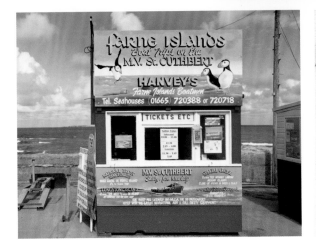

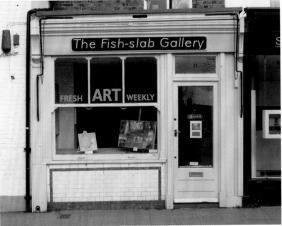

Lighthouses

The main thing about lighthouses is that they are meant to be seen far out to sea – giant candles visible by day and night.

They serve as warnings of danger and help determine position. They may be identified by the character and duration of the flash, or the paintwork on the tower which is often alternate stripes of red and white. No two are the same or else there would be total confusion. They have gradually become less important to navigation with advances in global positioning technology.

Automation has led to the loss of the Lighthouse Keeper, although someone must still be on hand to change the bulbs. I have been lucky enough to have talked to several keepers prior to automation hoping to find out what they thought about during all that gazing out to sea. Alas, they were disinclined to talk to me, being solitary types who answer all questions with the 'Maybe it will and maybe it won't' kind of reply.

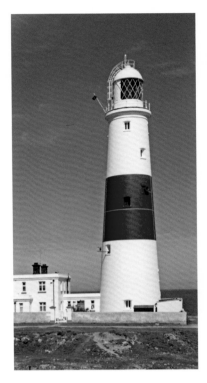

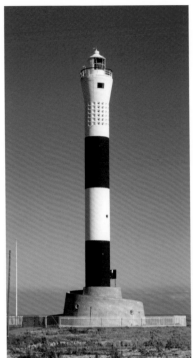

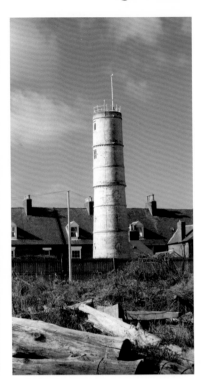

FACING PAGE The low lighthouse of 1752 at Spurn Head, Yorkshire.

ABOVE The well-known lighthouse at Portland Bill, Dorset, 1906.

BELOW A triangular sighting tree at Workington harbour, Cumbria.

ABOVE New Lighthouse, Dungeness, Kent, 1961.

BELOW The Low Lighthouse, Burnham-on-Sea, Somerset, constructed in 1832 after the High Lighthouse proved to be built on too low a vantage point to take account of the massive rise and fall of the tides.

ABOVE Lighthouse behind the Bath House Terrace, Blyth, Northumberland.

BELOW The 'Red Robot' at South Shields, Tyne and Wear, which was constructed in 1880.

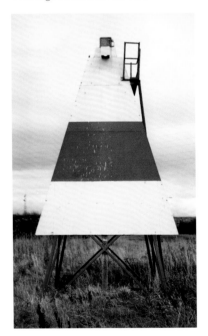

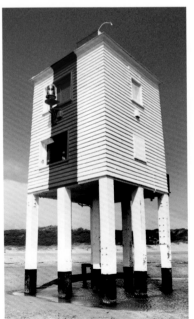

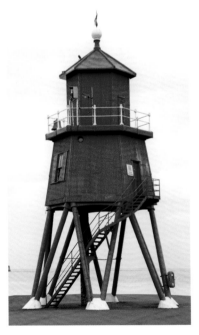

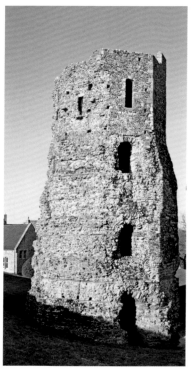

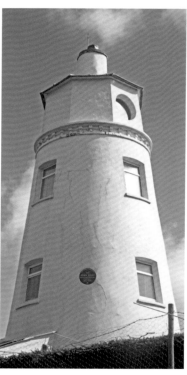
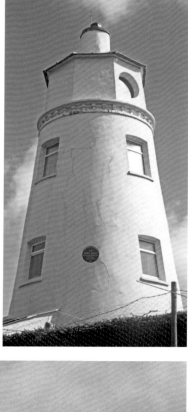

FAR LEFT The Roman Pharos at Dover Castle next to the church of St Mary-in-Castro. Built as a fire tower c 130 AD to guide the ships of the *Classis Britannica*. The top part is the remains of a medieval belfry.

LEFT The East Lighthouse at Sutton Bridge on the River Nene in Lincolnshire, formerly the home of Sir Peter Scott. In 1981 I was sent to photograph the strangely tapering built-in cupboards here and remember well the eerie mists, and weird echoing bird calls in this idyllic and remote haven.

BELOW LEFT The only independently run operational lighthouse in Britain at Happisburgh, Norfolk.

BELOW Red-painted landmark at Porthgwara, Gwennap Head, St Levan, Cornwall.

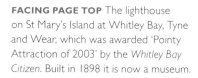

FACING PAGE TOP The lighthouse on St Mary's Island at Whitley Bay, Tyne and Wear, which was awarded 'Pointy Attraction of 2003' by the *Whitley Bay Citizen*. Built in 1898 it is now a museum.

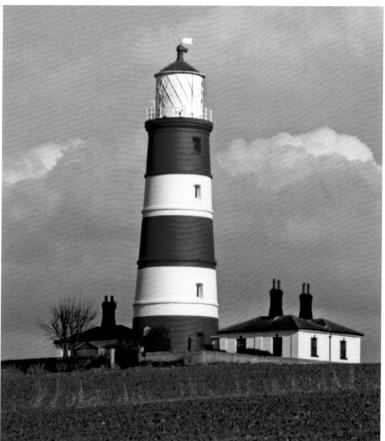

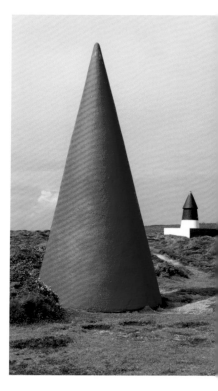

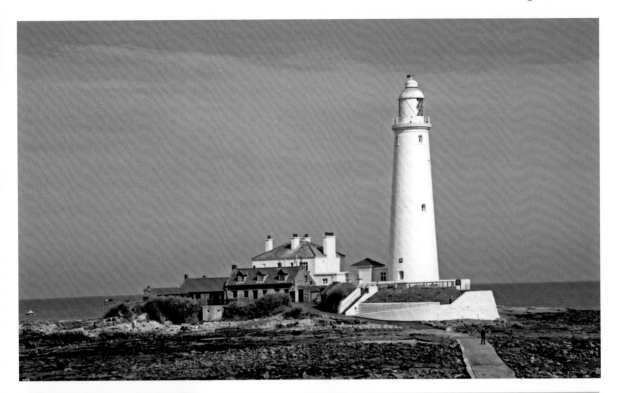

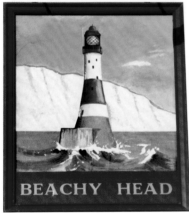

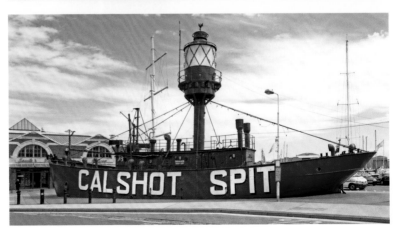

ABOVE The seaward side of the Beachy Head lighthouse, East Sussex, depicted on a pub sign.

ABOVE RIGHT The west harbour light at Newhaven, East Sussex. The light is just visible in the little oriel window on the right of the house. The whole thing is on rails and could once have been trundled back and forth.

RIGHT The former Calshot Spit lightship at Southampton. Dating from 1914, it is now a museum.

Time and tide

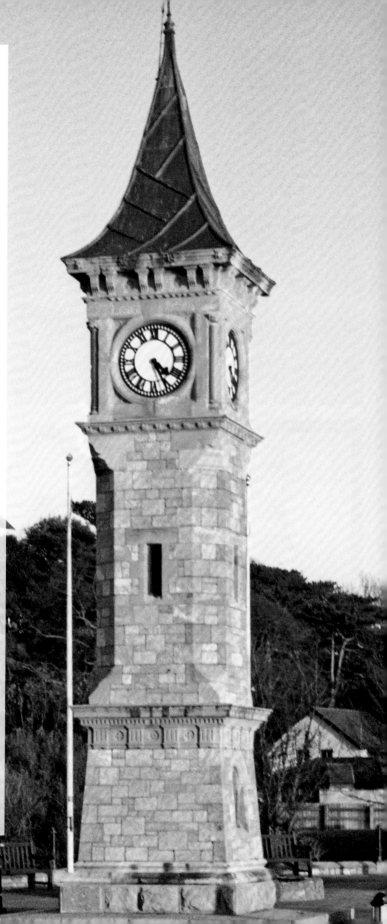

Accurate timekeeping is essential for navigation and it is no surprise that a great sea power was in the forefront of its development.

In 1714 the Board of Longitude offered a prize of £20,000 for an accurate seagoing chronometer – finally awarding the prize in 1776 to John Harrison, a joiner from Lincolnshire. Later, the coming of the railways encouraged the standardisation of time into zones, enabling timetables to work.

The science and philosophy of time is not a subject that immediately springs to mind when strolling down the prom wearing a 'kiss me quick' hat. What are we to make of all these different meridians, Flamsteed's, Halley's, Bradley's and Airy's? What indeed do we think of the Mean Sun, an imaginary body moving round the equator with a constant speed making one circuit with respect to the vernal equinox in one tropical year? We walk on, comfortable in the knowledge that someone understands it all and we can enjoy the visible results – the many fine and interesting clock towers and clock cases built for civic pride, for jubilee, for amusement.

In Brighton, however, they don't like clocks and every year, on the shortest day, hundreds of effigies of clocks are taken down to the beach and burnt.

Space precludes showing my other favourites: the station clock tower at Cleethorpes; Grange-over-Sands' clock tower; Shanklin's clock tower and drinking fountain, and the unusual concoction at Herne Bay.

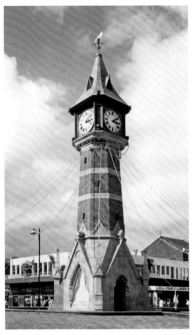

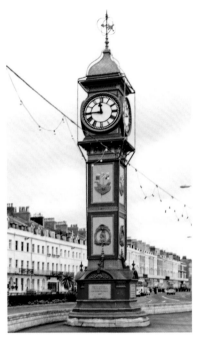

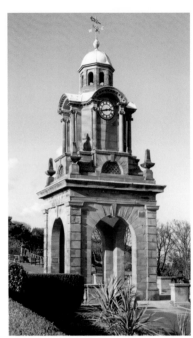

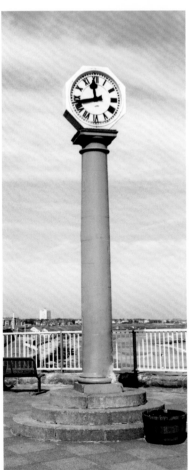

ABOVE LEFT The Jubilee Clock Tower at Skegness, Lincolnshire, erected by public subscription in 1898 and opened by the Countess of Scarborough.

ABOVE Jubilee Clock Tower at Weymouth, Dorset, built 1887 on a stone slab on the beach and subsequently absorbed by the new esplanade.

TOP RIGHT The Holbeck clock tower at Scarborough. This features in the television series *The Royal* centred on the fictional St Aidan's Royal Free Hospital. Arthur Shuttleworth presented the clock in 1911 as a memorial of the coronation of George V. He also later presented the gardens surrounding the clock which were originally called Red Court Gardens.

LEFT The pillar clock at Whitley Bay, Tyne and Wear. The saving grace of a rather worse-for-wear esplanade.

RIGHT The latitude and longitude marker at Ventnor, Isle of Wight, presented by Sir Thomas Brisbane in 1851.

FACING PAGE The Jubilee Clock Tower at Exmouth, Devon, architects Kerley and Ellis.

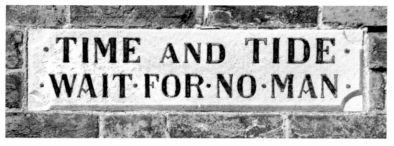

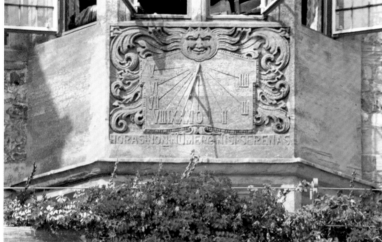

LEFT Time and tide wait for no man sign, Sandown, Isle of Wight.

BELOW LEFT At Lyme Regis, Dorset, a sundial of 1903 harks back to more ancient times.

BOTTOM LEFT Felixstowe water clock.

BELOW The high-tide indicator at Budleigh Salterton, Devon, in giant pocket-watch style.

BOTTOM The tide gauge at Teignmouth Pier, Devon.

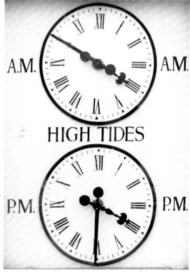

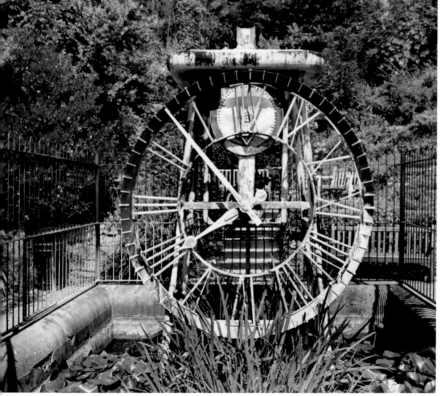

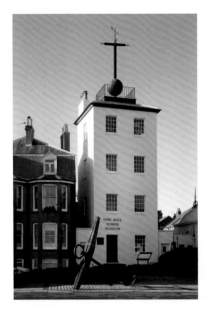

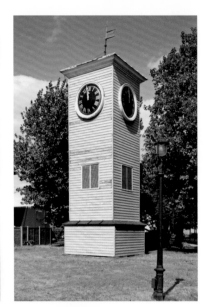

ABOVE Deal Time Ball Tower, Kent. Built in 1795 as a naval semaphore station to communicate with London via repeater stations, it was converted to a time ball clock in 1855. The ball was raised halfway at 12.55 pm, fully raised at 12.58 pm and dropped at 1 pm. The ball was dismantled in 1927, but has since been replicated, and the tower is now a museum.

ABOVE CENTRE Clock in the Blackpool Illuminations. 'Artifical sunshine' from eight arc lamps lit part of the promenade in 1879. The illuminations began in 1912 and are now the greatest free light show on earth utilising one million light bulbs.

ABOVE RIGHT Sheerness Dockyard, Kent. The rather 'American'-looking weatherboarded clock tower, formerly part of the Quadrangle storehouse of 1824.

RIGHT The Tim Hunkin and Will Jackson water clock on Southwold pier, Suffolk.

BELOW The high-tide indicator at Ventnor, Isle of Wight, on the gable of Blake and Sons' beach store.

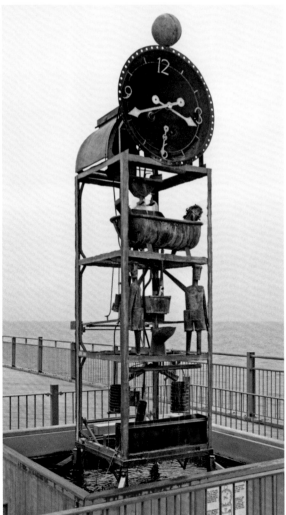

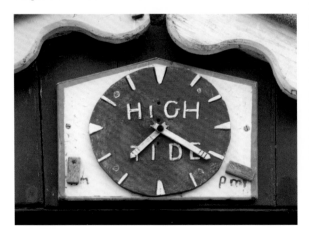

Weather

The cold, the wind, the driving rain, the leaden skies – why do we keep going back?

Well, just dive into a 'caff' or an amusement arcade, or a winter garden, or go to the pictures, or sit and read. All that bad weather will soon go by and the sun will come out. And there are spectacular sunsets. Always look on the bright side.

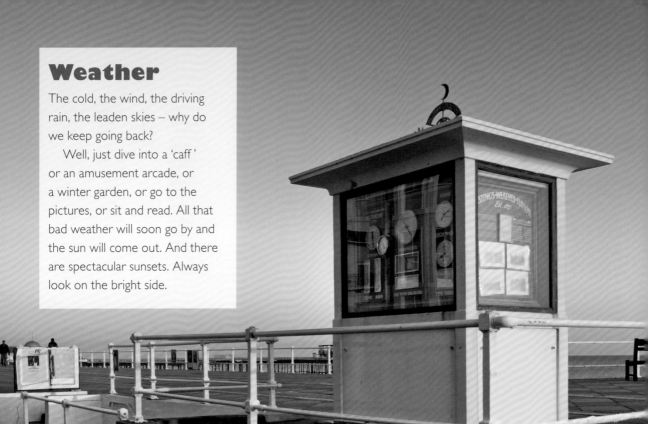

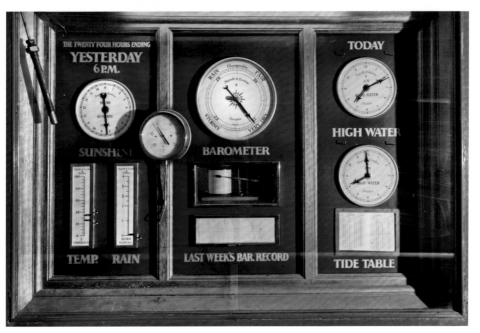

ABOVE Hastings Weather Kiosk. This is a very worthy thing. The data is gathered daily in White Rock Gardens and then transferred to the kiosk.

LEFT A detail of the Weather Kiosk instrumentation.

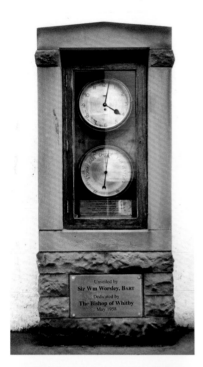

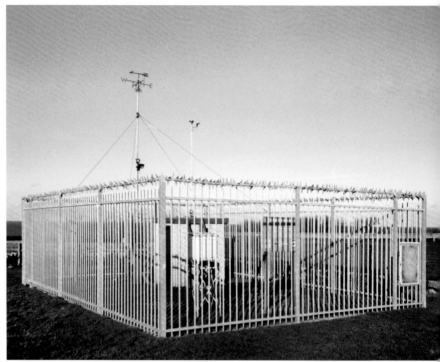

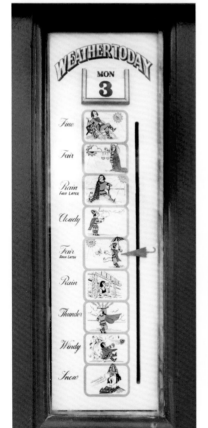

ABOVE LEFT The George Hanson memorial clock and barometer at Staithes, North Yorkshire.

LEFT Detail of the Hastings Weather Kiosk.

ABOVE Cromer Climatological Station, Norfolk. The information board has been ripped off but the rest of the equipment appears to be well protected against all comers.

BELOW Bude Weather Station, Cornwall.

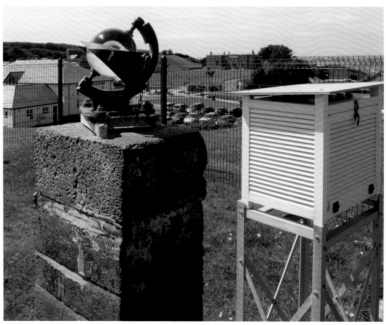

Wrecks

The coast of Britain is surrounded by countless wrecks wherever there are hazardous rocks or shallow waters.

Most wrecks, of course, are underwater and invisible. Some are occasionally revealed by wind or tide and we can marvel at their wood or metal bones sticking up from the sand and hope there was no loss of life. A real must-see wreck is the Bronze Age boat at Dover Museum.

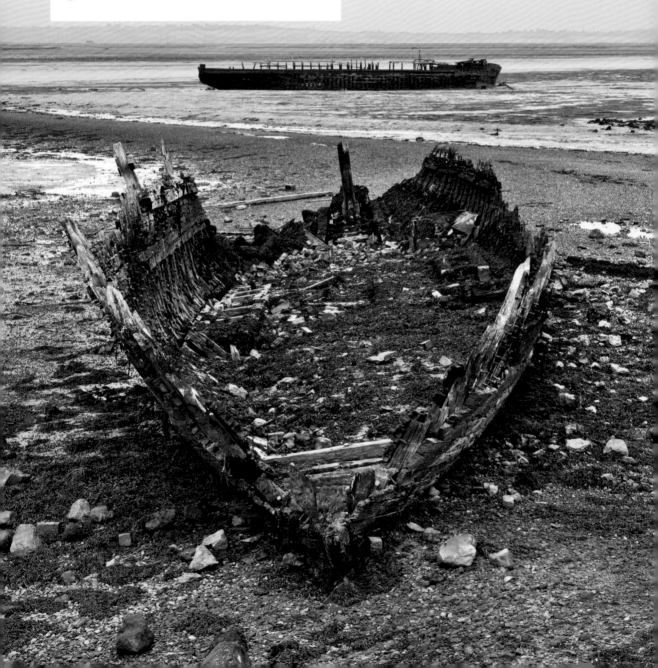

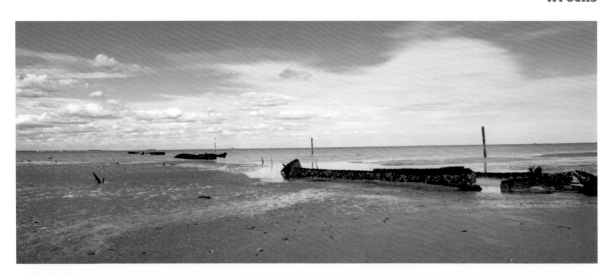

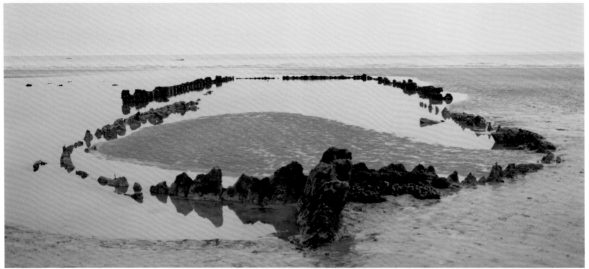

FACING PAGE Wrecks at
Elmley Ferry, Murston, Sittingbourne,
Kent.

TOP Sunken barges or wrecks,
Minster beach, Isle of Sheppey, Kent.

ABOVE Wreck of the *Amsterdam*,
Bulverhythe beach, St Leonards-on-
Sea, East Sussex.

RIGHT Wreck of the *Falcon* 1926,
Langdon Steps, Dover.

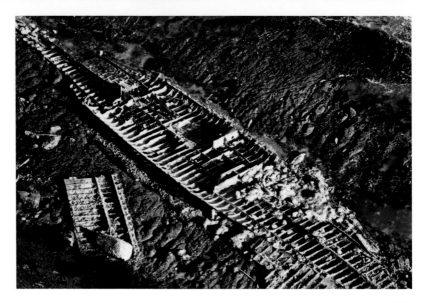

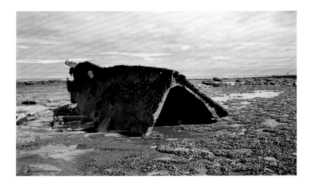

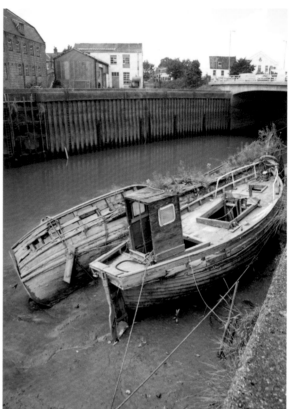

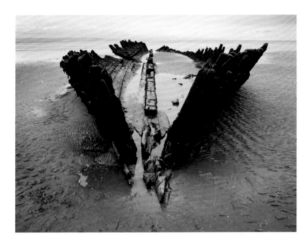

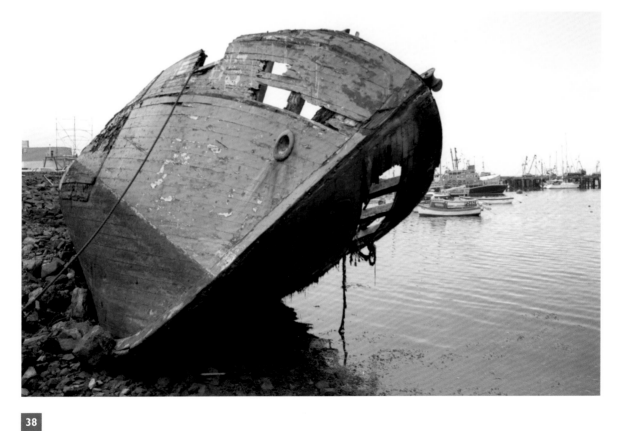

FACING PAGE

TOP LEFT The wreck of the *Creteblock* on the beach at Whitby Scaur, North Yorkshire. This was one of the first concrete boats, built around 1919.

CENTRE LEFT The wreck of the *Nornen*, a Norwegian barque driven ashore in 1897, on Berrow beach, Somerset. In 2003 it was thought to be a danger to jet skiers who wanted it blown up. Which would have been a pity. It now has yellow wreck marker buoys anchored at each side. This is a magical spot.

TOP RIGHT The creek in Boston, Lincolnshire – final resting place for large numbers of fishing boats.

BOTTOM Fishing boats are often drawn up on the beach at Newlyn, Cornwall, to be ignominiously broken up and even burnt.

ABOVE RIGHT Upturned boats used as fishermens' stores on the beach at Holy Island, Northumberland.

RIGHT Wrecked fishing boat, Rye Harbour.

BELOW The MV *Maanav Star* which went aground on 11 September 2004 at Jury's Gap near Camber, East Sussex. Not quite a wreck, but a close call.

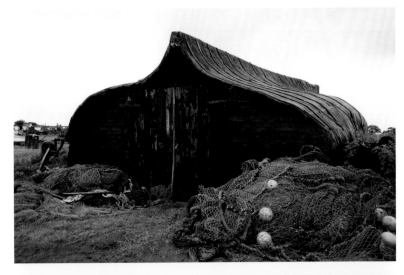

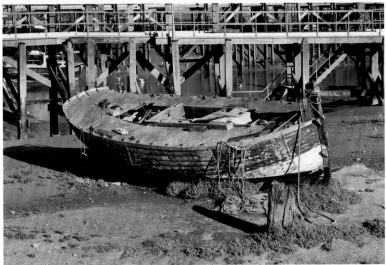

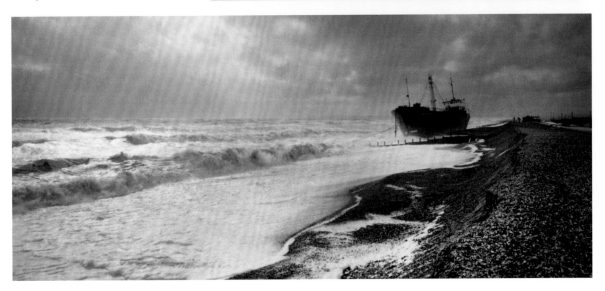

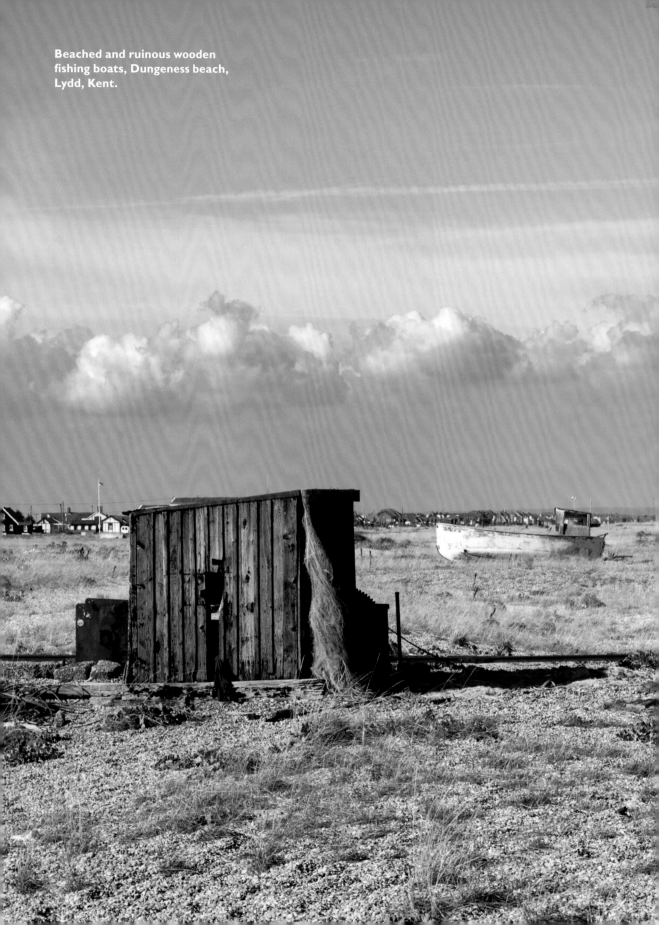

Beached and ruinous wooden
fishing boats, Dungeness beach,
Lydd, Kent.

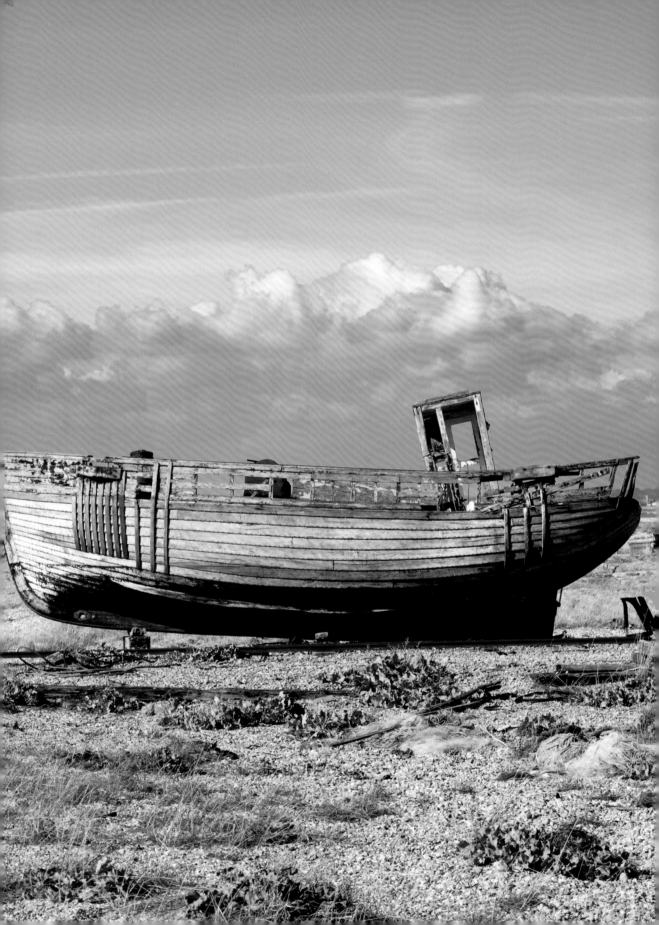

Lifeboats

The history of the lifeboat starts with the 'Unimmergible Boat' which was patented by Lionel Lukin in 1785. The sides of the boat were lined with cork and airtight cases.

We move swiftly on to Tynemouth and the two gentlemen associated with early lifeboats, Henry Greathead and William Wouldhave. The name of Greathead's craft was *The Lifeboat,* clearly a name more intelligible than Unimmergible.

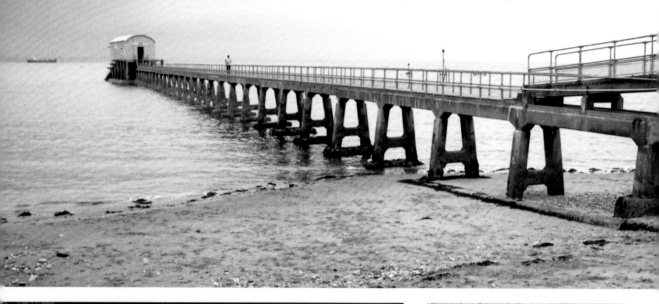

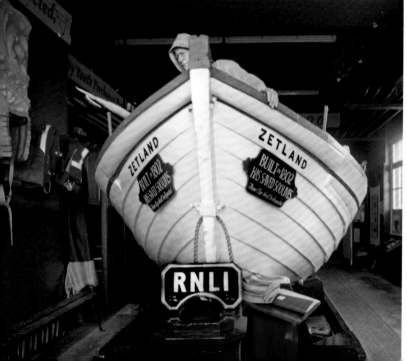

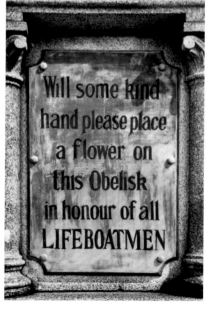

FACING PAGE

TOP The long jetty leading to the Bembridge lifeboat house on the Isle of Wight.

BOTTOM LEFT The oldest lifeboat *Zetland*, a clinker-built rowing boat of 1802, built by Henry Greathead and now on display at Redcar, North Yorkshire.

BOTTOM RIGHT Inscription on the lifeboat obelisk at Southport, Merseyside.

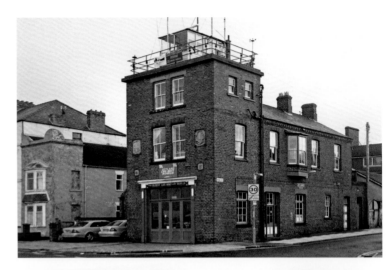

TOP RIGHT The Zetland Museum housed in the boathouse of 1877 on the esplanade at Redcar.

RIGHT *Tyne* – the second-oldest lifeboat in the country, built in 1833, South Shields, Tyne and Wear.

BELOW The lifeboat *Eric and Susan Hiscock* (*Wanderer*) at Yarmouth, Isle of Wight.

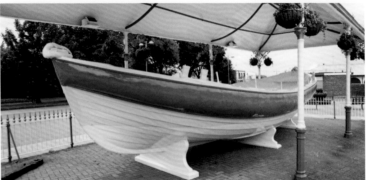

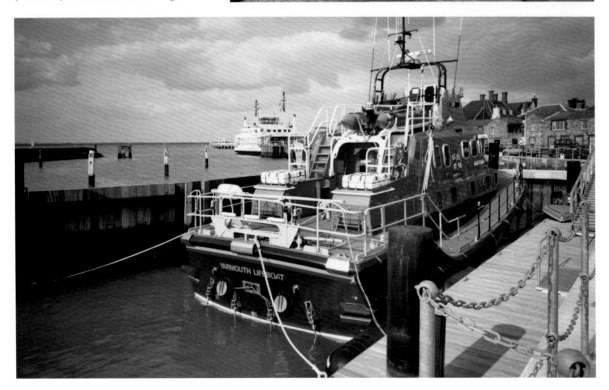

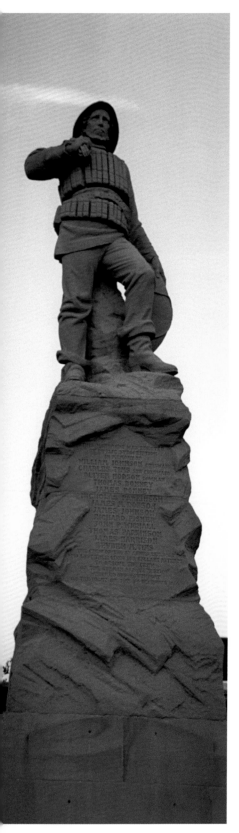

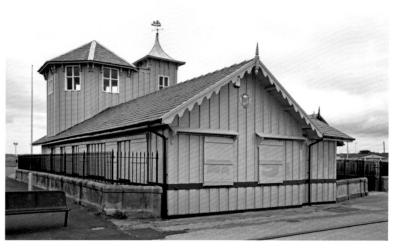

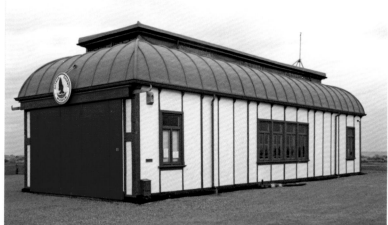

LEFT The lifeboat monument at St Anne's, Lancashire, 1890, commemorating the lifeboat men who lost their lives attempting to rescue the crew of the barque *Mexico*.

TOP South Shields Volunteer Life Brigade Watch House of 1867, South Shields, Tyne and Wear.

ABOVE The former 1923 lifeboat shed from Cromer pier, Norfolk, now used as the Alfred Corry Museum at Southwold, Suffolk, where the 1893 Southwold no 1 lifeboat is preserved.

RIGHT The monument to the crew of the coble *Two Brothers* at Flamborough, East Yorkshire.

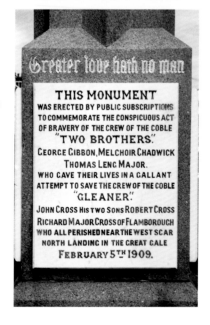

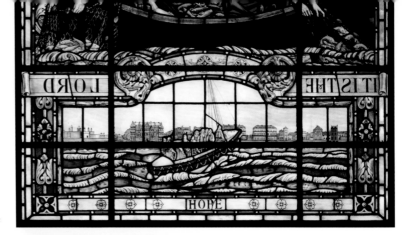

RIGHT Stained-glass window depicting a lifeboat, St George's Church, Deal, Kent.

BELOW RIGHT The Rocket Garage at Cullercoats, Tyne and Wear, formerly the life brigade apparatus house dated 1867. The early brigades pioneered rocket lifelines.

BELOW The Lifeboat Inn pub sign at St Ives, Cornwall.

BOTTOM The Life Brigade Watch House at Tynemouth, Tyne and Wear, built in 1886 by C T Gomoszynski.

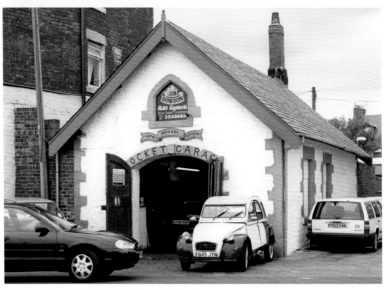

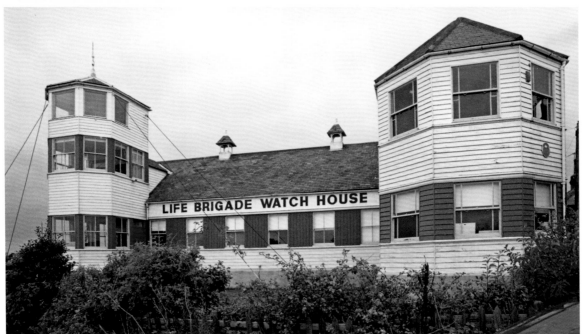

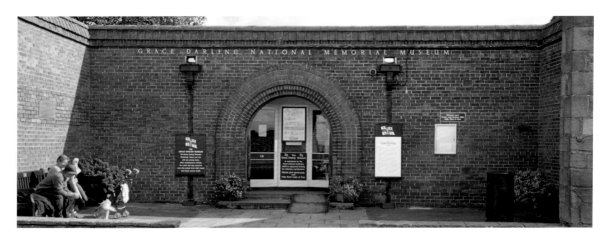

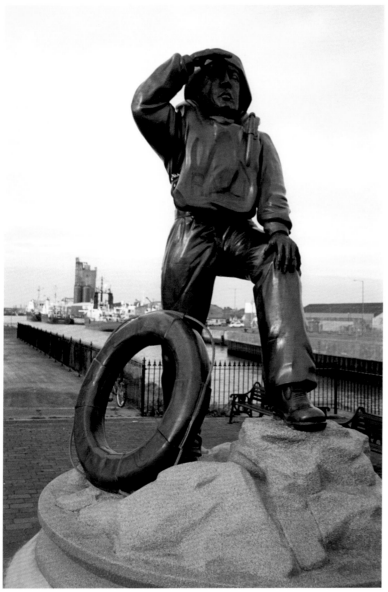

ABOVE The Grace Darling National Memorial Museum at Bamburgh, Northumberland. Grace Darling (1815–42) was one of England's greatest heroines.

LEFT The RNLI monument at Lowestoft, Suffolk.

BELOW The bust of Henry Blogg at Cromer, Norfolk. He served as a lifeboat-man for 53 years and no other lifeboat crew member has surpassed his record of gallantry medals.

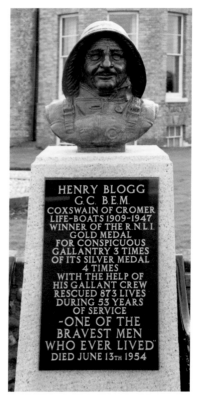

HENRY BLOGG
G.C. B.E.M.
COXSWAIN OF CROMER
LIFE-BOATS 1909-1947
WINNER OF THE R.N.L.I.
GOLD MEDAL
FOR CONSPICUOUS
GALLANTRY 3 TIMES
OF ITS SILVER MEDAL
4 TIMES
WITH THE HELP OF
HIS GALLANT CREW
RESCUED 873 LIVES
DURING 53 YEARS
OF SERVICE
-ONE OF THE
BRAVEST MEN
WHO EVER LIVED"
DIED JUNE 13TH 1954

ABOVE Caister-on-Sea lifeboat station, Norfolk. Famous for its record for most lives saved and for its motto 'Never turn back', it is now run independently from the RNLI.

RIGHT Cromer Church lifeboat window.

BELOW Lifeboat mosaic at Brixham Harbour, Devon.

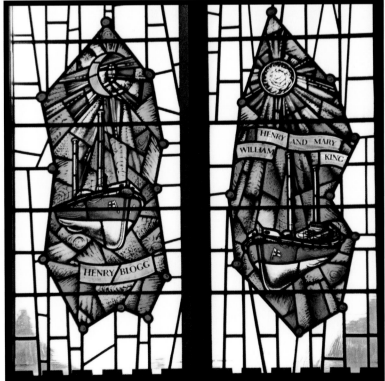

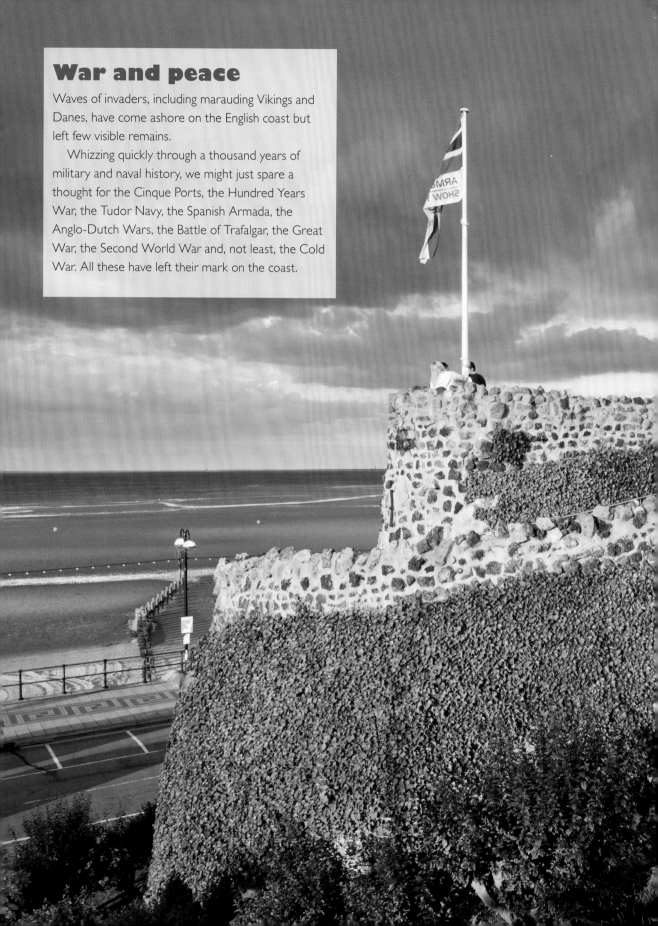

War and peace

Waves of invaders, including marauding Vikings and Danes, have come ashore on the English coast but left few visible remains.

Whizzing quickly through a thousand years of military and naval history, we might just spare a thought for the Cinque Ports, the Hundred Years War, the Tudor Navy, the Spanish Armada, the Anglo-Dutch Wars, the Battle of Trafalgar, the Great War, the Second World War and, not least, the Cold War. All these have left their mark on the coast.

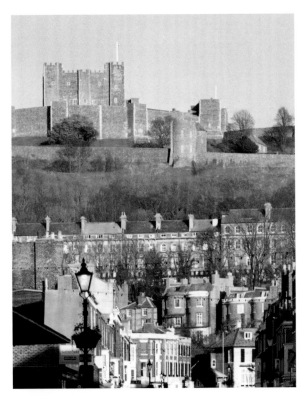

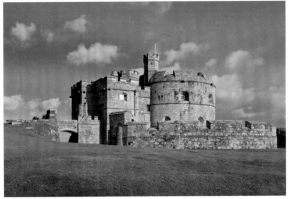

FACING PAGE Ross Castle at Cleethorpes, Lincolnshire. This mock ruin was constructed in 1883 by the Manchester, Sheffield and Lincolnshire Railway Company as a tourist attraction.

ABOVE Dover Castle seen from the town. Set on a vital strategic site commanding the shortest sea crossing between England and the Continent, it boasts the longest history of any fortress in the country.

ABOVE RIGHT Pendennis Castle, Falmouth, Cornwall.

RIGHT Bamburgh Castle, Northumberland.

BELOW Deal Castle, Kent. A Tudor artillery fortress.

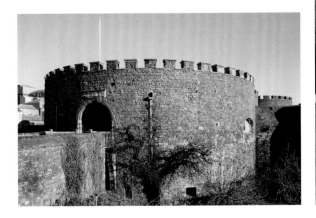

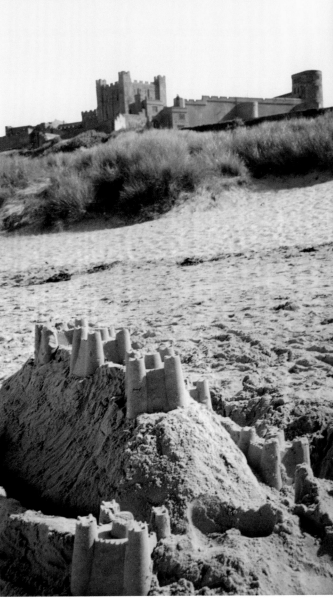

 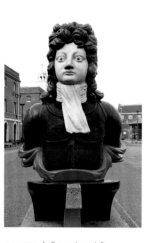 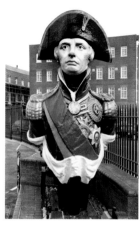

ABOVE A ship's figurehead at Brightlingsea, Essex. Another Nelson conundrum. Is this a depiction of Nelson at some stage between the Siege of Calvi, where he lost the use of one eye, and the Battle of Santa Cruz where he lost his right arm? In fact, he may never have worn an eye patch.

ABOVE A figurehead from HMS *Benbow*, a ship of 72 guns built in 1813, at the Royal Naval Dockyard, Portsmouth.

ABOVE A figurehead from HMS *Trafalgar*, a first-rate ship of 120 guns built in 1841, at the Royal Naval Dockyard, Portsmouth.

ABOVE HMS *Victory* at Portsmouth. Admiral Horatio Nelson's famous ship is now a museum.

BELOW HMS *Warrior* at Portsmouth. Commissioned in 1861 as a three-masted sailing and steam ship, with a 'central citadel' iron box containing the main armament.

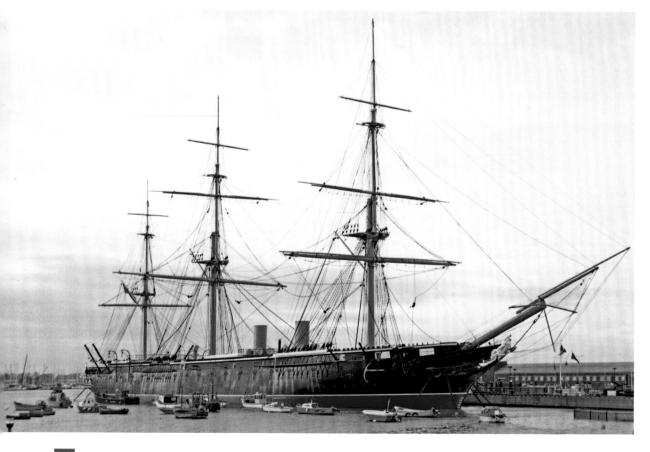

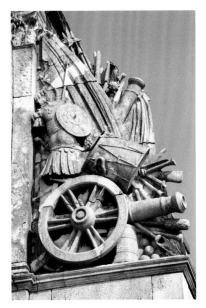

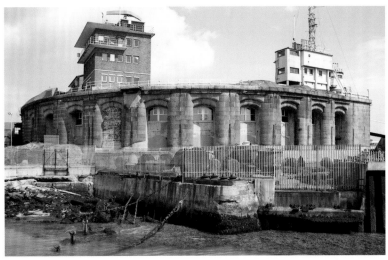

ABOVE Tilbury Fort, Essex. The full panoply of martial might is displayed on the late 18th-century gatehouse.

ABOVE Garrison Point Fort, Sheerness Dockyard, Kent. Protecting the River Medway in conjunction with Grain Tower, the fort dates from the 1860s. To the lower left of the photograph the remains of the stanchions of the Brennan torpedo system can be seen.

BELOW Fort Perch, New Brighton, Merseyside. Built in 1827 to defend the River Mersey.

BOTTOM The Boat Store at Sheerness Dockyard, Kent, 1856–60. An early surviving example of a multi-storey wrought-iron-frame building.

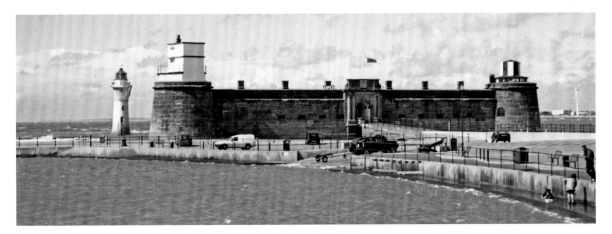

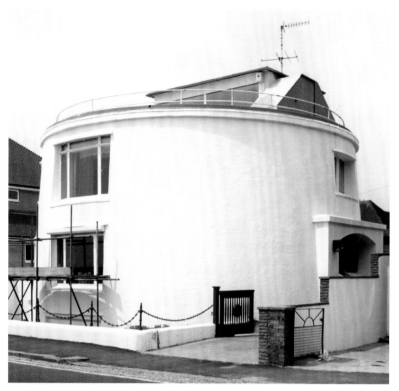

LEFT A converted martello tower at Hythe, Kent. One of 103 towers built 1805–12 to resist the potential Napoleonic invasion. The seaward walls were 4 metres thick.

BELOW LEFT Machine gun pillbox, Rye Harbour.

BELOW RIGHT Interior of machine gun pillbox, Rye Harbour.

BOTTOM LEFT A pillbox at Swanage, Dorset, probably predating the Second World War.

BOTTOM RIGHT An 'acoustic' or 'sound mirror' at Warden Point, Kent (now collapsed).

FACING PAGE TOP The large pillbox at Shellness beach in Kent was used as an XDO (extended defence officer's post) for a naval officer in charge of a marine minefield.

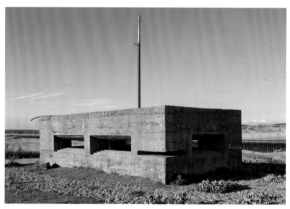

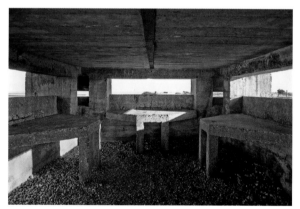

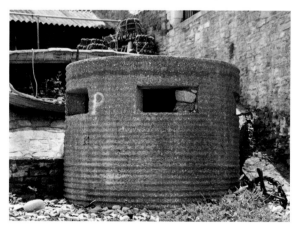

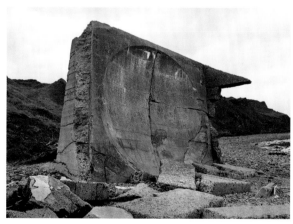

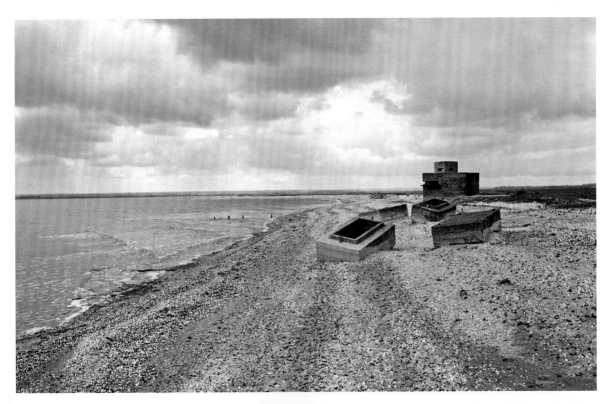

RIGHT Coastal erosion at Happisburgh, Norfolk, has led to Second World War structures falling onto the beach.

BELOW The stark functionality of a concrete pillbox to the east of Coalhouse Fort at East Tilbury in Essex.

BELOW RIGHT The Collingwood Memorial cannons at Tynemouth, Tyne and Wear. These are the original cannons from the *Royal Sovereign* which fought at the Battle of Trafalgar in 1805.

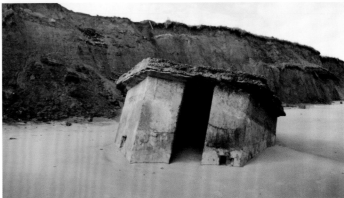

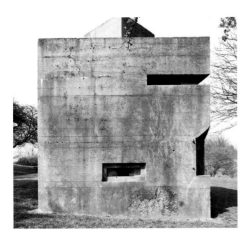

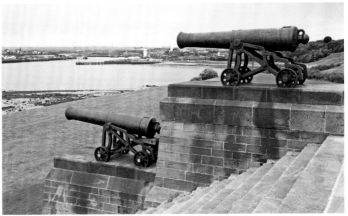

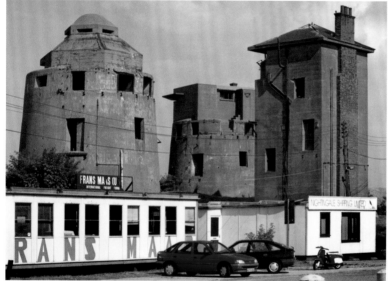

ABOVE Operation Overlord slipways at Torquay. The 4th Infantry Division of the VII Corps of the United States 1st Army departed from here on 6 June 1944 for the D-Day landings.

LEFT The concrete towers at Sheerness Dockyard in Kent.

BOTTOM A 32-ton Sherman Tank on Slapton Sands, Devon – rescued from the sea by Ken Small. Now a memorial to the 1943 disaster 'Exercise Tiger' when 946 American servicemen lost their lives during a D-Day landing exercise.

BELOW The Allen-Williams steel turret at Exmouth, Devon. Two men operated the turret, one to revolve it and one to fire a light machine-gun.

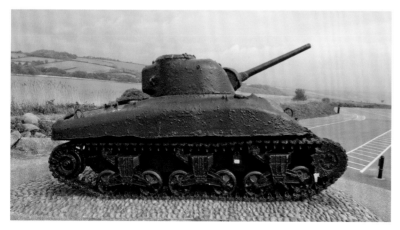

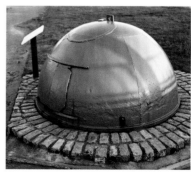

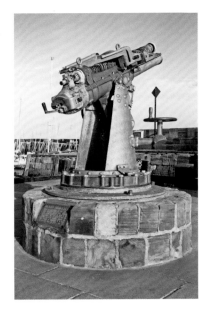

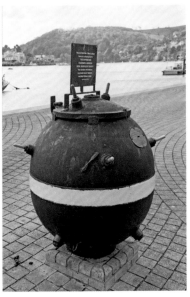

ABOVE The 1914 Vickers pattern 13 PDR gun at Scarborough.

ABOVE A black-painted sea mine at Dartmouth.

ABOVE Dozens of mines are still to be found in seaside towns. This one is at Watchet, Somerset.

BELOW Battery Observation Post [BOP], Pendennis Castle, Falmouth, Cornwall.

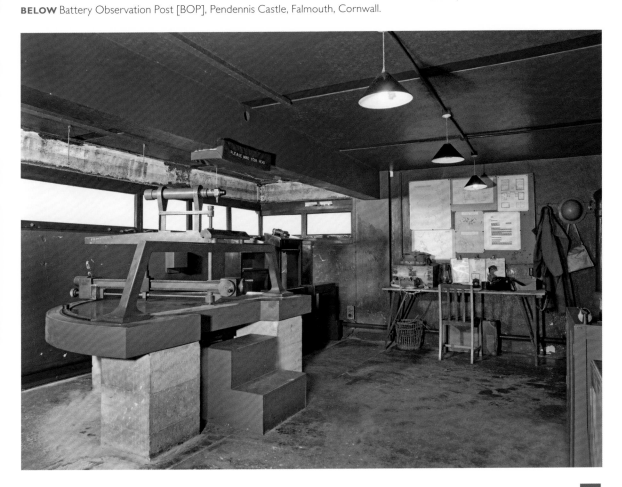

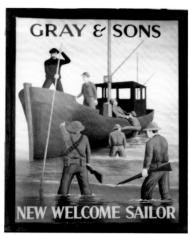

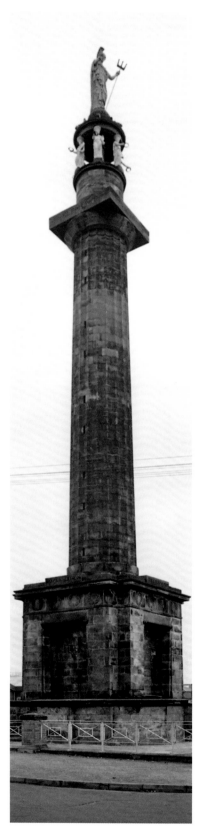

TOP A detail of a panel on the side of the Ramsey Monument at Dover Castle, showing the Normandy landings.

BOTTOM LEFT RAF Commonwealth and Allied Air Forces Second World War monument, Plymouth.

BOTTOM CENTRE The 'Yomper' Falklands Marine statue, Southsea, Hampshire.

BOTTOM RIGHT A window in the Royal Garrison Church, Portsmouth, showing two 'Tommies'.

ABOVE Dunkirk spirit on the New Welcome Sailor pub sign at Burnham-on-Crouch, Essex.

LEFT Nelson's Monument at Great Yarmouth. Erected 1817–19, the figure of Britannia on the top is now a fibreglass replica.

BELOW LEFT The statue of Sir Francis Drake at Plymouth, which was erected in 1884.

BELOW RIGHT Monument to Admiral Sir Bertram Ramsay at Dover Castle. He was Commander-in-Chief Allied Naval Expeditionary Force, 1944.

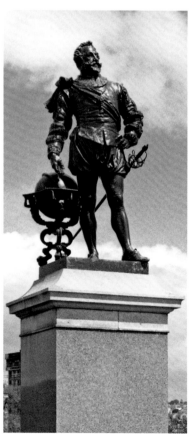

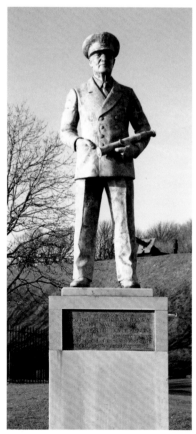

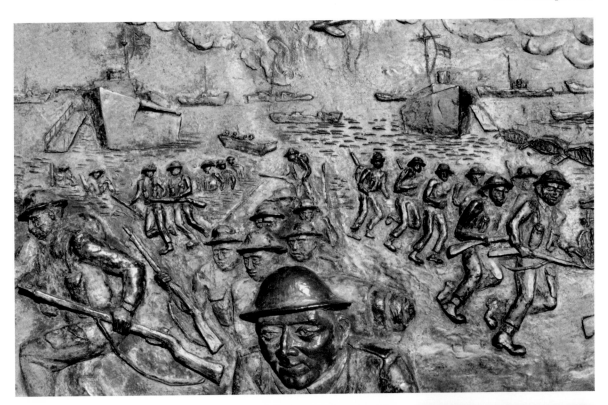

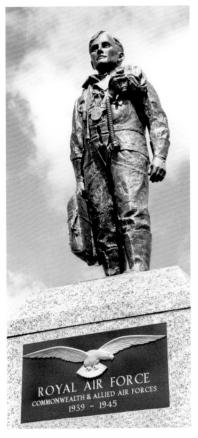

ROYAL AIR FORCE
COMMONWEALTH & ALLIED AIR FORCES
1939 - 1945

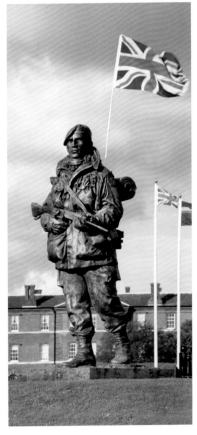

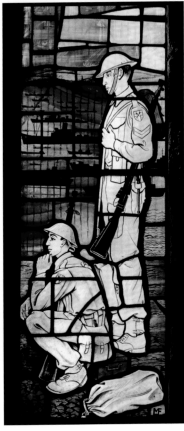

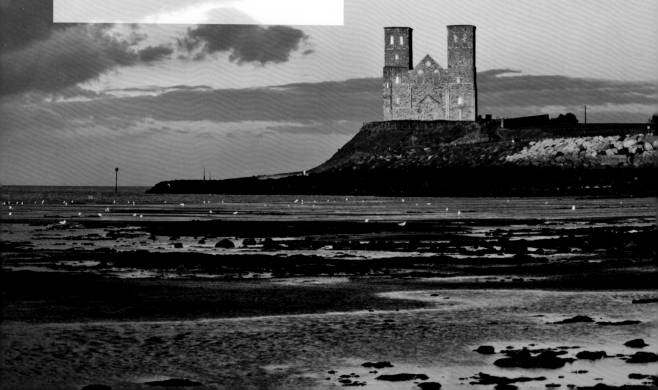

Religion

George Bernard Shaw wrote: 'Heaven, as conventionally conceived, is a place so inane, so dull, so useless, so miserable, that nobody has ever ventured to describe a whole day in heaven, though plenty of people have described a day at the seaside.'

Much blessing of water, fish, boats, fishermen, throwing of crucifixes in the sea, 'beach preaching' and other more arcane religious ceremonies seem to take place round the coast. Seaside towns also seem to have a large number of churches. Whitby, for example, has Whitby Abbey, site of the Synod of Whitby, St Hilda's Church and the Caedmon Memorial, the English Martyrs' Church, the Evangelical Church, the Methodist Church, the New Life Church, Order of the Holy Paraclete, Our Lady's Church, St Anne's Church, St Bede's Church, St Hedda's Presbytery Church, St Patrick's Church, Trinity Church, West Cliff Congregational Church as well as any number of 'alternative religion' sites.

Religion is bewilderingly complicated. Let's hope our gods know what they are doing and talk to each other.

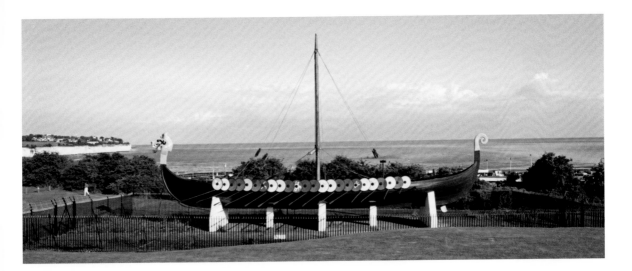

ABOVE The replica Viking longboat *Hugin* built in 1949 by the Frederickssund Shipyard in Denmark and now at Pegwell Bay, Kent. The boat commemorates the landing of Hengist and Horsa in AD 49. They may have not been people but horse gods.

RIGHT Whitby Abbey, North Yorkshire, seen across the 'hard garden'.

FACING PAGE The 'Twin Sisters' at Reculver, Kent. Dating to AD 669, the existing towers once had spires. These were erected in the 15th century on the orders of the Abbess of Faversham and her sister who had been shipwrecked off the Reculver coast. The main body of the church was demolished in 1809 but the towers were kept to aid navigation.

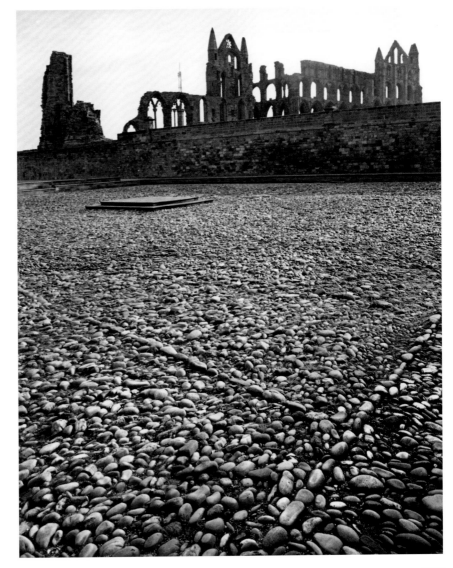

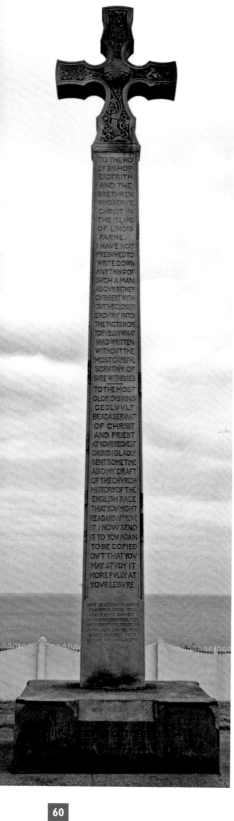

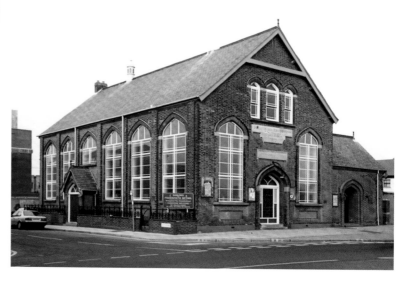

FACING PAGE

FAR LEFT The Bede Memorial Cross at Roker, Tyne and Wear.

LEFT TOP The Saxon church of St Peter, Barton-upon-Humber, Lincolnshire. Dating from the 9th century, the tower has characteristic 'long and short work'.

LEFT CENTRE The Sailors' Church and former Sailors' Home, Ramsgate. Opened in 1878, the dormitories at the top were provided for shipwreck survivors. To the right of the church is the Smack Boys' Home.

LEFT BOTTOM The Sailors' and Fishermen's Bethel, Lowestoft, Suffolk.

ABOVE LEFT The sign for the Witchcraft Museum at Boscastle, Cornwall.

ABOVE Chapel of St Mary, Bucklers Hard, Beaulieu, Hampshire.

BELOW The Sanger tombs at Margate Cemetery, including the Mazeppa circus horse. The Sanger family were showmen and menagerists and developed the precursor of Dreamland, the Hall by the Sea.

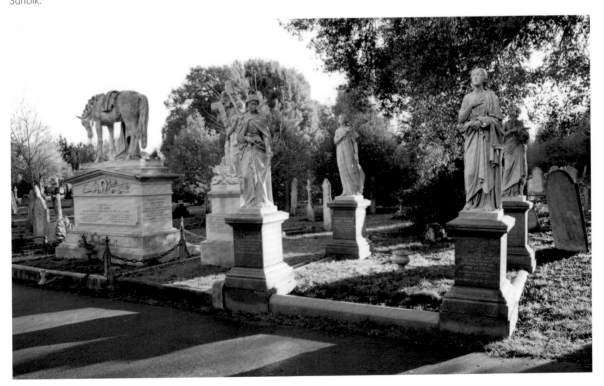

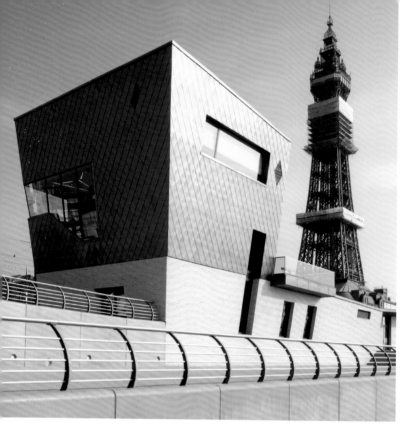

LEFT Blackpool's Festival House, the £3 million 'B-movie architecture' wedding chapel/restaurant, designed by de Rijke Marsh Morgan architects, opened in January 2012.

BELOW LEFT Rock-hewn graves at St Patrick's Chapel, Heysham, Lancashire.

BELOW The harbour wall at Lamorna Cove, Cornwall.

BOTTOM The Sister Kirkes Memorial at Withernsea, East Yorkshire. The sea claimed St Mary's Church in 1444 and St Peter's Church at Owthorne by 1824.

FACING PAGE View of Barnoon Cemetery, St Ives, Cornwall, with a double rainbow.

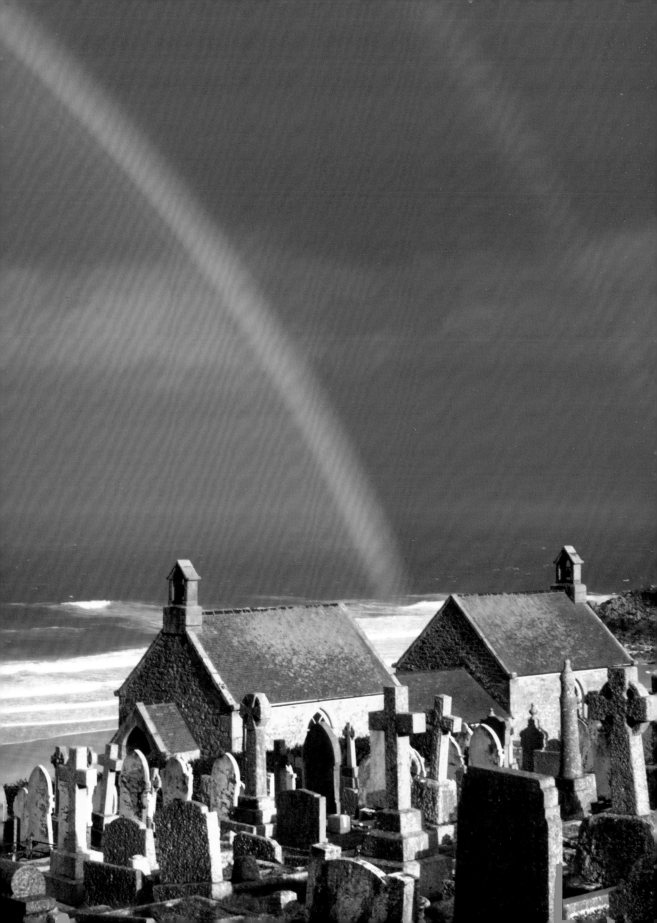

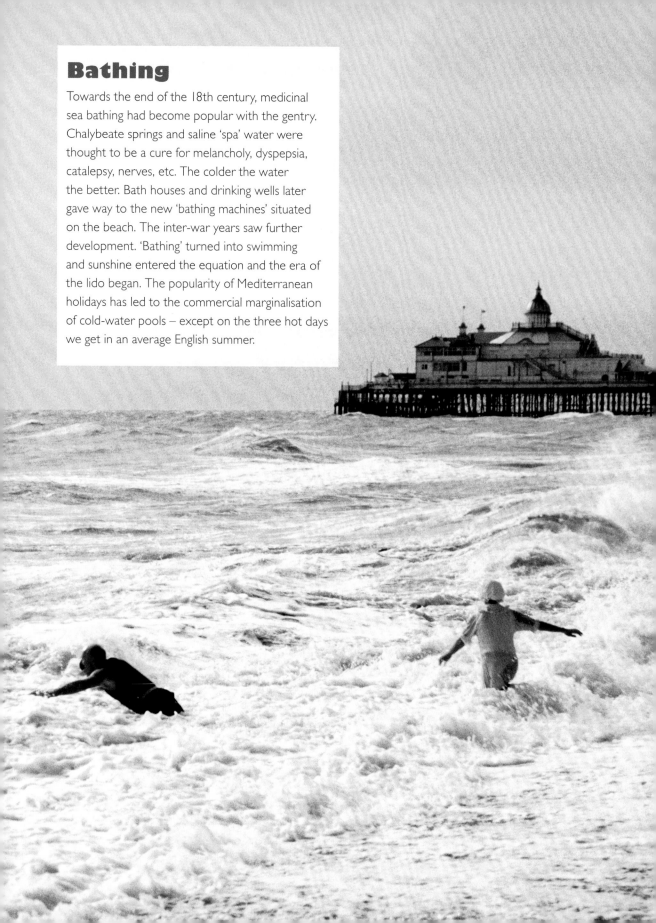

Bathing

Towards the end of the 18th century, medicinal sea bathing had become popular with the gentry. Chalybeate springs and saline 'spa' water were thought to be a cure for melancholy, dyspepsia, catalepsy, nerves, etc. The colder the water the better. Bath houses and drinking wells later gave way to the new 'bathing machines' situated on the beach. The inter-war years saw further development. 'Bathing' turned into swimming and sunshine entered the equation and the era of the lido began. The popularity of Mediterranean holidays has led to the commercial marginalisation of cold-water pools – except on the three hot days we get in an average English summer.

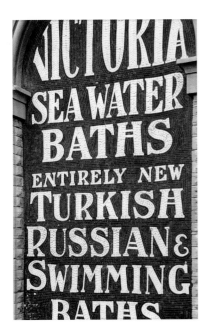

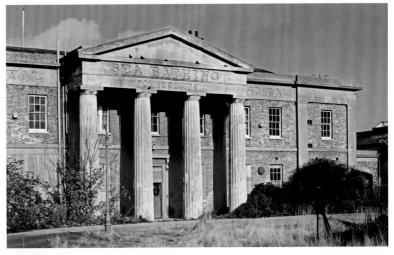

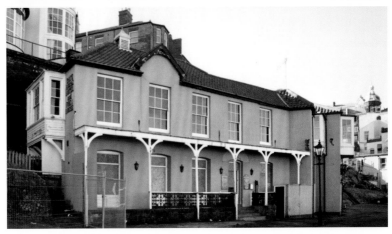

ABOVE The mosaic sign for the Victoria Sea Water Baths of 1871, Southport, Merseyside. Seen here before restoration and conversion to flats.

ABOVE RIGHT The Royal Sea Bathing Hospital of 1791 at Margate.

RIGHT The former bath house at Cromer, Norfolk. Built in 1814 as a subscription library, it later pumped sea water into private bathrooms.

BELOW RIGHT Two huts on the beach at Teignmouth, Devon. The one on the left is possibly a former bathing machine.

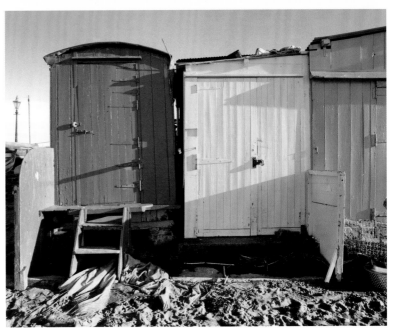

FACING PAGE Sea bathing in October at Eastbourne. Brrr!

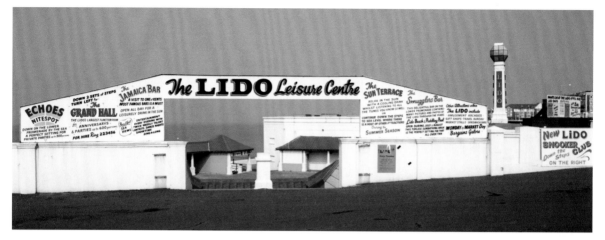

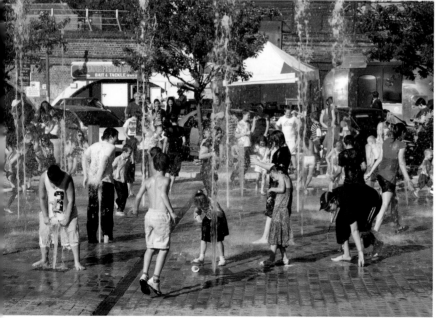

TOP Margate Lido, sadly now defunct – though the beacon survives.

ABOVE LEFT Paddling pool at Filey, North Yorkshire.

ABOVE The Jubilee bathing pool at Penzance, 1935.

LEFT The intermittent water jet feature at Folkestone.

RIGHT Saltdean Lido, near Brighton, built in 1938 and still going strong.

BELOW Tynemouth paddling pool, Tyne and Wear. It appears to be a more hazardous place to paddle than the adjacent beach!

BELOW RIGHT The Art Deco Tinside Lido at Plymouth, which has recently been renovated.

BOTTOM The curvaceous paddling pool at Whitby, North Yorkshire.

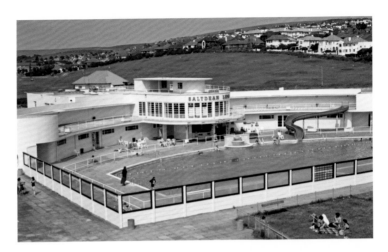

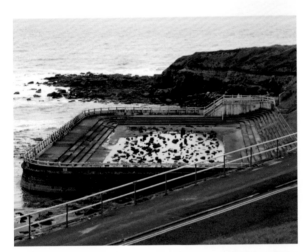

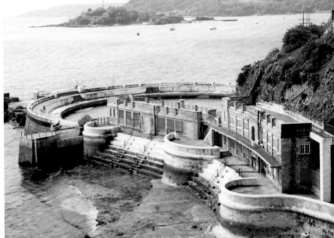

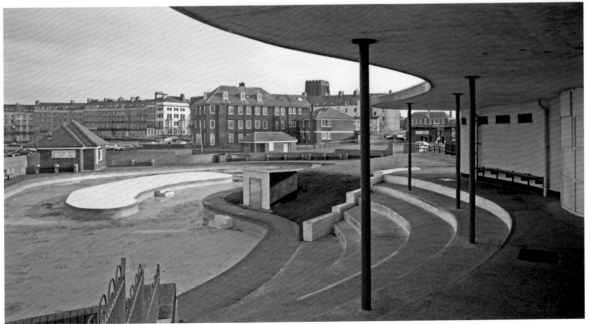

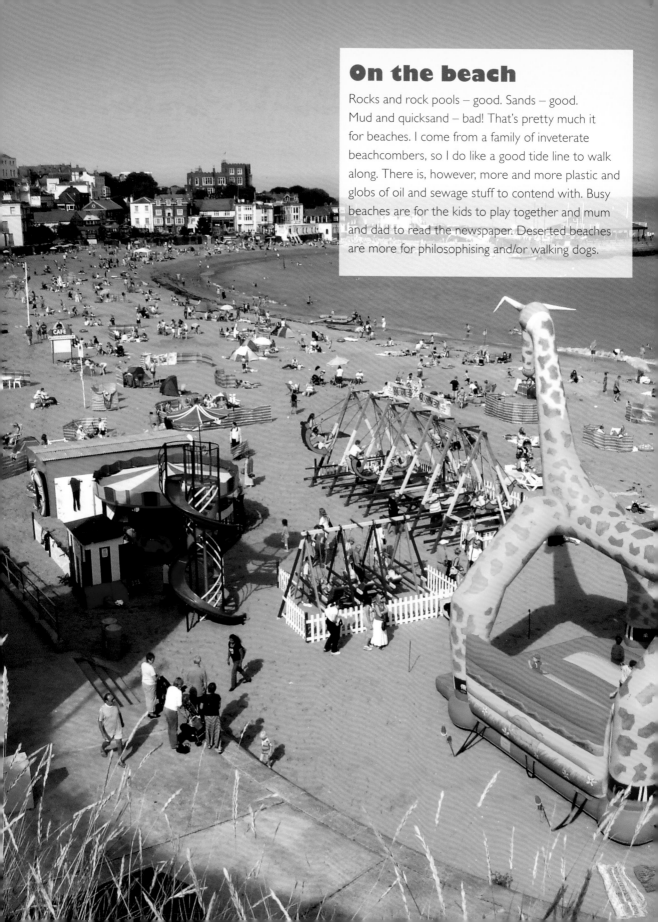

On the beach

Rocks and rock pools – good. Sands – good. Mud and quicksand – bad! That's pretty much it for beaches. I come from a family of inveterate beachcombers, so I do like a good tide line to walk along. There is, however, more and more plastic and globs of oil and sewage stuff to contend with. Busy beaches are for the kids to play together and mum and dad to read the newspaper. Deserted beaches are more for philosophising and/or walking dogs.

CAFE

FACING PAGE Viking Bay Sands, Broadstairs, Kent.

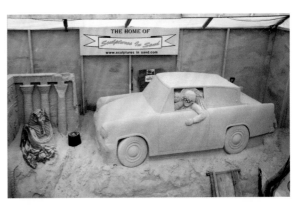

RIGHT 'Sculptures in the Sand' at Weymouth, Dorset – the business started by the late Fred Darrington and now continued by Mark Anderson.

BELOW A giant hippo sand sculpture at Scarborough.

BELOW RIGHT A sandcastle on the beach at Newquay, Cornwall.

BOTTOM On the beach at Weymouth.

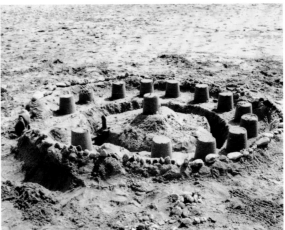

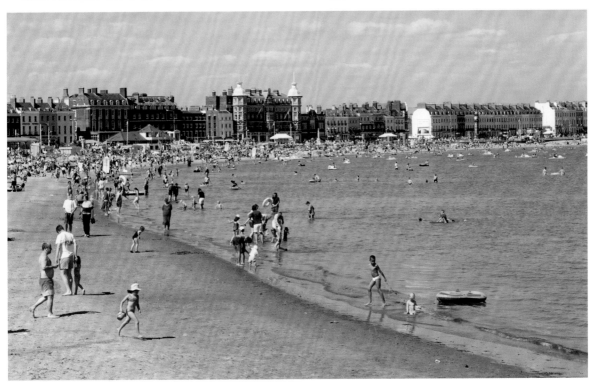

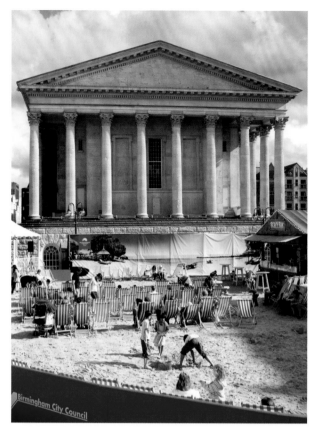

ABOVE Spinnaker Tower and Gunwharf Quay, Portsmouth. Seaside and urban beach.

LEFT Town Hall with sandy urban beach, including deckchairs, Birmingham. Urban beaches became popular after 2002 reflecting the success of the Paris-Plages installation.

BELOW LEFT Stainless-steel railings, Deal, Kent.

BELOW Mobile Gull Appreciation Unit, made by Mark Dion, seen here at Folkestone.

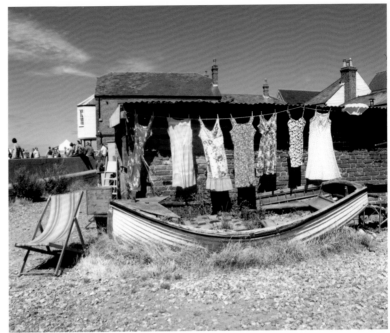

ABOVE Trampoline sign at Southend-on-Sea.

RIGHT Vintage on Sea – secondhand beach shop at Whitstable, Kent.

BELOW A busy August day at Lyme Regis, Dorset.

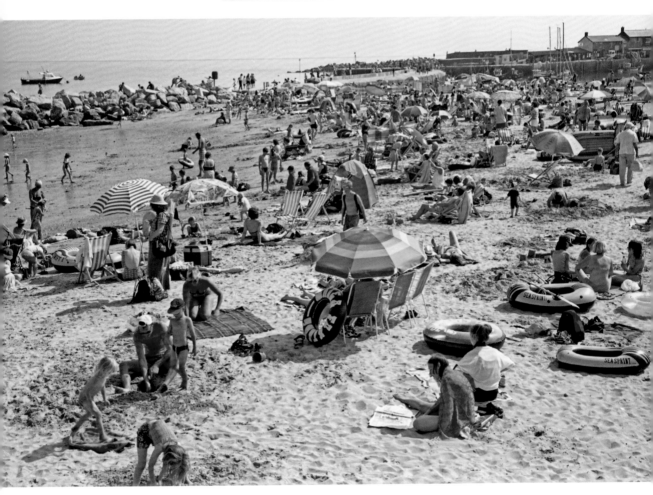

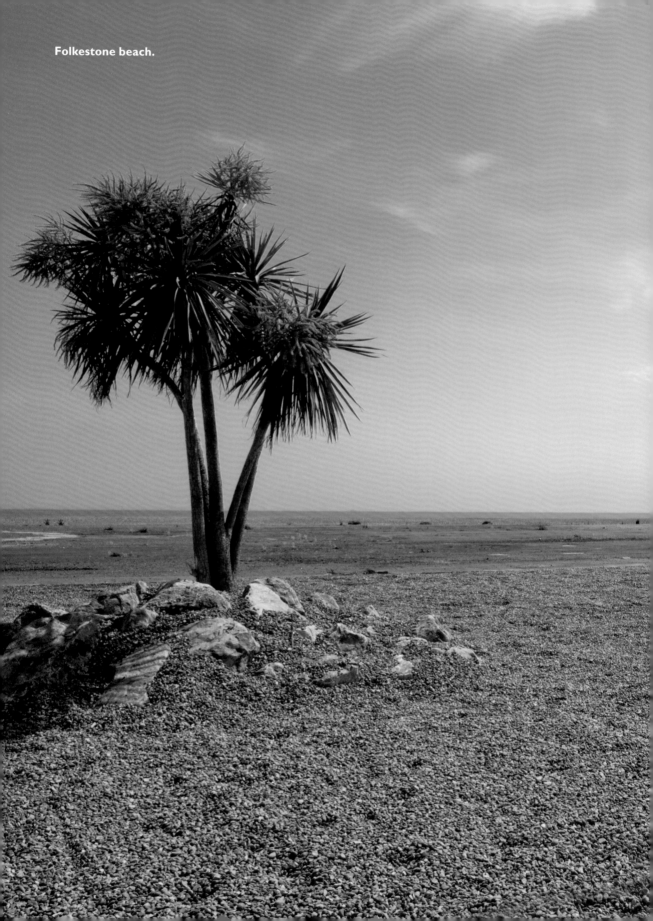

Folkestone beach.

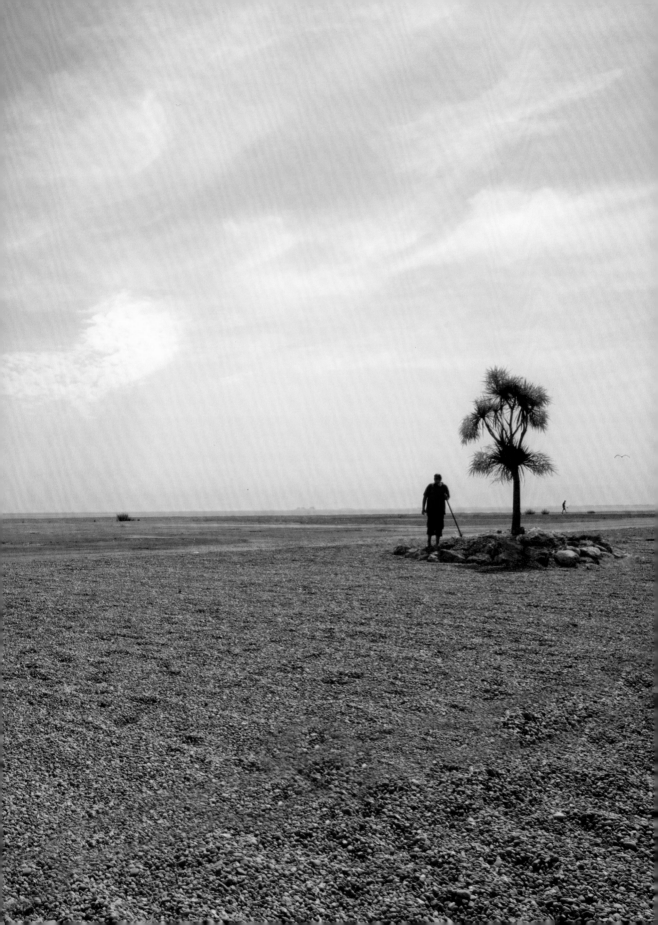

Punch and Judy

Descending from the Italian Pulcinella and the Commedia dell 'Arte, Mr Punch is a trickster, jester and lord of misrule. He does bad things, is very frightening and small children love him. His nearest modern equivalent is the Dalek. In France he is Polichinelle, in Germany he is Hans Wurst and in Russia, Petrushka. His props include a sausage, a ghost, a policeman, the devil, a crocodile and a big stick. So get out your swozzle and all shout: 'That's the way to do it!'.

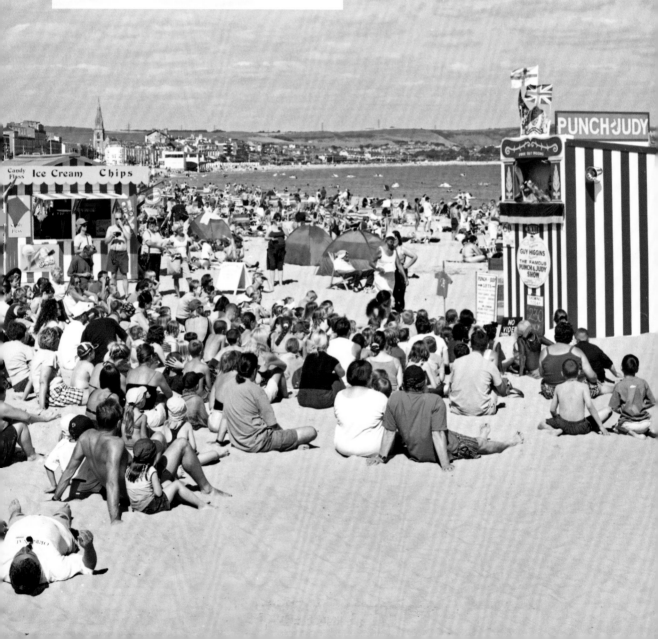

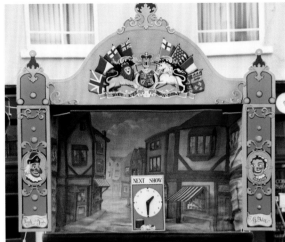

ABOVE Picture postcard railings at Redcar, North Yorkshire.

ABOVE RIGHT Professor Felix at Herne Bay, Kent.

RIGHT Professor Des Turner at Herne Bay.

BELOW Professor Robanti's sign.

BELOW RIGHT On the beach at Swanage, Dorset.

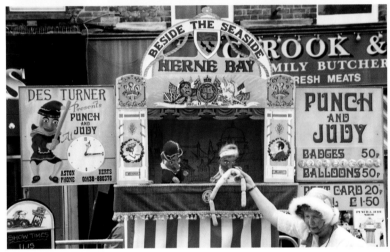

FACING PAGE On Weymouth beach, Dorset.

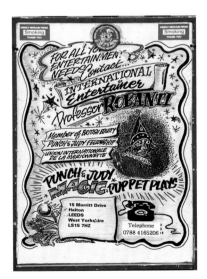

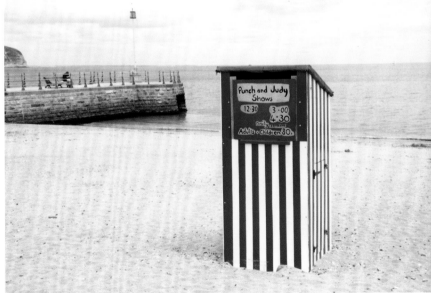

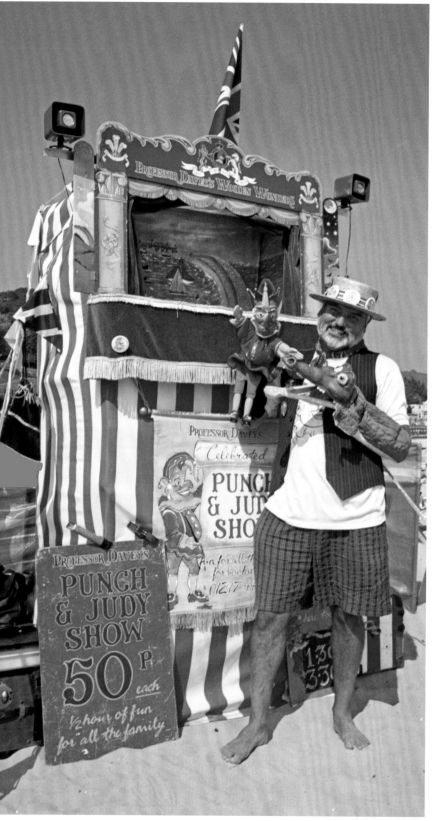

ABOVE That's the way to do it!

LEFT Professor Davey at Lyme Regis, Dorset.

BELOW A painting on a beach hut on Broadstairs beach, Kent.

FACING PAGE

TOP LEFT Professor Jingles' sign.

TOP RIGHT Professor Jingles at Herne Bay, Kent.

RIGHT On the beach at Broadstairs.

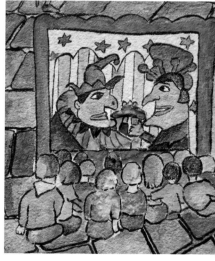

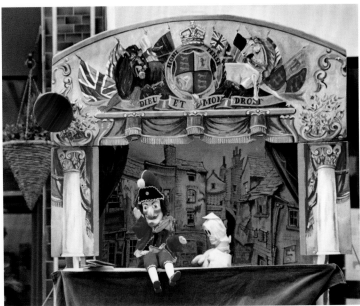

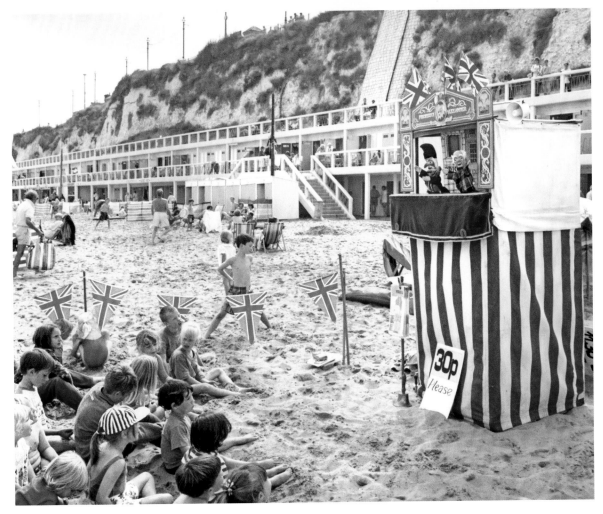

Donkeys

Do donkeys know they are donkeys? They can, after all, interbreed with horses and zebras. A male donkey (known as a jackass) bred with a mare produces a mule, while the offspring of a stallion and a female donkey (called a jenny or jennet) is a hinny. You can, mostly, recognise a donkey by its long ears and characteristic 'Ee-aw' bray.

The first seaside resort to have donkey rides is thought to be Margate which introduced them around 1790. Donkeys at Blackpool now have workers' rights and work between 10 am and 7 pm, with Fridays off.

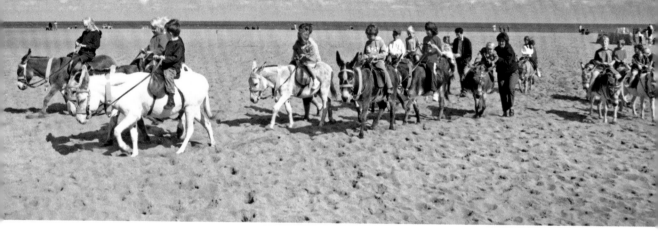

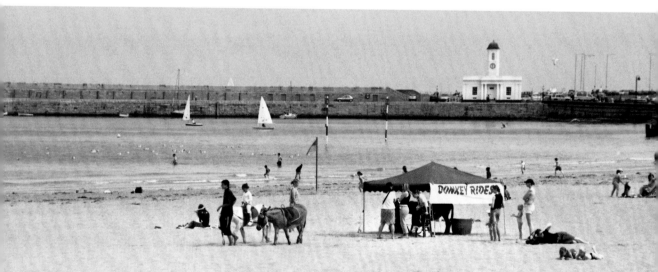

ABOVE Two donkeys tuck into a haynet on a hot June day at Margate.

ABOVE RIGHT Enjoying 40 winks on the beach at Ramsgate, while waiting for the next customer.

RIGHT Donkeys mural at Scarborough painted by Woodhead.

BELOW Bells and bows bedeck these pretty donkeys posing near the pier at Cleethorpes, Lincolnshire.

FACING PAGE

ABOVE 'They're off!' – donkey rides at Skegness, Lincolnshire.

BELOW On the beach at Margate.

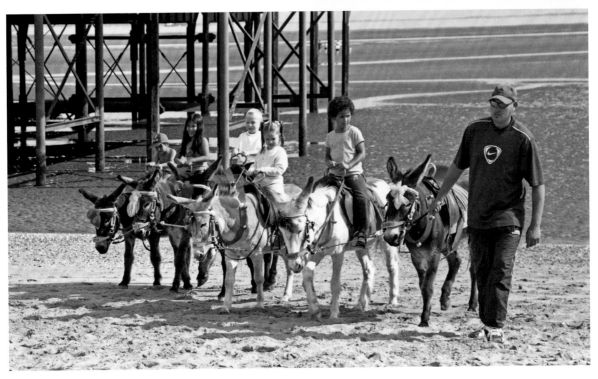

Piers

Defined as structures with decks built over water, piers can be functional for berthing vessels or, as is more common, for promenading and pleasure.

Ryde on the Isle of Wight appears to have the oldest pier built about 1814 for the landing of the ferry from the mainland. During the 19th century the developing resorts near London benefited from the paddle steamer services which provided popular 'day trips'. Arrival and departure were intermixed with promenading and 'taking the air' until commercial amusements became more organised. At the 'end of the pier' there might be an amusement arcade, or a camera obscura, or a café, or a theatre, or an aquarium, or a menagerie, or even a lifeboat station. The superstructure soon became more complex with pavilions, kiosks, shelters, seats, toilets and lighting. The piers at Ryde, Southend and Southport were so long they needed railways to get to the end.

Whilst we may have lost the West Pier at Brighton, all is not lost. The new pier at Southwold is a great success and there are 77 listed piers to visit.

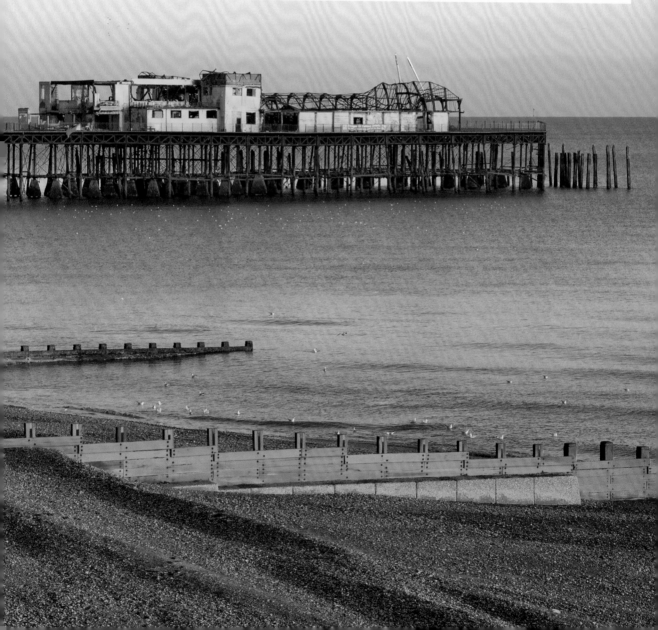

FACING PAGE Hastings Pier photographed some months after the fire of 5 October 2010.

RIGHT A sign for the Brighton Palace Pier.

BELOW Cromer Pier, Norfolk, opened in 1900. Notice the Lifeboat Station at the end.

BOTTOM LEFT Detail of Hastings Pier.

BOTTOM RIGHT A lone kiosk stands to the side of the twisted fire-damaged girders of the West Pier, Brighton and Hove.

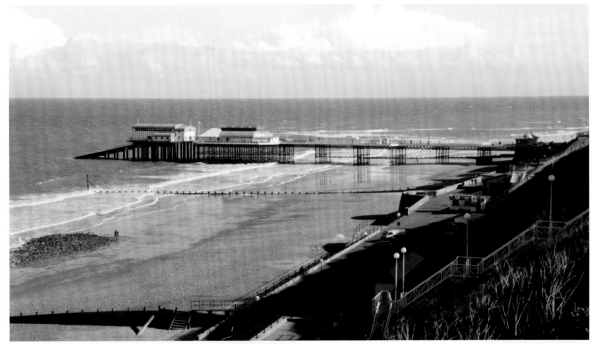

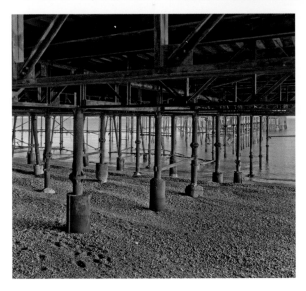

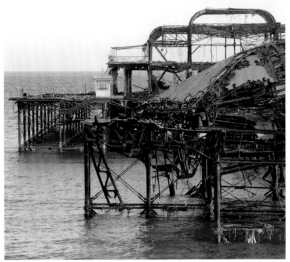

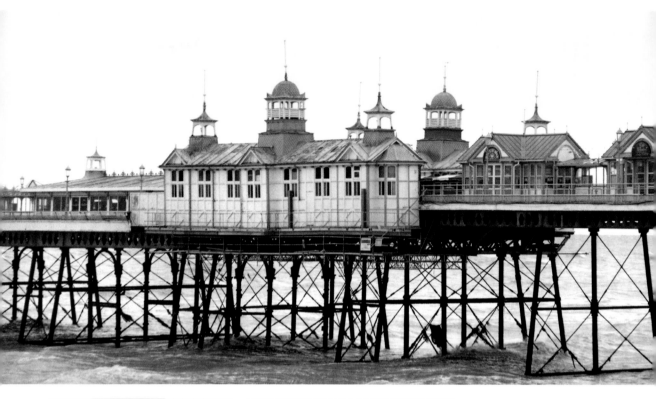

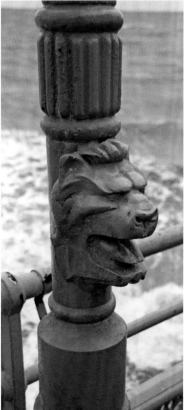

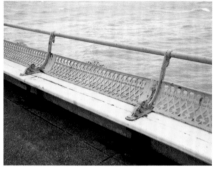

ABOVE Eastbourne Pier.

FAR LEFT A cast-iron gargoyle on Eastbourne Pier, painted blue like pretty much everything in Eastbourne, including the cast-iron seating along the pier, LEFT.

BELOW Wrought-iron and timber seating along the Princess Pier at Torquay.

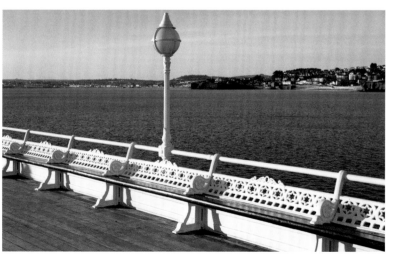

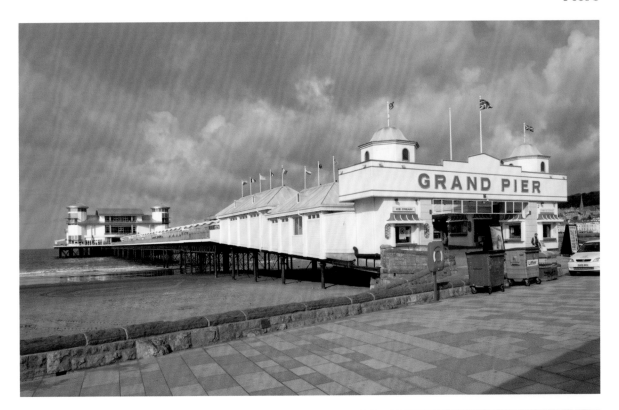

ABOVE Grand Pier, Weston-super-Mare, Somerset.

RIGHT Time you returned to the sanatorium. A glimpse of the Grand Pier at Weston-super-Mare before restoration.

BELOW A decorative ironwork capital beneath the deck of the Cleethorpes Pier, Lincolnshire.

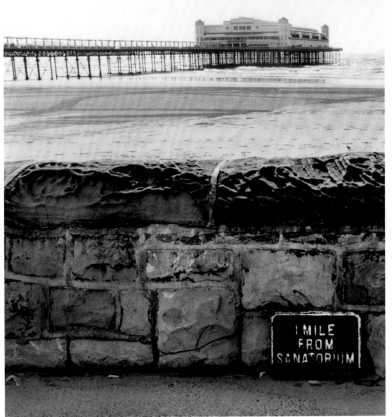

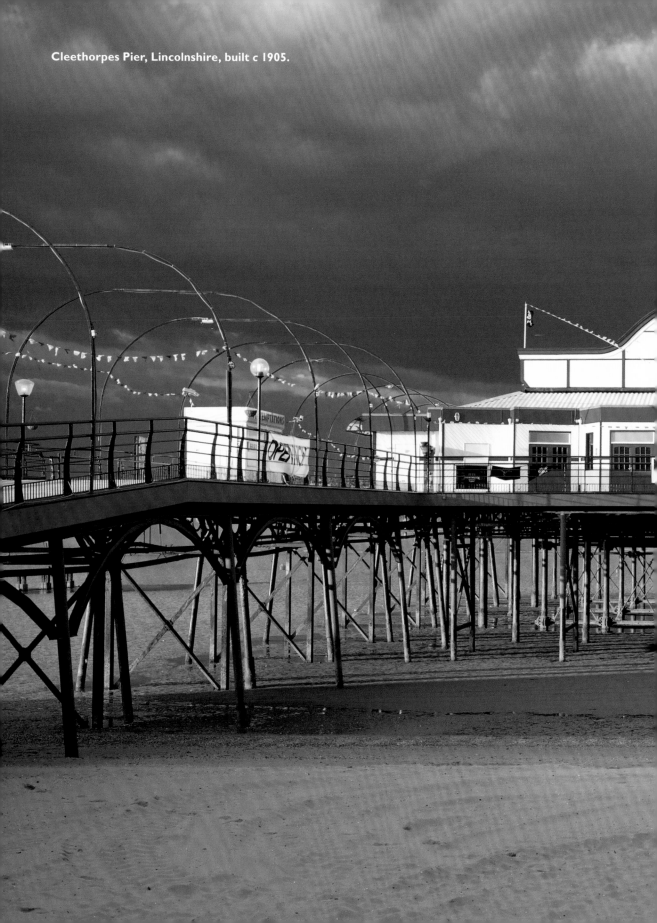

Cleethorpes Pier, Lincolnshire, built c 1905.

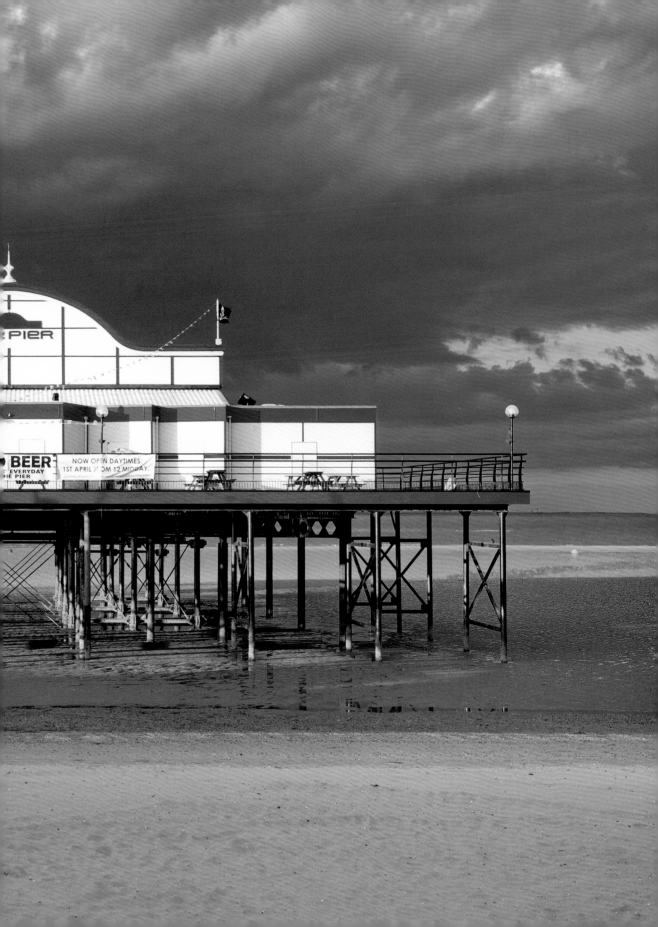

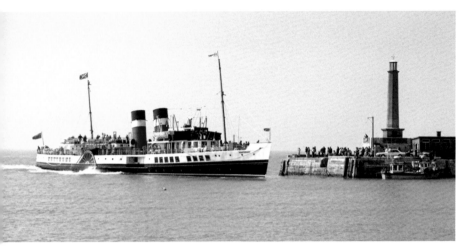

ABOVE The paddle steamer *Waverley* approaching Margate Pier.

ABOVE RIGHT A screw pile from Bournemouth Pier, now at the Amberley Museum, West Sussex.

LEFT Broken piece of plate with partial inscription 'Refreshment Pavilion Margate Jetty'.

BELOW Totland Bay Pier, Isle of Wight, built 1879.

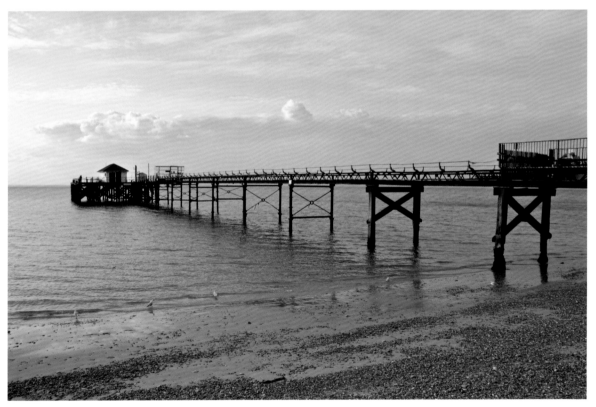

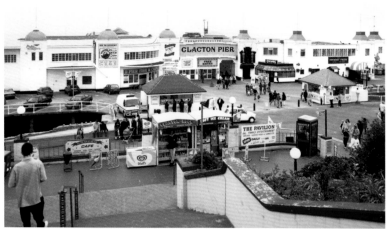

ABOVE Attraction on Sandown Pier, Isle of Wight, which opened in 1895.

ABOVE RIGHT The busy entrance of Clacton-on-Sea Pier, Essex, which was opened in 1871.

RIGHT The remarkable entrance towers are all that remain of Withernsea Pier, East Yorkshire, 1877–1903.

BELOW Worthing Pier, West Sussex.

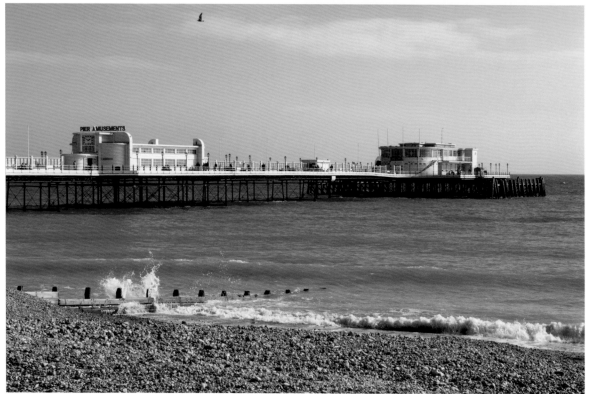

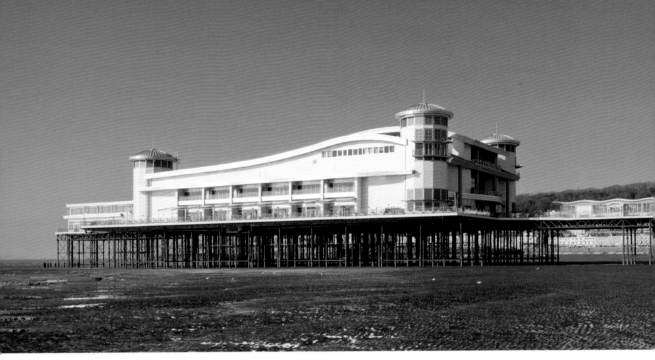

ABOVE The Grand Pier, Weston-super Mare, Somerset. The new pavilion, which was opened in October 2010 and designed by Angus Meek, is a replacement following the fire of 2008.

LEFT Colourful photographers posing board, Palace Pier, Brighton.

BELOW LEFT Not a seaside pier, but the wooden deck of HMS *Warrior*. Built in 1860, she now lies at Portsmouth.

BELOW RIGHT Walton-on-the-Naze Pier, Essex, 1895. The third longest pier in the UK with a marvellously complicated deck.

NO JUMPING OFF THE PIER

IT COULD BE THE DEATH OF YOU! OR YOU MAY BE PROSECUTED

ABOVE A cautionary note at Eastbourne Pier.

RIGHT Skegness Pier, Lincolnshire. Opened in 1881, it quickly developed a thriving pleasure steamer service sailing from the pier across The Wash to Hunstanton where passengers could visit the Prince of Wales' estate at Sandringham.

BELOW Enjoying the pleasures of the North Pier at Blackpool, which opened to the public in 1863.

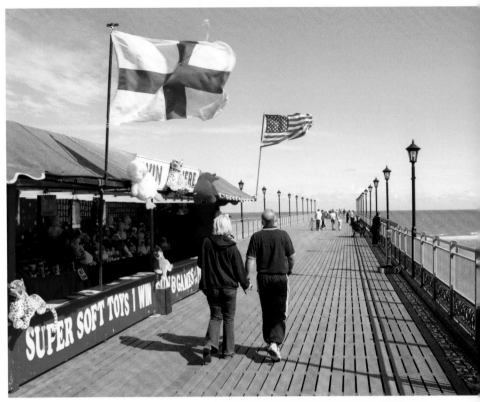

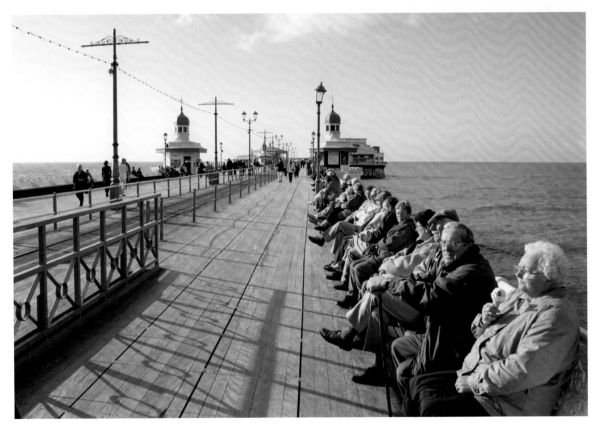

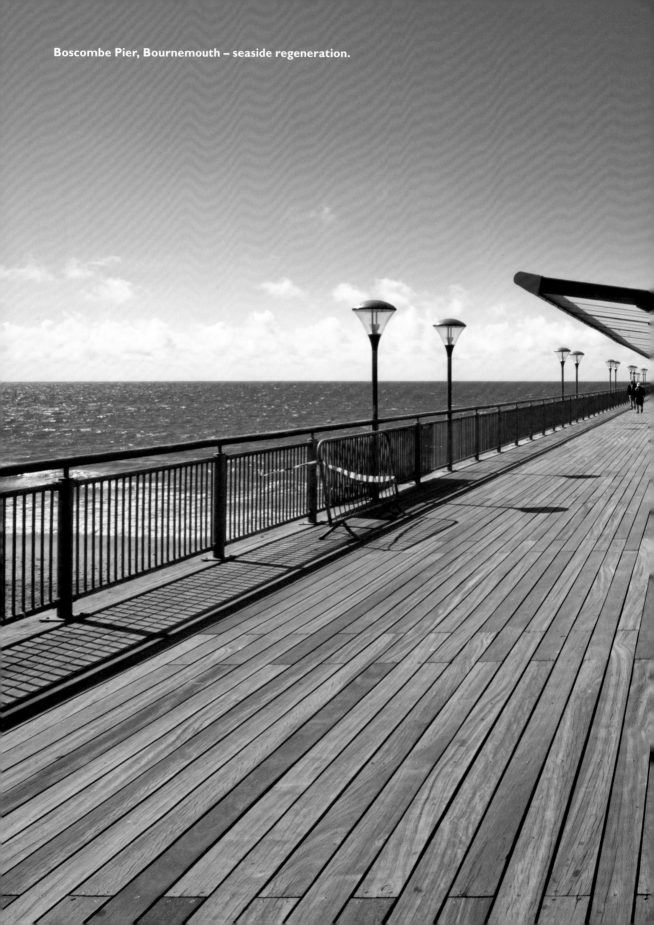

Boscombe Pier, Bournemouth – seaside regeneration.

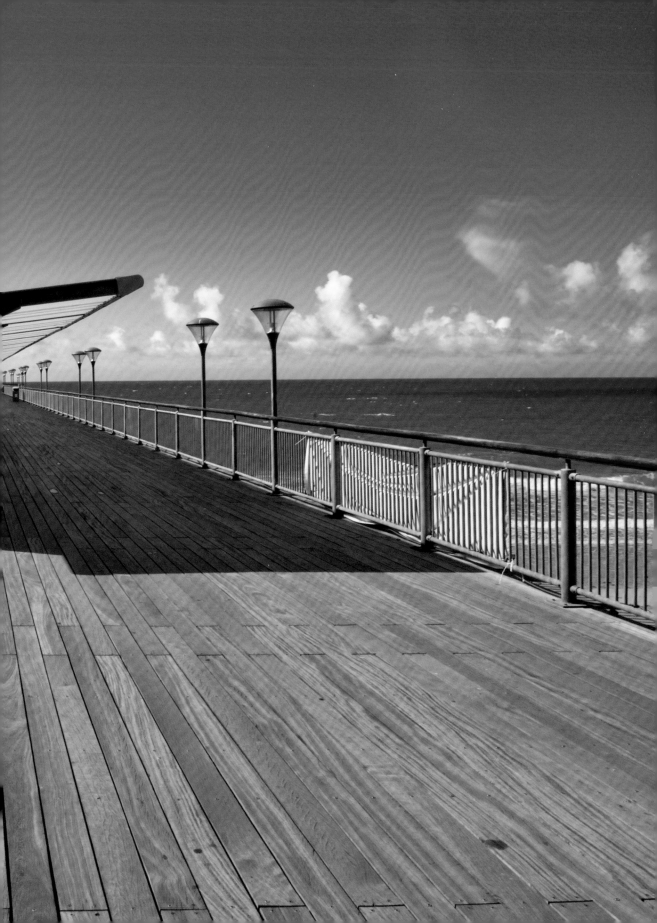

Beach huts

What can be the origin of the beach hut? Some suggest that 'bathing machines' were reused as changing rooms and then developed into picnic and sun rooms. Others maintain that fishermen's stores were taken over by holidaymakers. A surge in hut building happened in the post-war years when huts were cobbled together with whatever materials came to hand. Local authorities then stepped in to create order (ie rules) and to design, build and let out huts. Some huts even have residential status and overnight stays are possible as at Mudeford in Dorset. These command high prices – over £100,000. If you like to sit in a musty, damp box full of yesterday's furniture and smelling of butane gas, listening to the rain on the roof and doing that wretched jigsaw with the missing piece, then this is for you. I salute the owner of Felixstowe's Beach Hut of the Year competition, first prize a china beach-hut teapot. But there is a strange conflict in the world of the beach huts. They are quirky and individuals obviously try to personalise them but, at the same time, they are very samey and regimented. I want one.

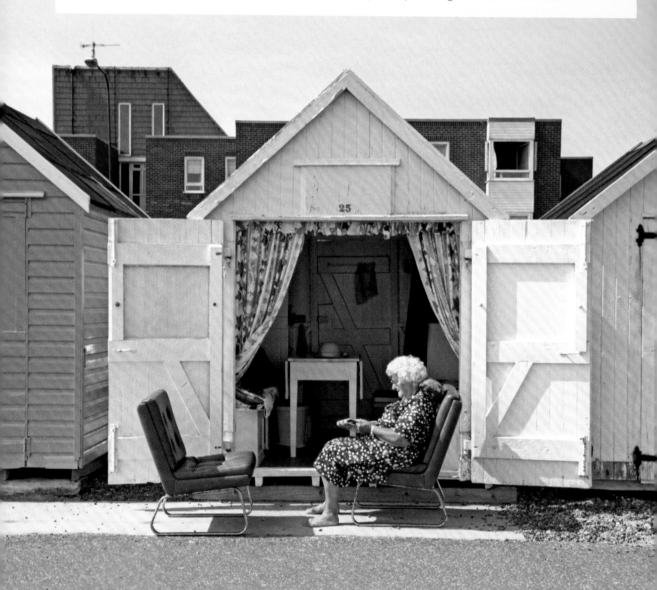

FACING PAGE A home from home at Felixstowe, Suffolk.

RIGHT 'Edsdream', Whitstable, Kent.

BELOW Detail of the painting of Southwold on 'Spunyarns', by Serena Hall, 1994.

BOTTOM 'Spunyarns' at Southwold, Suffolk.

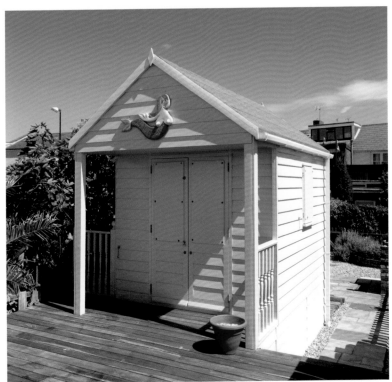

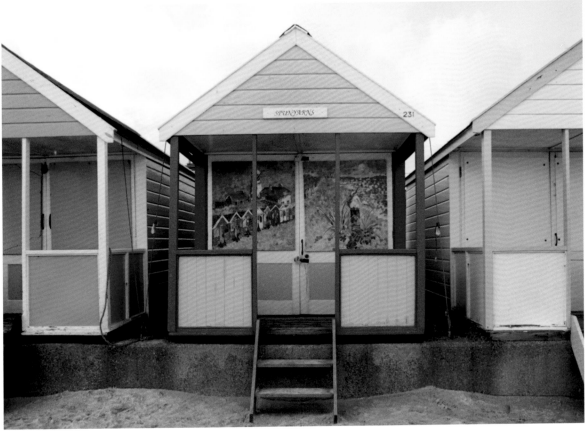

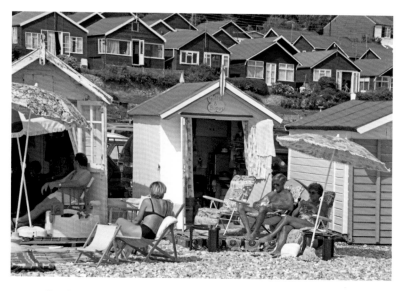

ABOVE Beach huts at Lyme Regis, Dorset.

ABOVE RIGHT Representation of a beach hut on railings, Bournemouth.

BELOW Beach huts, Littlehampton, West Sussex.

FACING PAGE

TOP LEFT 'Nuttahutta' at Whitstable, Kent.

CENTRE LEFT 'Thistledoo' at Brightlingsea, Essex.

BELOW LEFT 'Forarest' at Walton-on-the-Naze, Essex.

TOP RIGHT Huts at Seaford, East Sussex.

CENTRE RIGHT A royal pair at Southwold.

BOTTOM More beach huts at Littlehampton.

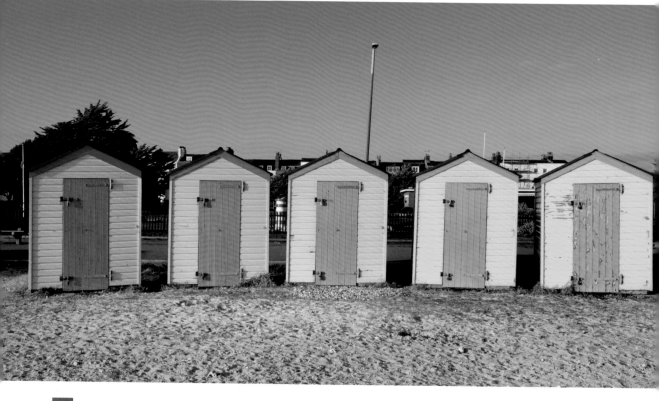

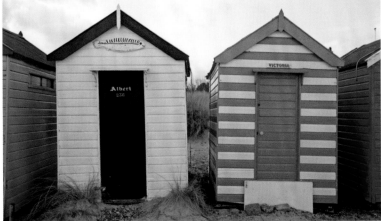

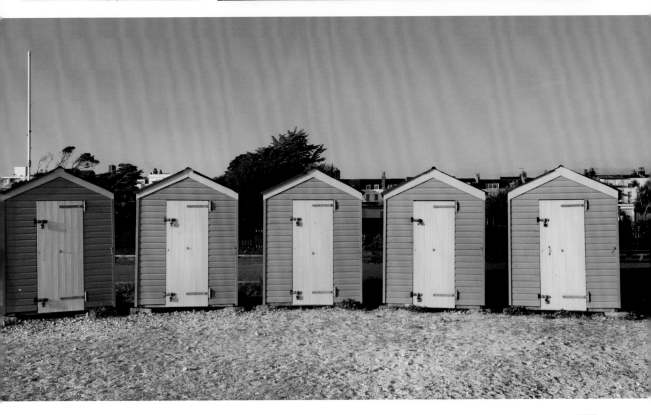

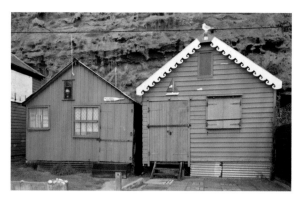

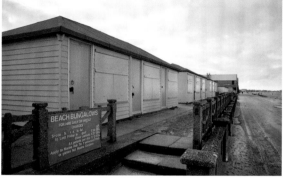

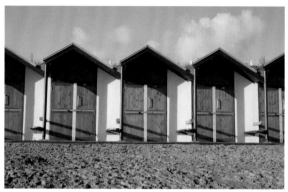

ABOVE LEFT 'West Winds Cottage' and 'Sheila's Cottage' – two large huts at Sandown, Isle of Wight.

ABOVE Beach bungalows at Fleetwood, Lancashire.

LEFT Huts at Bridlington, East Yorkshire, part of the extensive regeneration of the seafront.

BELOW '76 Trombones' at Felixstowe, Suffolk.

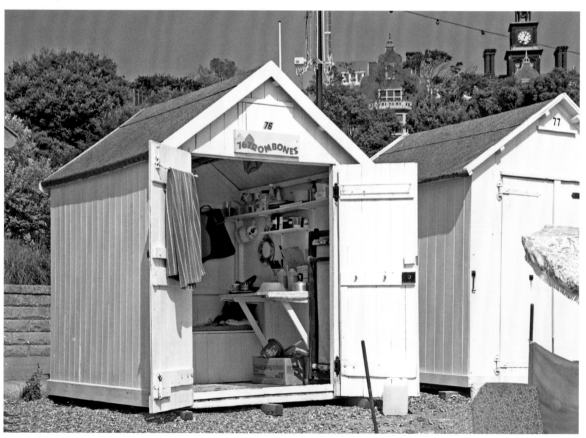

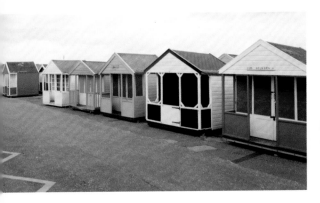

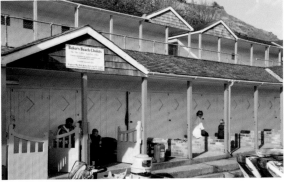

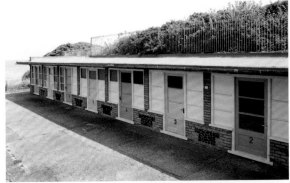

ABOVE What happens to huts in the winter at Southwold, Suffolk.

ABOVE RIGHT Chalets at Filey, North Yorkshire.

RIGHT Beach huts at Kingsgate Bay, Broadstairs, Kent.

BELOW Beach huts, Blyth, Northumberland.

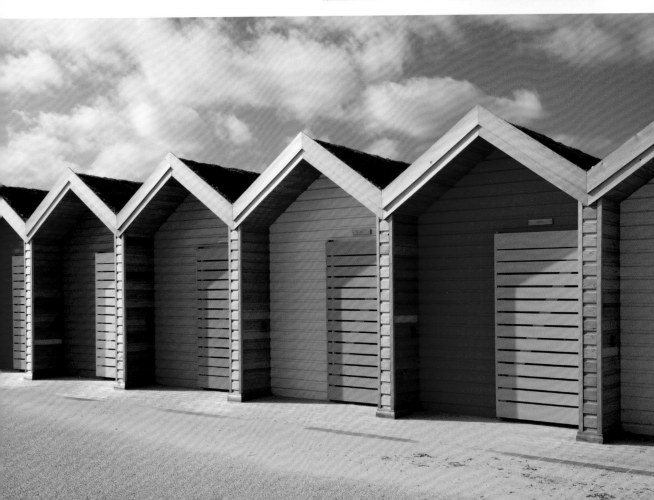

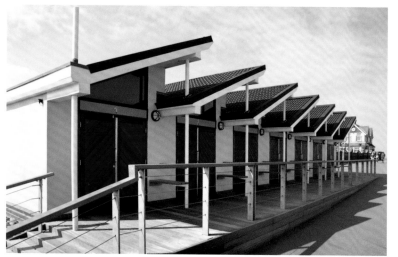

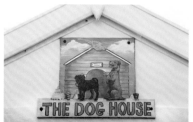

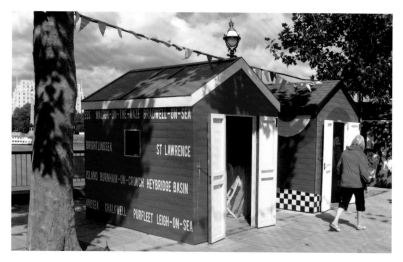

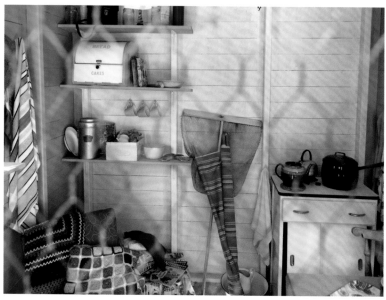

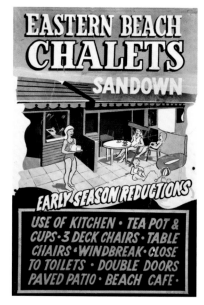

ABOVE LEFT Innovative beach huts at Hornsea, East Yorkshire.

ABOVE 'Forty Winks' and 'The Dog House' at Southwold, Suffolk.

LEFT Urban Beach, The Queens Walk, London.

BELOW LEFT Beach-hut interior, The Queens Walk.

BELOW Sign at Sandown, Isle of Wight.

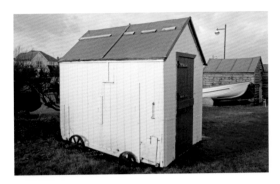

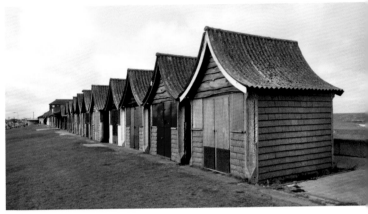

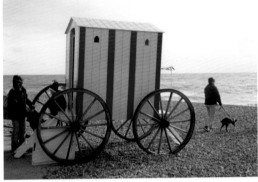

ABOVE LEFT A beach hut with tiny wheels near the pier at Southwold, Suffolk.

ABOVE Pagoda-shaped corrugated iron roofs at Mablethorpe, Lincolnshire.

LEFT Hounsoms No 49 bathing machine on the beach at Eastbourne.

BELOW 'Jabba the Hut' at Mablethorpe. Sculpture, or hut?

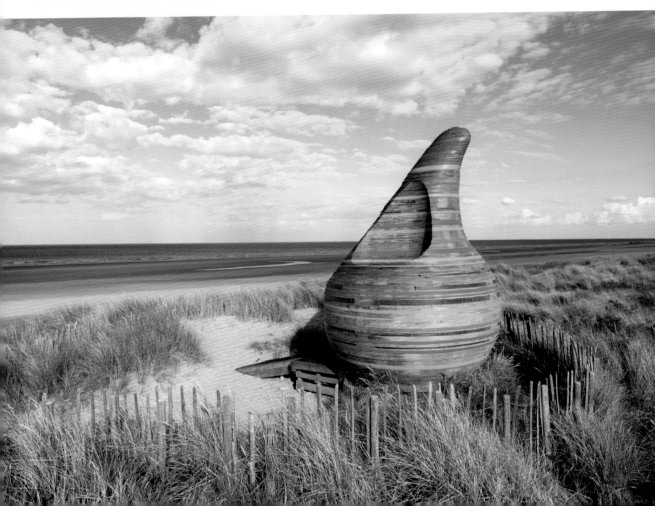

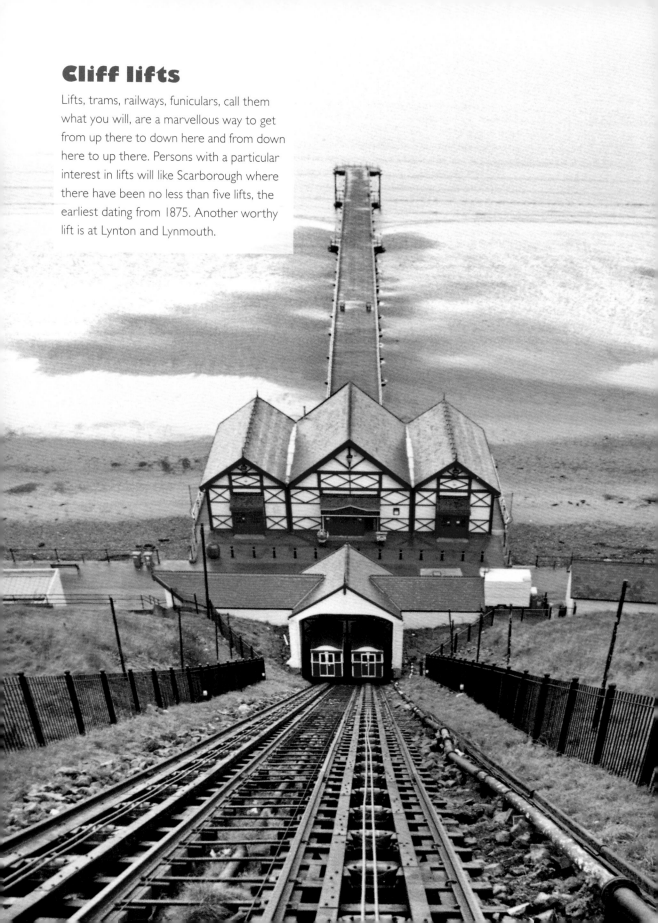

Cliff lifts

Lifts, trams, railways, funiculars, call them what you will, are a marvellous way to get from up there to down here and from down here to up there. Persons with a particular interest in lifts will like Scarborough where there have been no less than five lifts, the earliest dating from 1875. Another worthy lift is at Lynton and Lynmouth.

ABOVE The South Cliff Lift at Scarborough. Opened in 1875 and designed by Crossley Bros of Manchester, the lift used sea water as a counterweight.

ABOVE CENTRE The Central Tramway at Scarborough, dating to 1881. Designed originally for steam, it was converted to electricity in 1910.

BELOW West Hill Cliff Lift, Hastings. The journey is made through a brick-lined tunnel and emerges at a café.

FACING PAGE Saltburn-by-the-Sea, North Yorkshire, looking down towards the pier.

ABOVE RIGHT The lift at Shanklin, Isle of Wight. A vertical hydraulic lift was built in 1891 and replaced by an enclosed concrete tower lift in 1956.

BELOW East Hill Lift at Hastings, built in 1903.

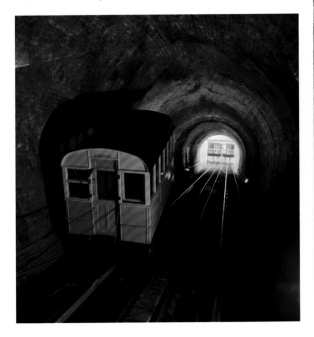

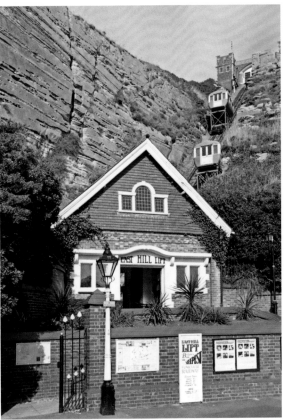

Hotels

You can pore over brochures, agonise over hundreds of little pictures of samey-looking hotels and guest houses – and still seem to get it wrong. The answer often lies in the name. 'Hotels' seem to be anonymous while 'guest houses' seem to imply that you will be treated as a guest and be properly looked after. Very large seaside hotels can often be swamped by coach parties – I can recall being thrown aside at breakfast at a Newquay establishment by the surge to get to the crispy bacon. The very small amateur establishment can be friendly, but this can sometimes be a problem if the owners want to know all about you and insist that you sit in their lounge and entertain them. Beware of places with too many rules and regulations – 'No baths on Mondays', 'No more than two persons in the shower at one time' and 'If you touch the twin bed you are not using, you will have to pay for it'. I really dislike those 'breakfast choice cards' you have to fill in the night before, itemising what you must eat in the morning. And also don't you just hate being put at a breakfast table with strangers? However, we mustn't carp. More often than not you will find a safe haven and you are there to see the sea, not the bedrooms. (Incidentally, does anybody actually use those trouser presses?)

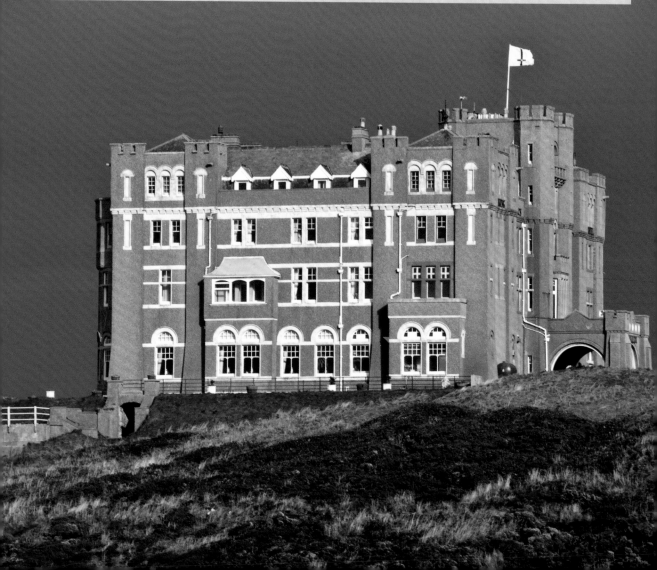

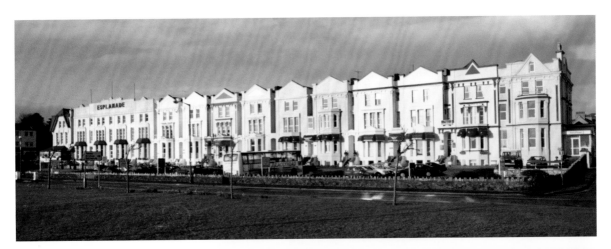

ABOVE Colourful hotels on the Eastern Esplanade at Paignton, Devon.

RIGHT The romantic House in the Sea, Newquay, Cornwall, complete with its own suspension bridge.

BELOW Burgh Island, Devon, 1930s 'Poirot style'.

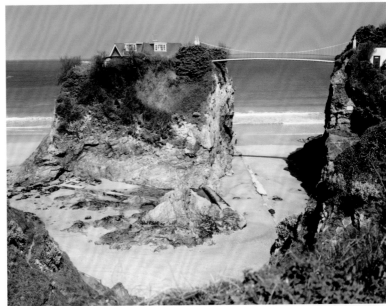

FACING PAGE Camelot Castle, Tintagel, Cornwall.

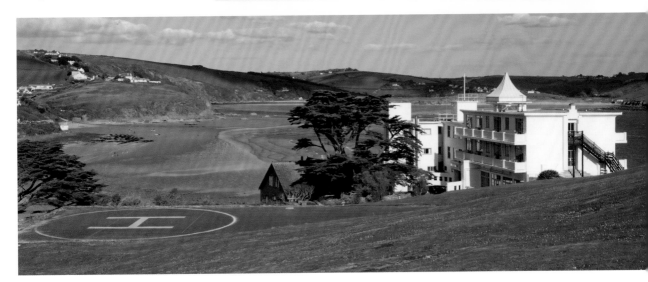

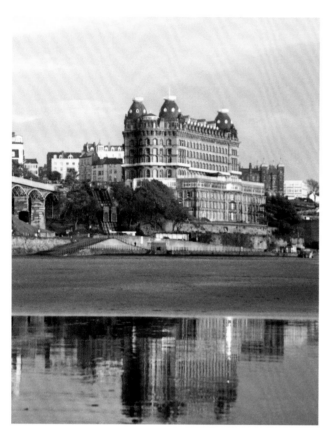

LEFT The Grand Hotel, Scarborough. Built in 1863–7 and designed by Cuthbert Brodrick, this immense structure dominates the town.

BOTTOM Palatial Victorian opulence at the Grand Hotel in Brighton. This five-star hotel was built on the seafront in 1864.

FACING PAGE

TOP LEFT The Metropole Arts Centre, Folkestone. Formerly the New Metropole Hotel, 1895.

TOP RIGHT The Grosvenor House Hotel at Skegness, Lincolnshire, incorporates a café, chemist and, amazingly, a ballroom.

RIGHT The Palace Hotel, Paignton, Devon. The former home of Washington Singer, son of Sir Isaac Singer, the inventor of the sewing machine.

FAR RIGHT Court Royal, Bournemouth. Formerly the Madeira Hotel where Marconi received the first paid radio message in 1898, it is now a miners' convalescent home.

BOTTOM The elegant Brighton Metropole Hotel, built in 1890 to designs by Alfred Waterhouse, the architect of the Natural History Museum in London.

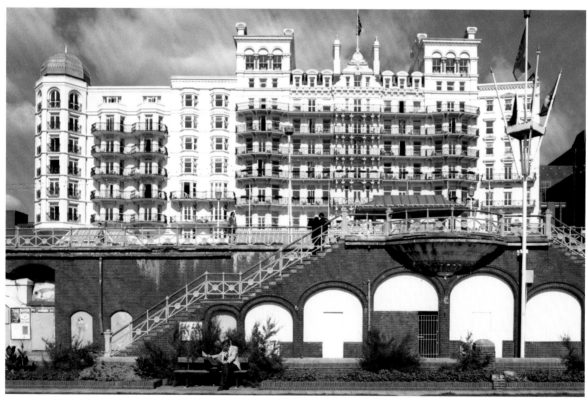

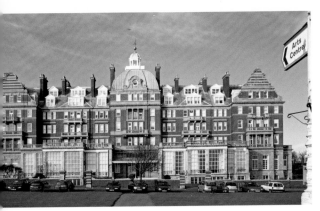

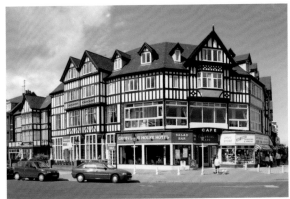

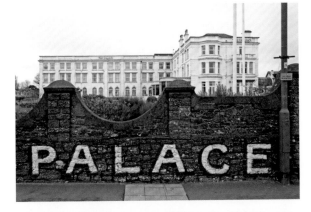

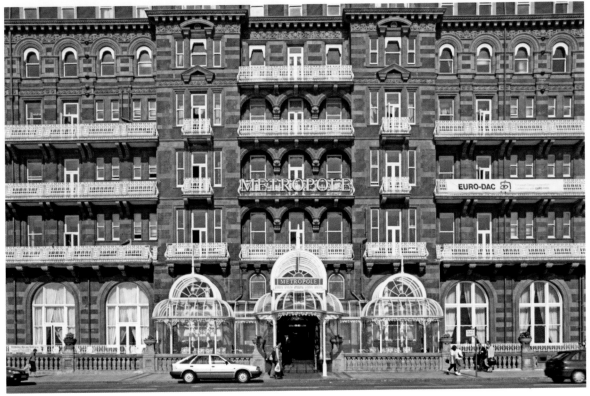

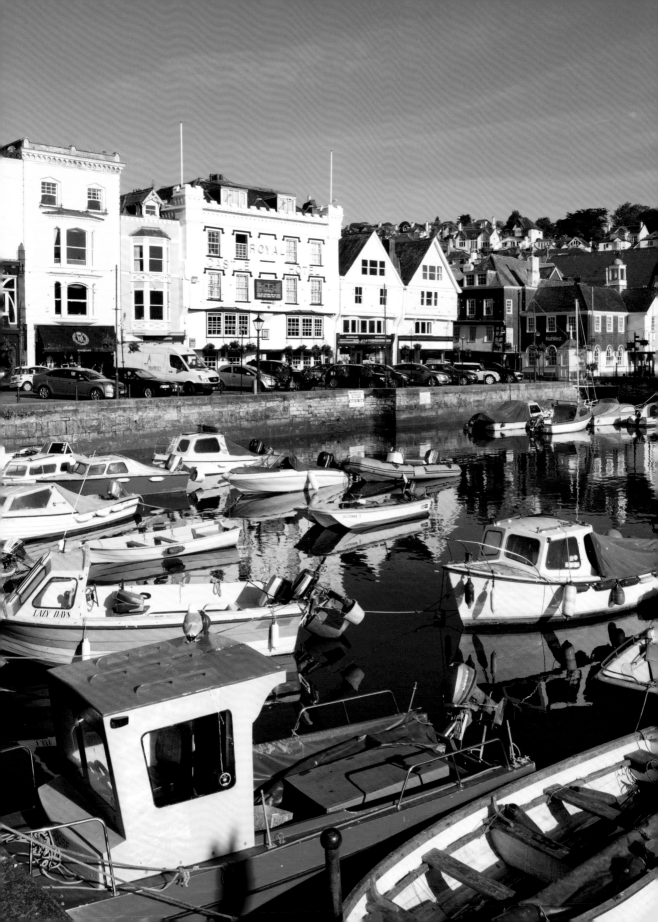

FACING PAGE Royal Castle Hotel, Dartmouth. The TV series, *The Onedin Line* was filmed hereabouts.

RIGHT TOP Central Spa Hotel, Blackpool. A 'three lamper' at night.

RIGHT The Howard Hotel, Blackpool. A 'four lamper' at night.

BELOW Willow Grove Hotel, Blackpool. The usual three lamps in the window here replaced by a tiger with cubs.

BELOW RIGHT Franklin Hotel at Blackpool. A typical 'three lamper'.

BOTTOM The Xoron Floatel at Bembridge, Isle of Wight. An ex-Second World War motor gunboat with a guest lounge over 27 metres in length.

BOTTOM RIGHT The Wellington Hotel at Boscastle, Cornwall. Pictured before the great flood of 2004, this hotel has 17th-century origins but was rebuilt in 1853.

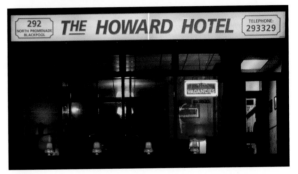

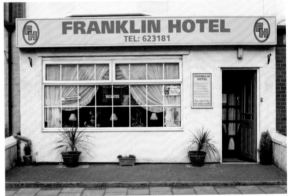

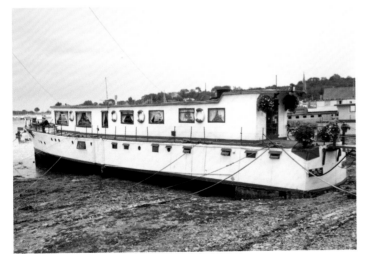

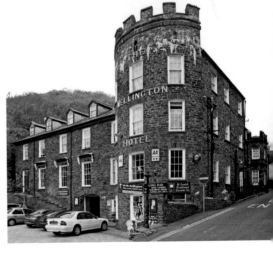

Wooden walls

Miscellaneous wooden buildings dot the coast. Often these are clinker built or constructed from salvage, while others are reused railway carriages. These buildings are often places created by free spirits who don't like the regimentation of beach huts or chalets or caravans.

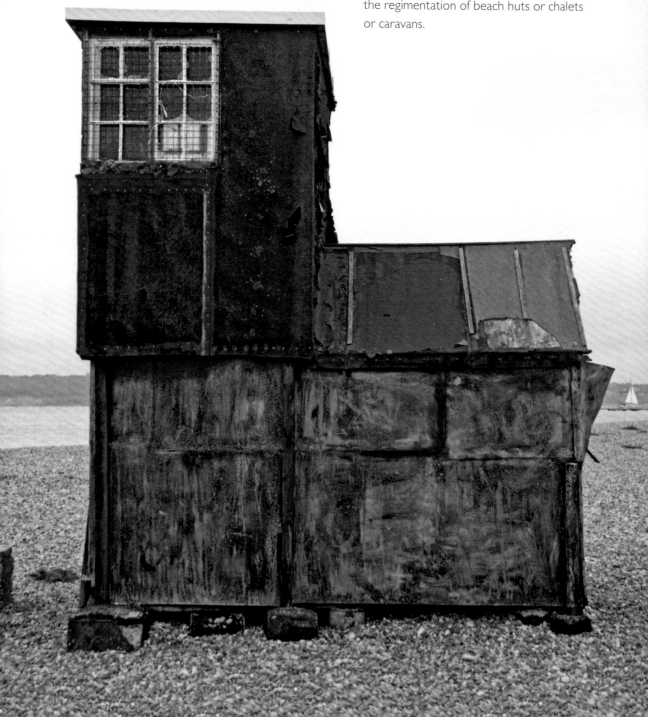

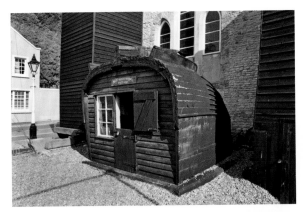

FACING PAGE Beach lookout at Hurst
Spit, Hampshire.

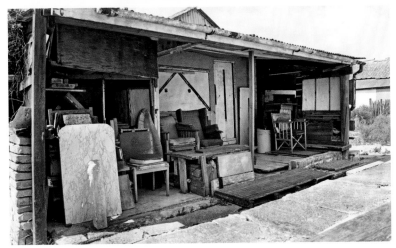

ABOVE 'Half Sovereign Cottage' on the
Stade at Hastings.

ABOVE RIGHT Hut with portholes to
the side of 'The Beach House',
Whitstable, Kent.

BELOW Houses directly on the beach at
Shellness, Isle of Sheppey, Kent. RIGHT
The veranda.

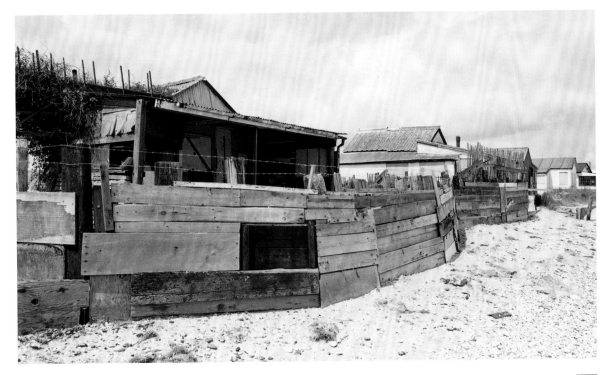

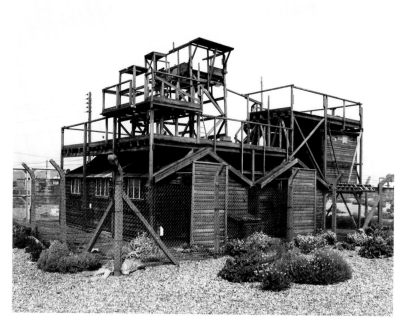

LEFT Marconi Laboratory at Dungeness, Kent.

BELOW LEFT Holiday camp chalets, Bognor Regis, West Sussex.

BELOW 'Leven' at Dungeness. A former railway carriage.

BOTTOM A new age houseboat at Shoreham-by-Sea, West Sussex.

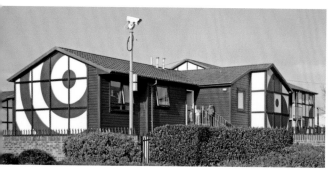

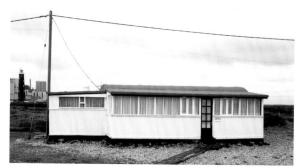

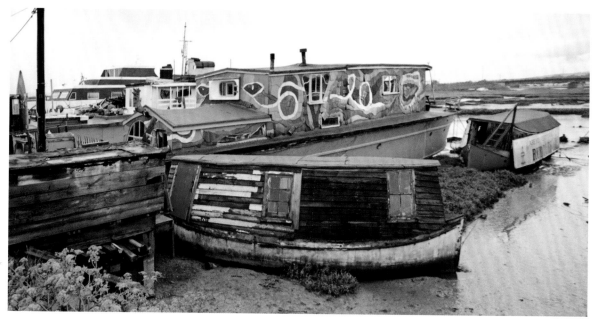

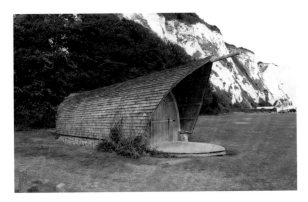

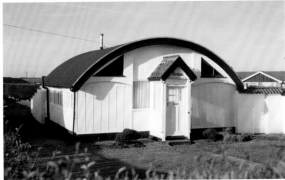

ABOVE Hut at St Margarets at Cliffe, Kent.

ABOVE RIGHT 'Lindum', Sutton-on-Sea, Lincolnshire. Built from two railway carriages.

RIGHT The Edwardian sail lofts or yacht stores at Tollesbury, Essex.

BELOW 'Waveland', Sutton-on-Sea. A stack of four railway carriages built about 1908.

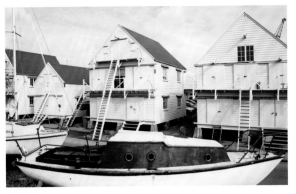

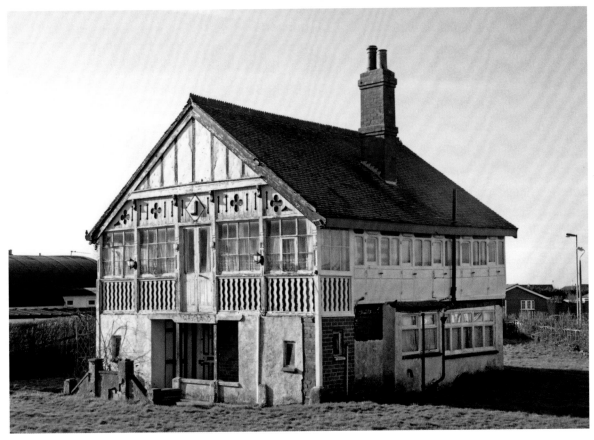

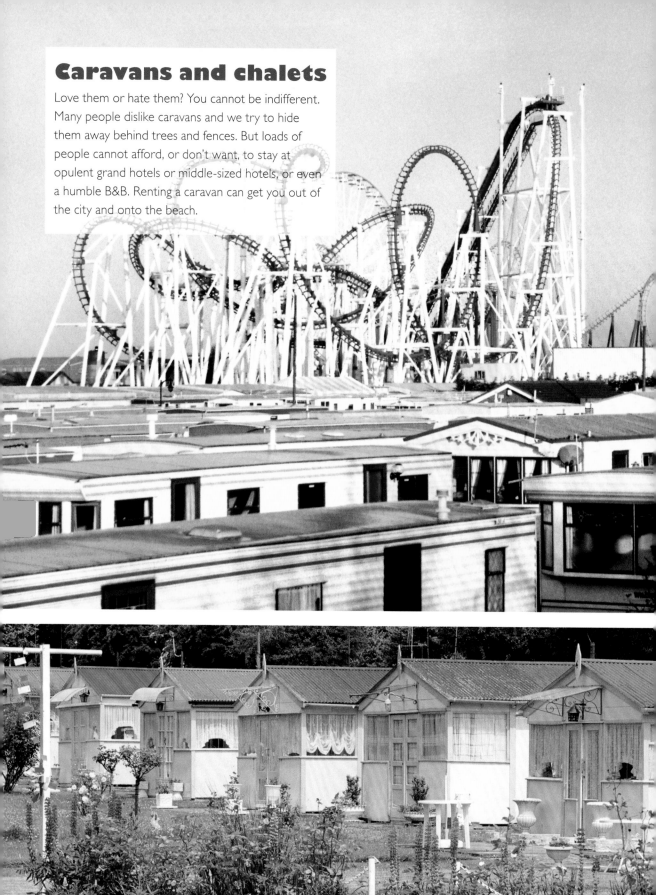

Caravans and chalets

Love them or hate them? You cannot be indifferent. Many people dislike caravans and we try to hide them away behind trees and fences. But loads of people cannot afford, or don't want, to stay at opulent grand hotels or middle-sized hotels, or even a humble B&B. Renting a caravan can get you out of the city and onto the beach.

FACING PAGE

TOP Caravans at Fantasy Island, Ingoldmells, Lincolnshire.

BELOW Chalets dating from the 1930s at Eden Leisure Park, Leysdown-on-Sea, Kent.

RIGHT Redcar Beach caravan park, North Yorkshire, with British steelworks in the distance.

BELOW More chalets at Leysdown-on-Sea.

BELOW RIGHT Sand Bay caravan park sign at Kewstoke, Somerset.

BOTTOM Winchelsea Beach, East Sussex, caravan park.

BOTTOM RIGHT The 1954 Airstream caravan outside 'Vista', the rubber-clad beach house designed by Simon Conder at Dungeness, Kent.

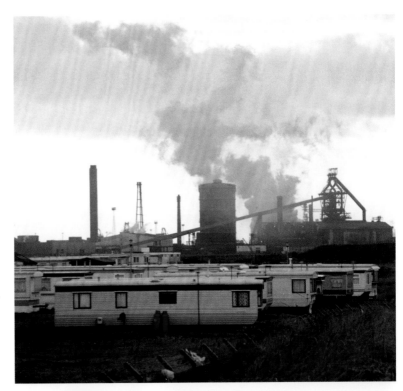

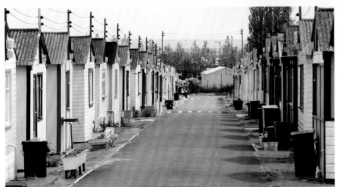

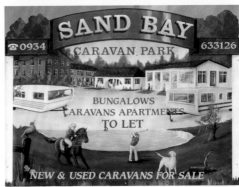

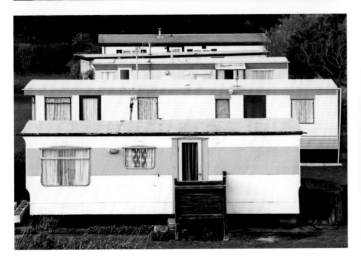

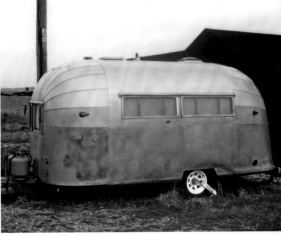

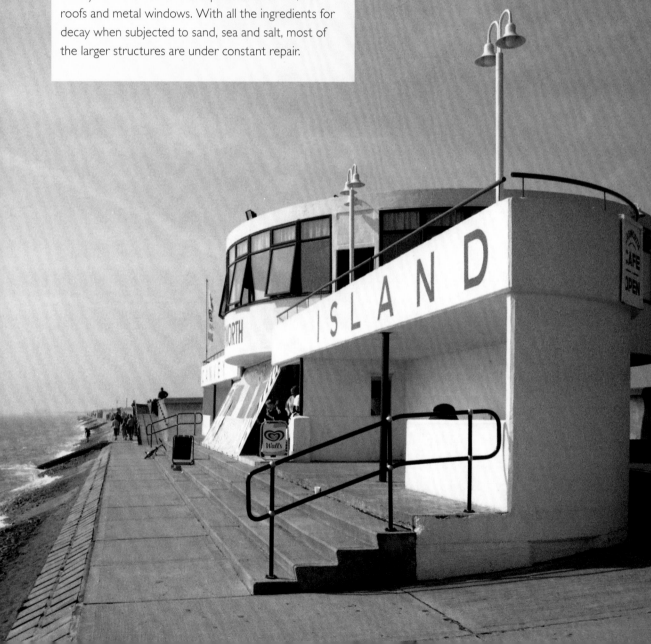

Seaside architecture of the 1930s

The 1930s was a period when buildings began to mirror the clean lines of ocean liners, when 'form was to follow function'. The origin of this style of architecture is firmly rooted in the Bauhaus tradition and it is no surprise to find many European architects working in England – including Erich Mendelsohn, Serge Chermayeff and Berthold Lubetkin.

The 1930s buildings to be seen at the seaside usually have masses of white-painted concrete, flat roofs and metal windows. With all the ingredients for decay when subjected to sand, sea and salt, most of the larger structures are under constant repair.

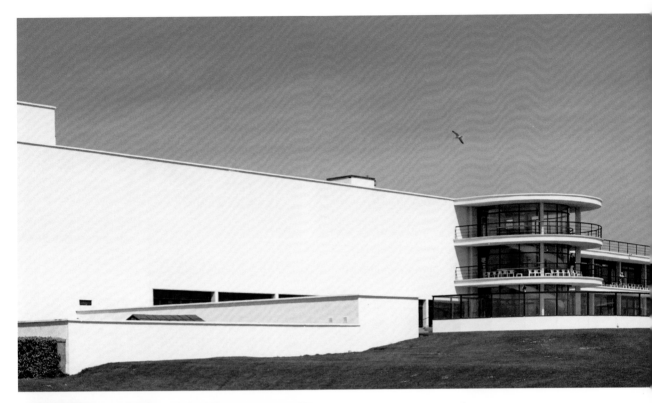

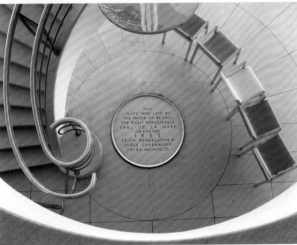

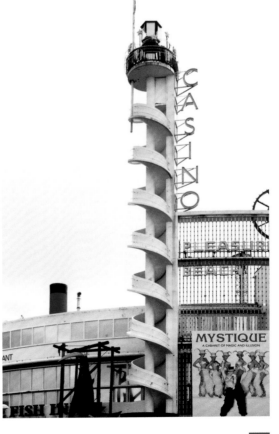

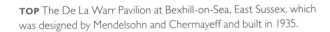

TOP The De La Warr Pavilion at Bexhill-on-Sea, East Sussex, which was designed by Mendelsohn and Chermayeff and built in 1935.

ABOVE Stairs at the De La Warr Pavilion, Bexhill-on-Sea – notice the Aalto chairs.

RIGHT The 1930s chic corkscrew tower of Blackpool Pleasure Beach 'New Casino' entrance.

FACING PAGE The Labworth Café at Canvey Island, Essex, which was built by Ove Arup in 1933.

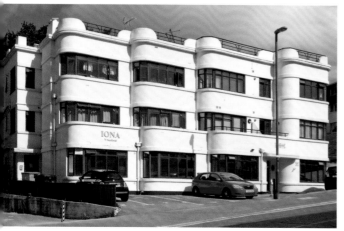

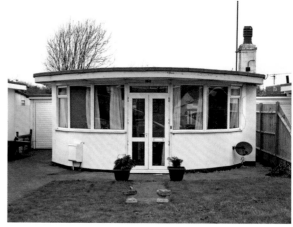

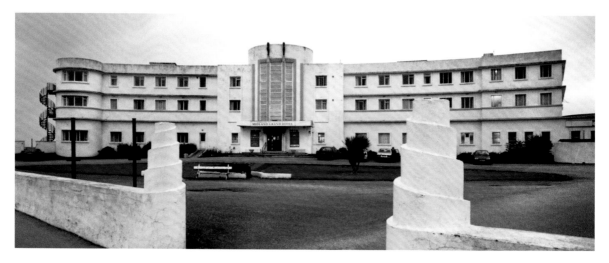

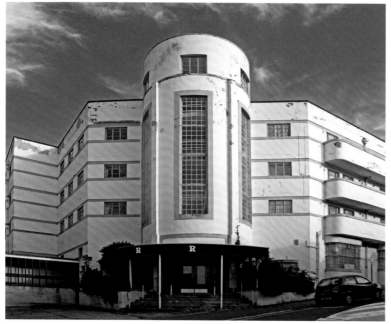

TOP LEFT 'Iona' at Boscombe, Dorset.

TOP RIGHT An 'Oyster' bungalow at Beachlands estate, Pevensey, East Sussex, dating to the late 1930s.

ABOVE The Midland Hotel, Morecambe. Built by the LMS Railway in 1932–3 to the design of Oliver Hill, with interior details by Eric Gill and Eric Ravilious.

LEFT The Royal York Hotel, Ryde, Isle of Wight, was designed in 1937–8 by the architects J B Harrison and H P Gilkes.

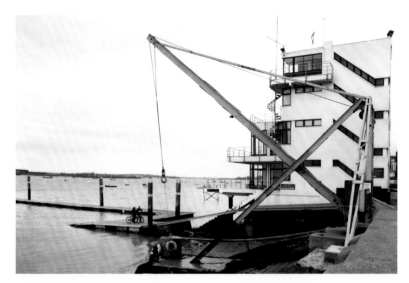

ABOVE The RIBA medal awarded to the RCYC in 1931.

ABOVE RIGHT The Royal Corinthian Yacht Club (RCYC) at Burnham-on-Crouch, Essex. Designed in 1931 by Joseph Emberton.

RIGHT Royal Birkdale Golf Club, Southport, Merseyside, 1935.

BELOW RIGHT 'The Roundhouse', Southport.

BELOW A detail of the broken bottles in 'Bottle Alley', Hastings. The lower deck of the 'double-decker' seafront promenade built in the early 1930s by the 'Concrete King' Sidney Little.

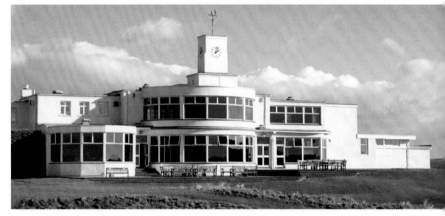

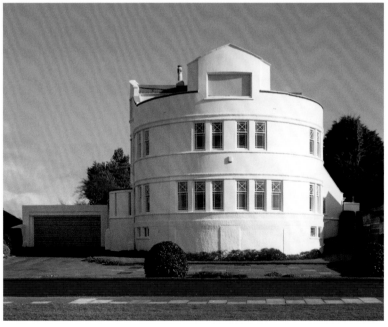

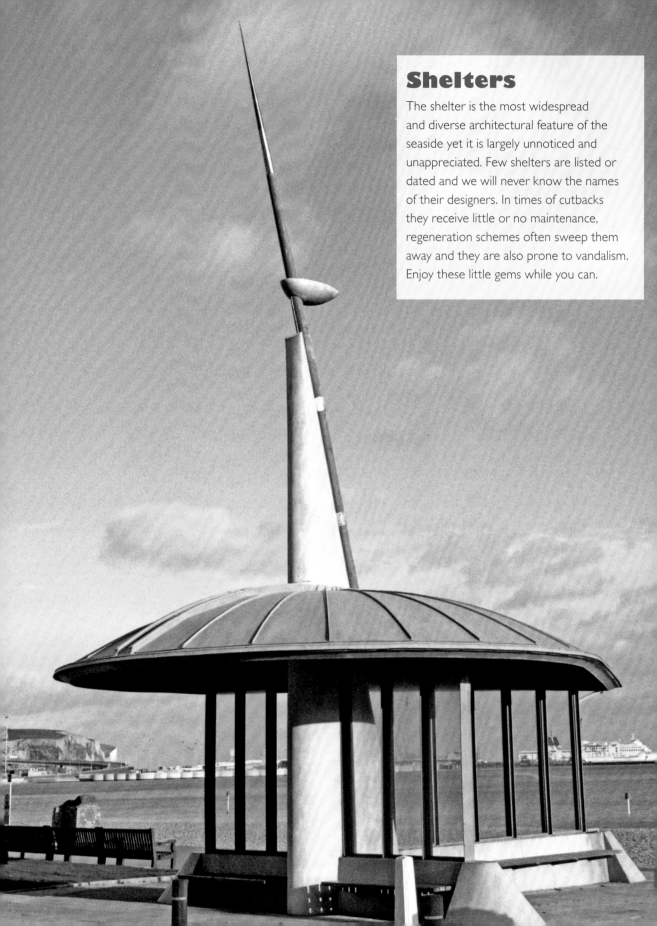

Shelters

The shelter is the most widespread and diverse architectural feature of the seaside yet it is largely unnoticed and unappreciated. Few shelters are listed or dated and we will never know the names of their designers. In times of cutbacks they receive little or no maintenance, regeneration schemes often sweep them away and they are also prone to vandalism. Enjoy these little gems while you can.

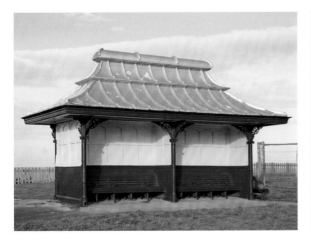

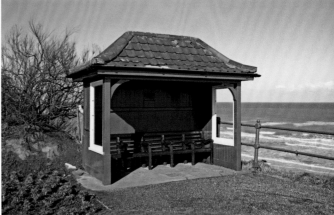

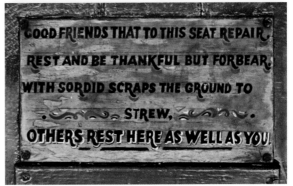

ABOVE The Blackpool pagoda-like style of about 1905.

ABOVE RIGHT A shelter at Mundesley, Norfolk.

RIGHT The sign in the Mundesley shelter.

BELOW Bandstand style at St Anne's, Lancashire. Note the gas lamp and a glimpse of the cast-iron esplanade wall.

FACING PAGE New shelters at Dover.

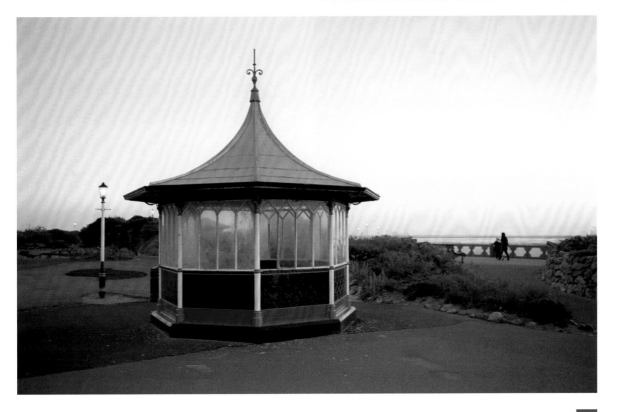

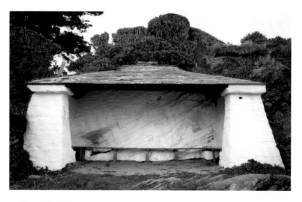

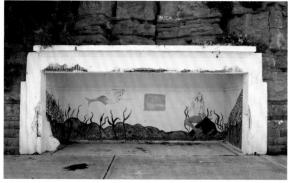

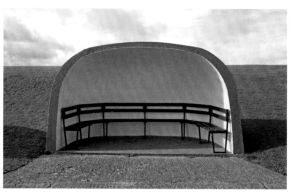

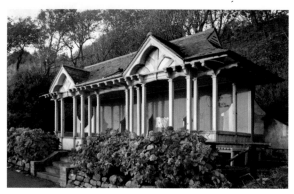

TOP LEFT The wonderful rock-cut shelter at Polperro, Cornwall.

TOP RIGHT Ramsgate seafront shelter with mermaids.

ABOVE LEFT Shelter, Silloth, Cumbria.

ABOVE The extraordinary little blue-painted shelters at Trusville, Trusthorpe, Lincolnshire.

LEFT Summerhouse style at Scarborough.

BELOW LEFT A grand masonry shelter at Scarborough.

BELOW The 'United States Navy' shelter at Fowey, Cornwall.

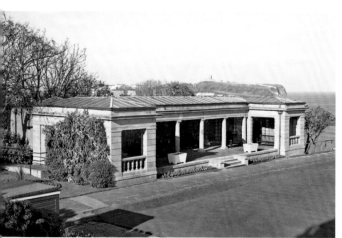

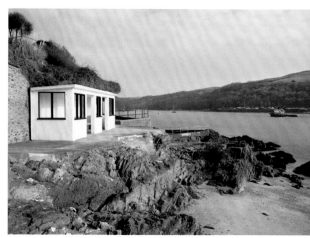

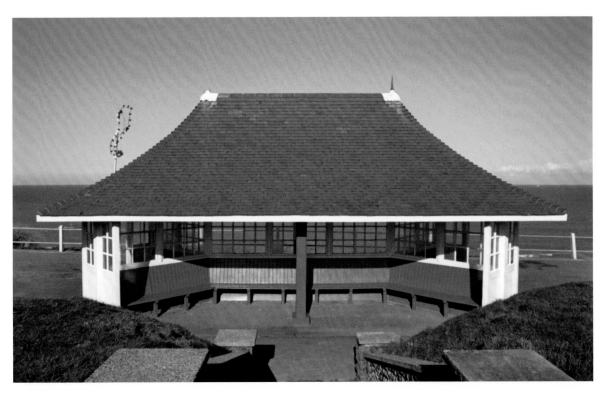

ABOVE Massive tiled roof at Cromer, Norfolk.

BELOW A thatched shelter at North Lodge Park, Cromer.

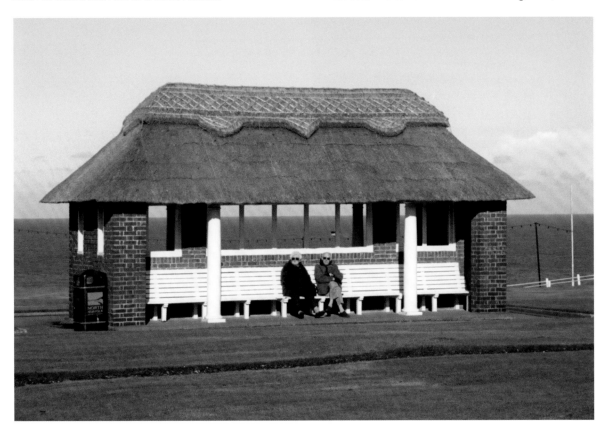

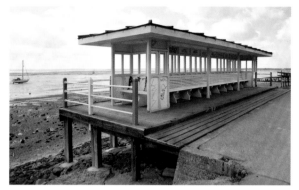

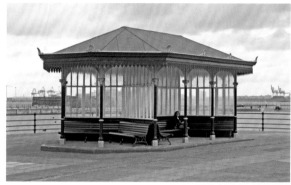

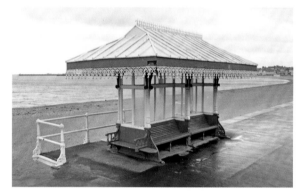

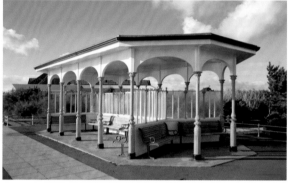

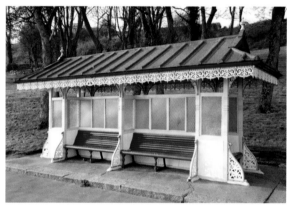

TOP LEFT A shelter built on stilts at Southend-on-Sea.

TOP King's Parade, New Brighton, Merseyside.

ABOVE LEFT An example from Weymouth, Dorset.

ABOVE A shelter at Southsea, Hampshire.

LEFT High Victoriana at Southend-on-Sea.

BELOW LEFT The 'Art Nouveau' shelter at Southport, Merseyside.

BELOW The Rockcliffe Bowling Club shelter at Whitley Bay, Tyne and Wear. The right-hand side seats face the bowling green and the left-hand seats face the sea.

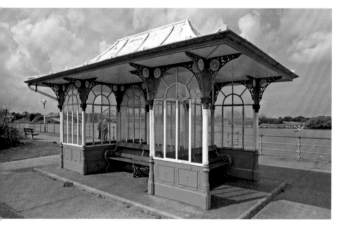

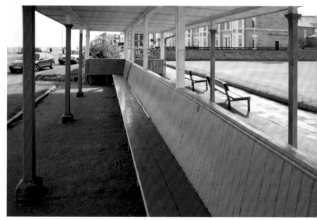

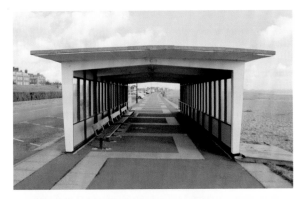

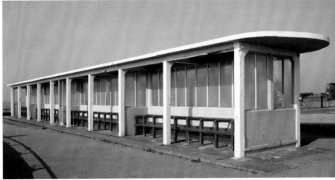

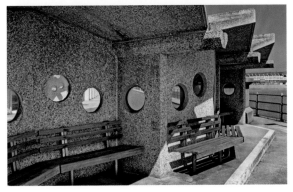

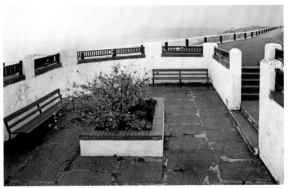

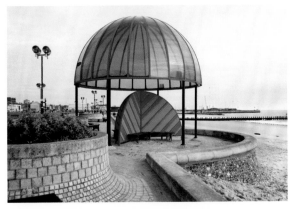

TOP Walk through at Southsea, Hampshire.

TOP RIGHT A 1930s shelter at Margate.

ABOVE 1960s style at Prince of Wales Pier, Dover.

ABOVE RIGHT An example of a roofless wind shelter at Saltburn-by-the-Sea, North Yorkshire.

RIGHT Domed shelters at Lowestoft, Suffolk.

BELOW Nayland rock Shelter, Margate. This is where T S Eliot wrote part of *The Wasteland* in 1922. Pity there is no information sign. The adjacent conveniences, however, provide a useful amagramatical clue.

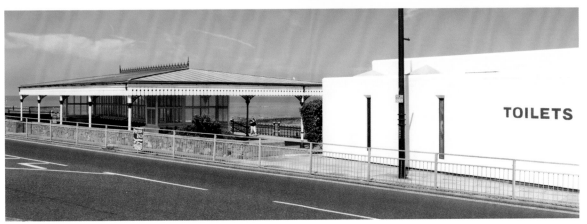

TOILETS

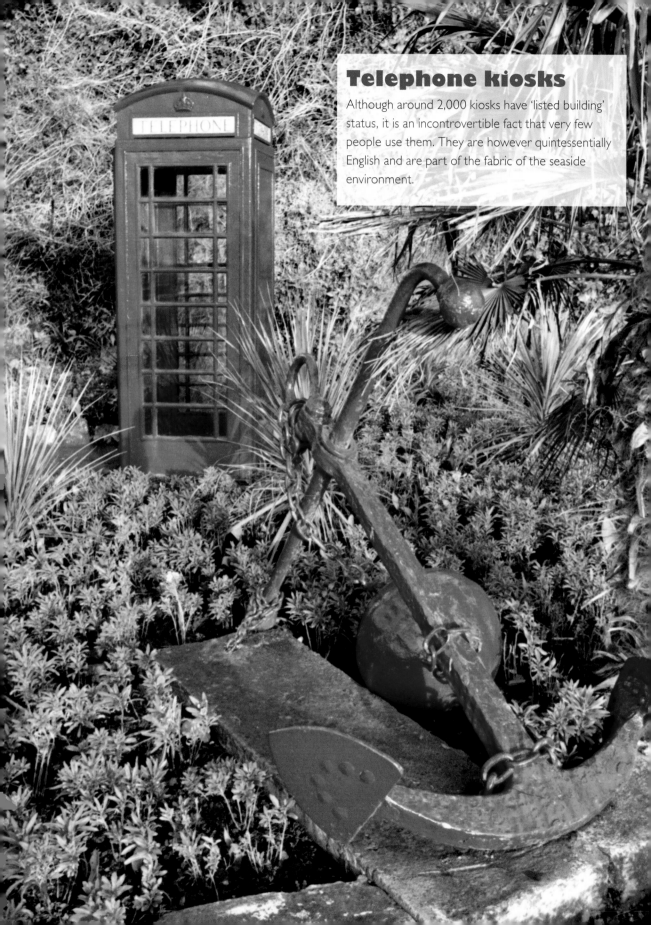

Telephone kiosks

Although around 2,000 kiosks have 'listed building' status, it is an incontrovertible fact that very few people use them. They are however quintessentially English and are part of the fabric of the seaside environment.

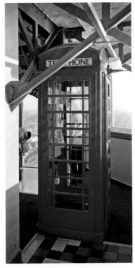
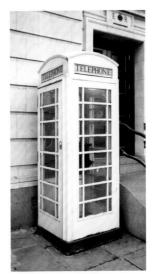
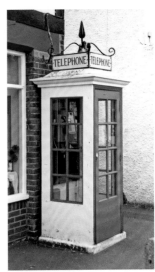

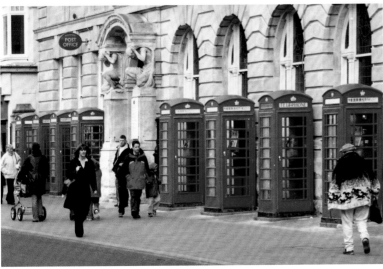
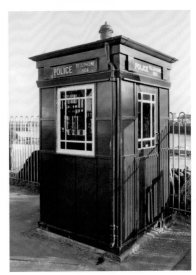

TOP LEFT A blue-painted kiosk at Ramsgate.

TOP CENTRE LEFT The more usual K6 kiosk of 1924. This one is at the top of Blackpool Tower.

TOP CENTRE RIGHT The distinctive white-painted kiosks at Hull.

TOP RIGHT A rare example of the K1 designed by Giles Gilbert Scott in 1921, standing in the High Street at Bembridge, Isle of Wight.

ABOVE Telephone kiosks at Blackpool.

ABOVE RIGHT A rare 'Tardis' police telephone box at Scarborough.

RIGHT A K6 virtually on the beach at Budleigh Salterton, Devon.

FACING PAGE Nautical flavour at Paignton Harbour, Devon.

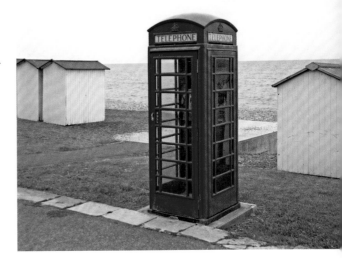

Something to sit on

Deckchairs

Usually found corralled in piles with deckchair attendants not in attendance. Others are seemingly abandoned, their occupants having given up and gone for a cuppa. The old cotton versions have long given way to nylon, but the traditional stripes remain. Some resorts even have their own colour codes. One of life's small pleasures is watching someone struggling to put up a deckchair in the wind.

Solid seats

Seats are made from a multiplicity of materials – cast iron, wood, stainless steel, plastic, concrete, you name it. Lots of seats seem to commemorate those who sat there in their favourite place staring out to sea. Designers and manufacturers are usually anonymous and perhaps we are not really meant to notice a well-placed seat – especially if we are sitting on it.

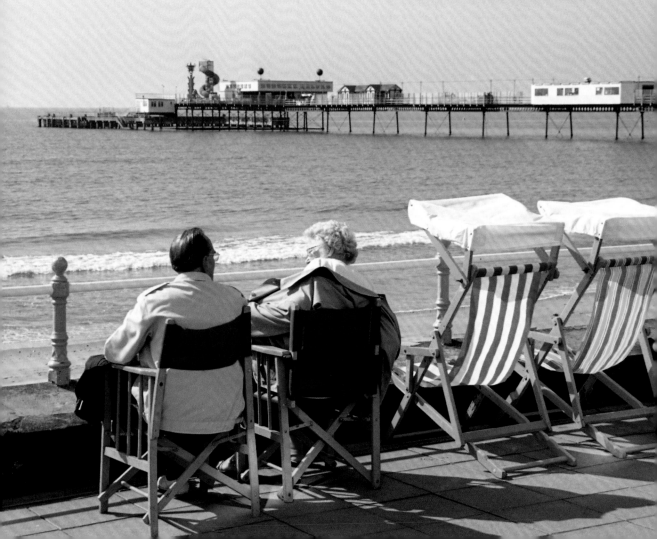

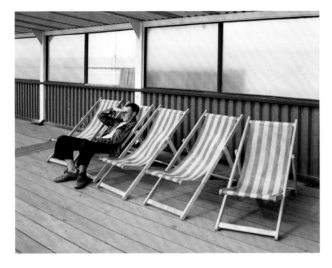

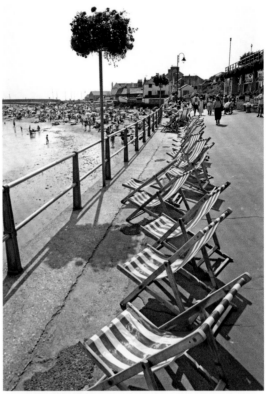

ABOVE On the pier at Bournemouth.

RIGHT Waiting for customers at Lyme Regis, Dorset.

BELOW On the front at Brighton.

FACING PAGE Looking towards the pier at Sandown, Isle of Wight.

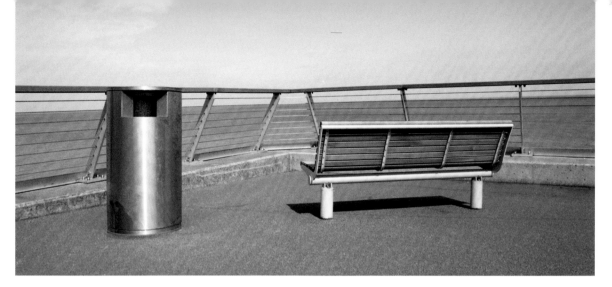

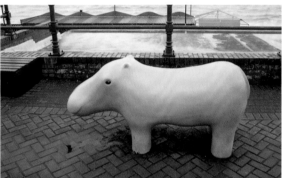

ABOVE Stainless steel at Hornsea, East Yorkshire.

LEFT Hippopotamus seat at Bridlington, East Yorkshire.

BELOW LEFT The Edith Cavell seat at Hunstanton, Norfolk.

BELOW Seat with whale-fin back, Millenium Promenade, Whitehaven, Cumbria.

BOTTOM LEFT At Corbyn Head, Torquay.

BOTTOM RIGHT The next seat along.

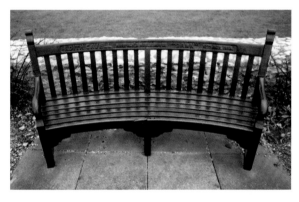

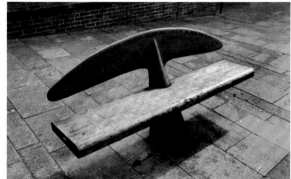

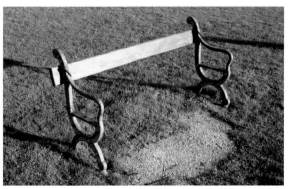

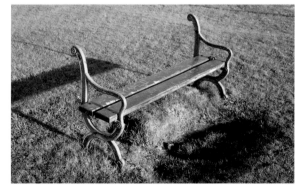

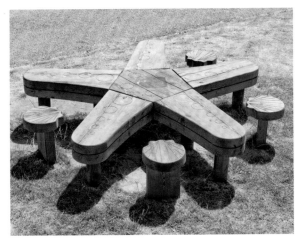

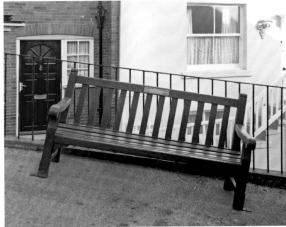

ABOVE The Lower Leas Coastal Park, Folkestone.

ABOVE RIGHT Unsitonable seat at Scarborough.

RIGHT The extraordinary long seat at Bridlington, East Yorkshire.

BELOW Longest Seaside Bench, Littlehampton, East Sussex. You may say that this, being a 'bench', is not comparable with a 'seat'. I still say the longest seat is in Bridlington!

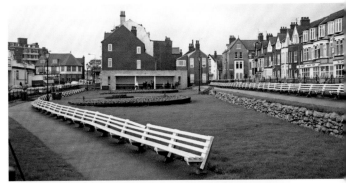

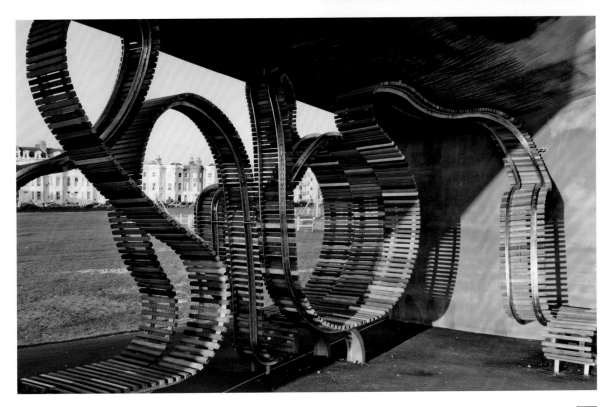

LEFT Torpedo used as bench or seat, Gunwharf, Portsmouth.

BELOW LEFT Seats atop the Public Conveniences, Brixham, Devon.

BELOW Regeneration at South Shore Promenade, Bridlington, by the architectural practice of Bauman Lyons with artist Bruce McLean.

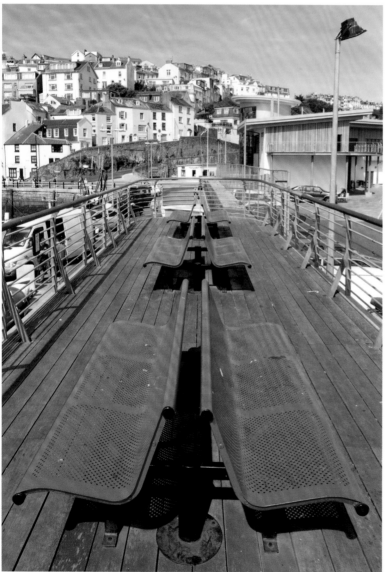

FACING PAGE

TOP LEFT A seat on the reconstructed Promenade at Blackpool.

TOP RIGHT A poetical seat and table at Hunstanton, Norfolk.

CENTRE LEFT Sandcastle seats at Whitley Bay, Tyne and Wear.

BOTTOM LEFT Ammonite seats at Whitby, North Yorkshire.

BOTTOM RIGHT 'The Folkestone Mermaid' by Cornelia Parker, end of The Stade, Folkestone.

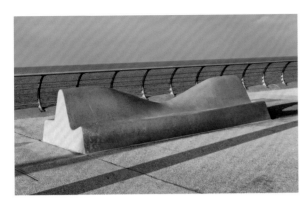

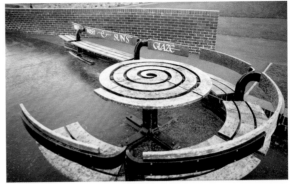

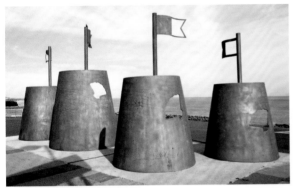

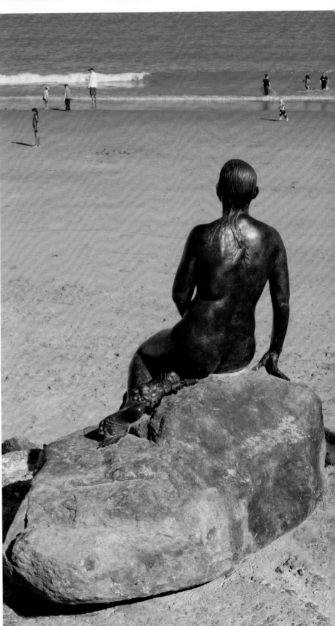

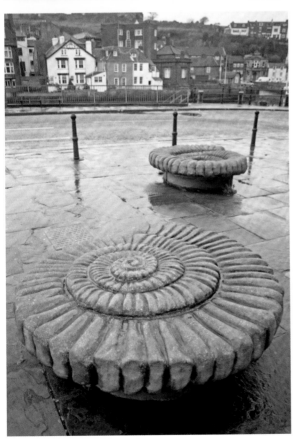

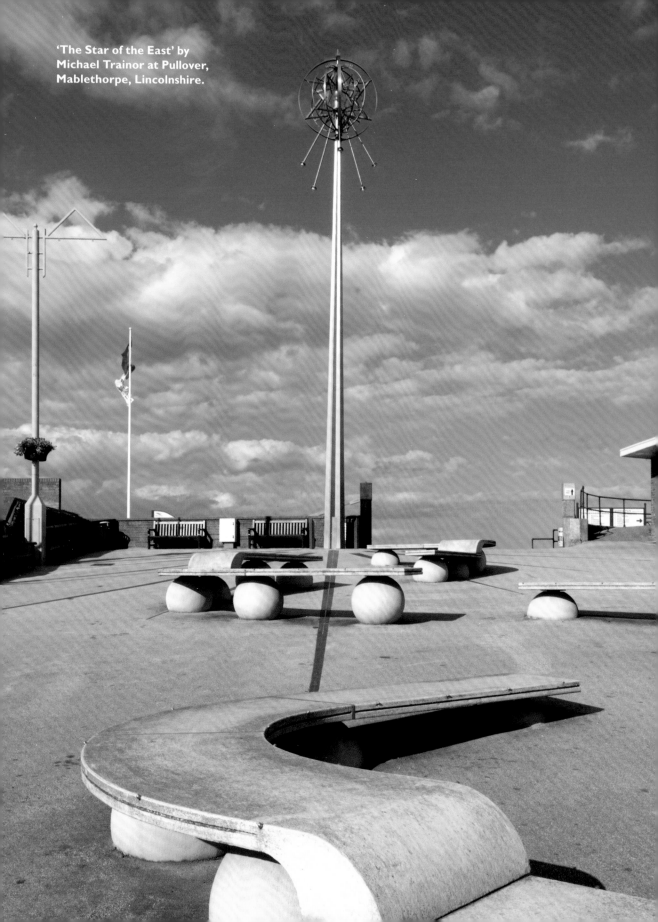

'The Star of the East' by
Michael Trainor at Pullover,
Mablethorpe, Lincolnshire.

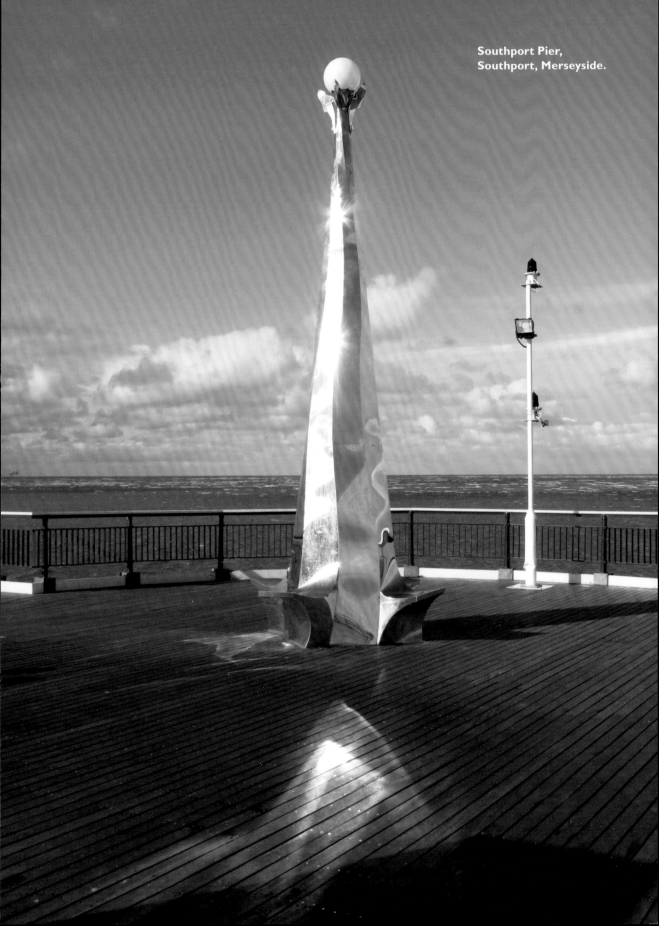

Southport Pier,
Southport, Merseyside.

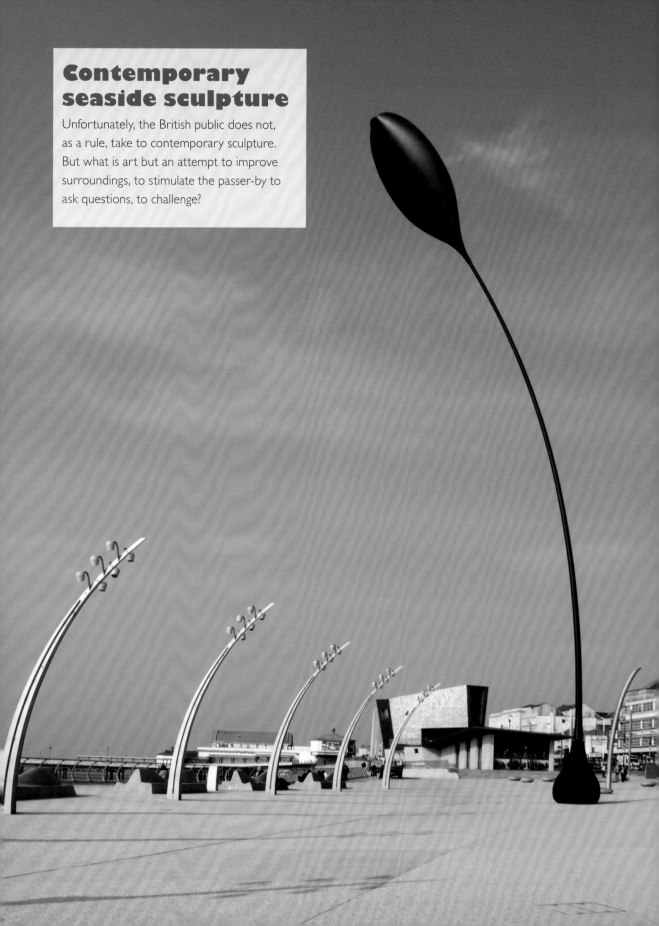

Contemporary seaside sculpture

Unfortunately, the British public does not, as a rule, take to contemporary sculpture. But what is art but an attempt to improve surroundings, to stimulate the passer-by to ask questions, to challenge?

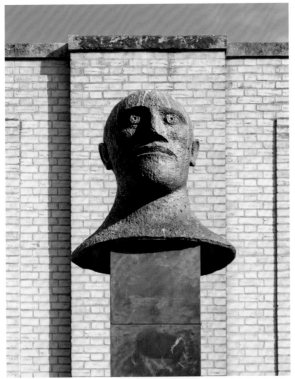

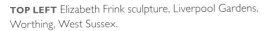

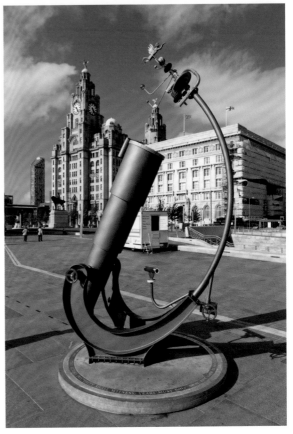

TOP LEFT Elizabeth Frink sculpture, Liverpool Gardens, Worthing, West Sussex.

TOP RIGHT 'They Shoot Horses Don't They?' by Michael Trainor, 2002. The world's largest mirror ball, Blackpool.

ABOVE Tracey Emin sculpture 'I Never Stopped Loving You' at Droit House, Margate.

RIGHT Liverpool Waterfront. 'Heaven and Earth' sculpture by Andy Plant celebrating the work of Jeremiah Horrocks, with the Liver building beyond.

FACING PAGE Grass sculpture on the Esplanade, Blackpool.

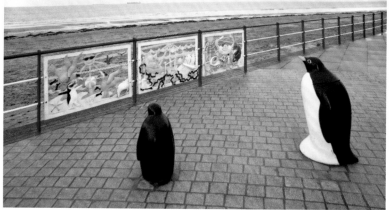

FACING PAGE

TOP 'Whalebone' by Reece Ingrams, at Herne Bay, Kent – a sculpture very popular with children.

BOTTOM LEFT Bird sculptures at Morecambe.

CENTRE RIGHT 'Lunar Pieces', seven phases of the moon set in concrete bowls by Chaz Brenchley at Roker beach, Sunderland, Tyne and Wear.

BOTTOM RIGHT 'Family of Penguins' by Tony Wiles, 1994, at Redcar, North Yorkshire. The penguins are looking at another work, 'Picture Postcard Railings' by Chris Topp.

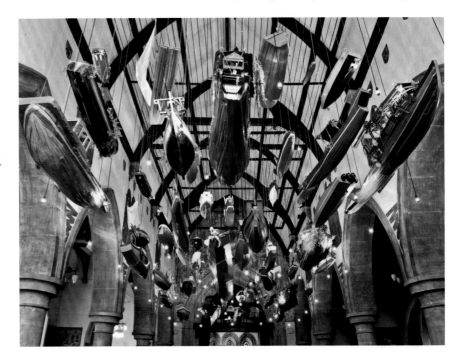

ABOVE RIGHT Sculpture 'For Those in Peril on the Sea', by Hew Locke 2011 at St Mary and St Eanswythe's Church, The Bayle, Folkestone, for the Folkestone Triennial.

RIGHT 100 cast-iron figures on Crosby beach, Merseyside, by Anthony Gormley.

BELOW New sign by Nathan Coley for the Folkestone Triennial 2008.

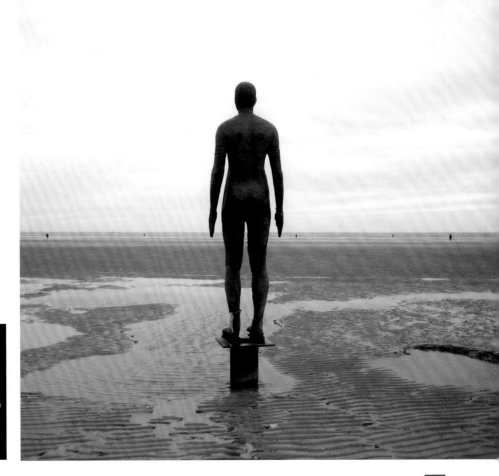

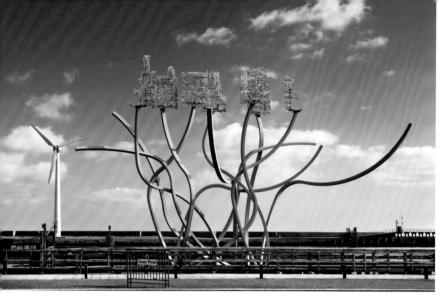

LEFT 'The Spirit of the Staithes' sculpture by Simon Packard 2003, Blyth, Northumberland.

CENTRE LEFT The Henry Moore sculpture at Snape Maltings, Suffolk. I think we can award it 'seaside status' as the visitors to Snape generally stay at the seaside.

BOTTOM LEFT 'Embracing the Sea' by Jon Buck, 1998 on Deal Pier, Kent.

BOTTOM CENTRE 'Mrs Booth, Shell Lady of Margate', on the pier at Margate.

BOTTOM RIGHT 'Conversation Piece' by Juan Munoz, 1999, South Shields, Tyne and Wear.

FACING PAGE

TOP LEFT 'Scallop' by Maggi Hambling at Aldeburgh, Suffolk, which has suffered from vandalism.

CENTRE LEFT 'Jewels of the Sea' sculptures at East Shore Village, Seaham, Co Durham. One of 30 created by Andrew McKeown on the site of the former Vane Tempest Colliery.

BOTTOM LEFT Sculpture of a lookout boy with telescope, Whitehaven, Cumbria.

FAR RIGHT 'The Bude Light', Bude, Cornwall was designed by Carole Vincent and Anthony Fanshawe in 2000 to commemorate the inventor Sir Goldsworthy Gurney. Bude lights were installed in the House of Commons in 1839.

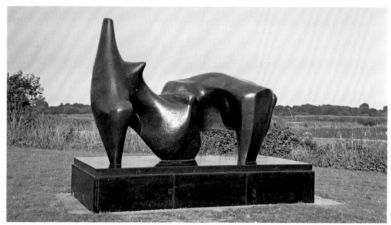

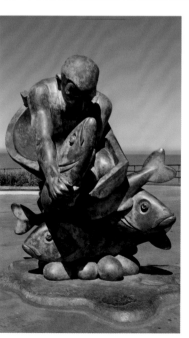

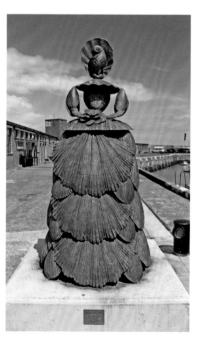

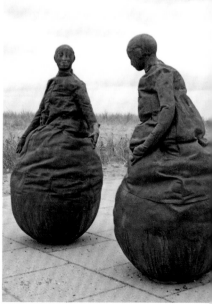

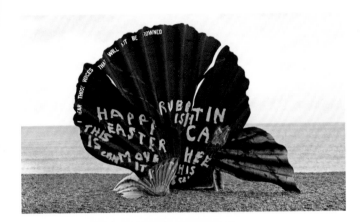

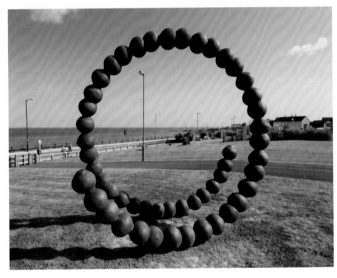

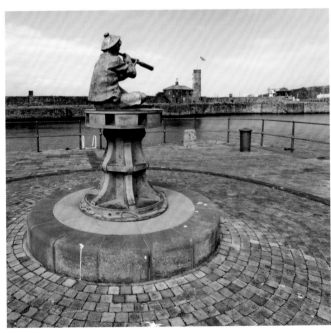

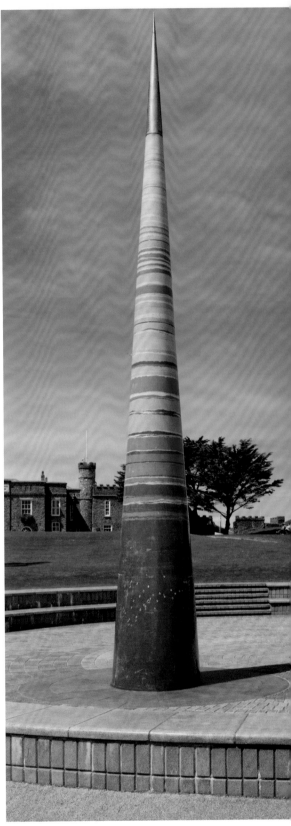

Public conveniences

Often combined with shelters or bandstands, these buildings of lowly status are frequently disregarded and subject to vandalism and neglect. Few original interiors remain.

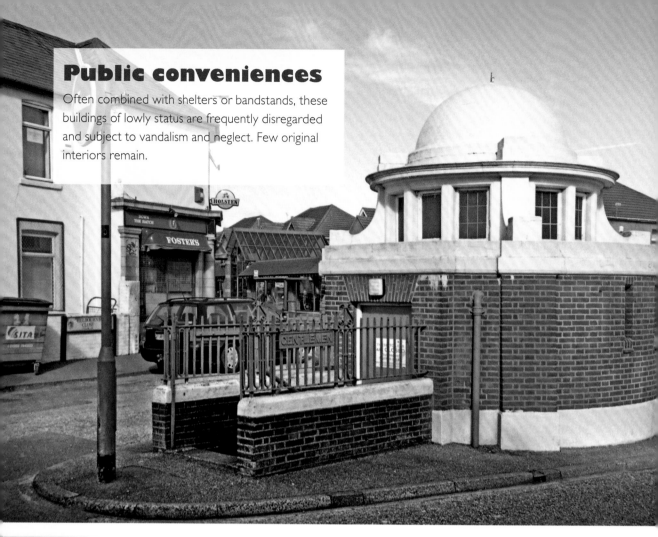

ABOVE Gentlemen's public convenience c 1905 at Bournemouth.

LEFT Conveniences at Southport, Merseyside, with stained glass and timber framing. Flowers and lace curtains are an added attraction, and an attendant is on call.

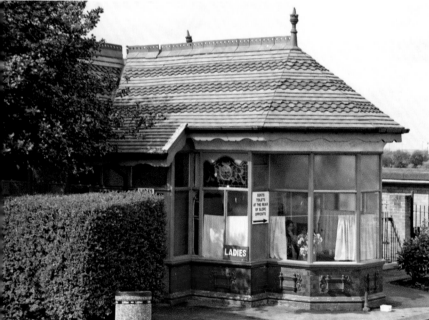

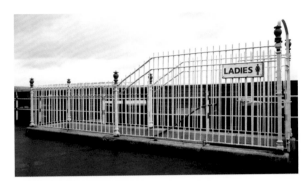

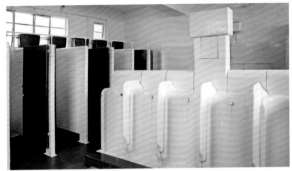

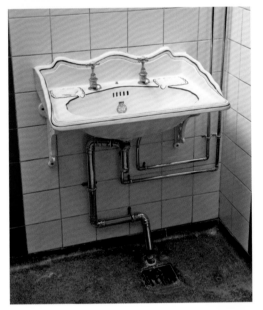

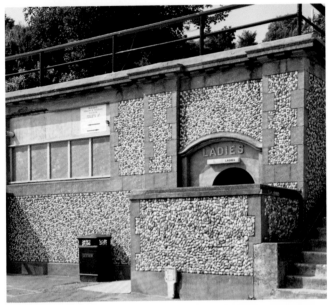

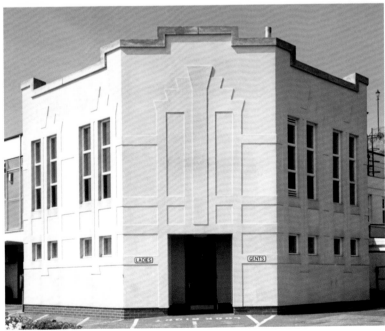

TOP LEFT Railings surround the underground facilities at Weymouth, Dorset.

TOP RIGHT Gentlemen's conveniences at Frinton-on-Sea, Essex.

ABOVE Hand washbasin in the award-winning Victoria Pier conveniences at Hull.

ABOVE RIGHT Public conveniences at Lyme Regis, Dorset.

RIGHT Public conveniences at Felixstowe, Suffolk.

FACING PAGE BOTTOM Late 19th-century cast-iron decoration in the disused public conveniences at Margate.

Seaside gardens

Municipal seaside parks and gardens seem to have been in decline for some years. A stroll along the prom will often reveal a general contraction of flower-bed area and an increase in lawn area. But, though there may be fewer flower beds, there are still loads left to provoke plenty of 'oohs' and 'aahs' at their bright and brash splashes of colour.

At Southport, for example, there is the classic Botanic Gardens, the British Lawn Mower Museum, Hesketh Park with its wooded lakeland setting, Rotten Row – an internationally renowned flower bed, King's Gardens, the aptly named Floral Hall and, not least, Victoria Park, the home of the Southport Flower Show. Unlike the colder and windy east coast, Southport enjoys a balmy Gulf-Stream kind of weather ideal for growing sub-tropical and Mediterranean plants.

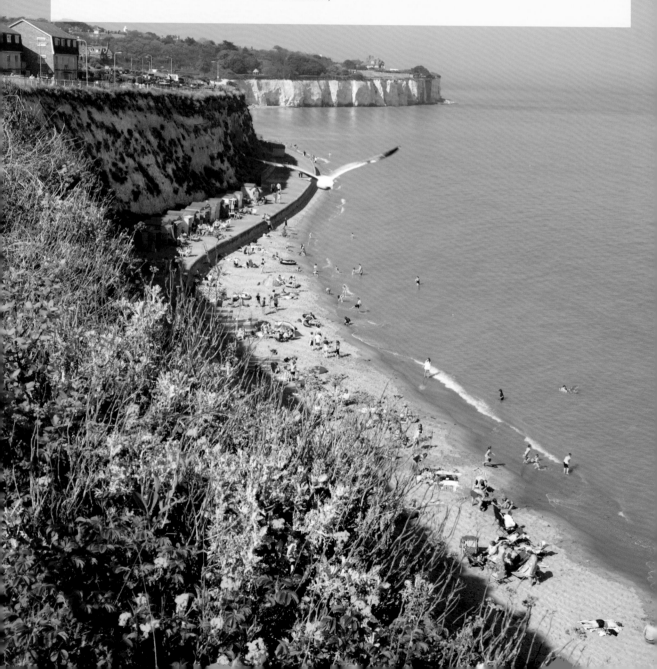

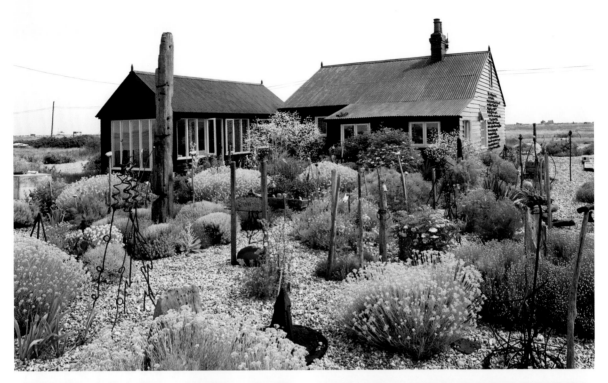

TOP 'Prospect Cottage', the former home of Derek Jarman, at Dungeness, Kent.

ABOVE The 'Venus of Dungeness' garden, Dungeness.

ABOVE RIGHT Flotsam and jetsam at the 'Venus of Dungeness' garden.

RIGHT A floral fish at Sidmouth, Devon.

FACING PAGE Wild flowers along the cliff edge at Broadstairs, Kent.

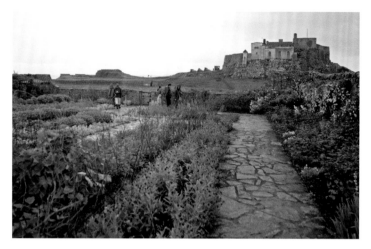

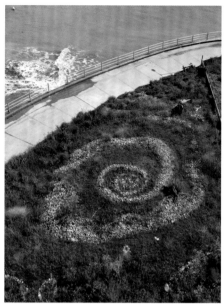

TOP LEFT The Gertrude Jekyll walled garden, created in 1911 at Lindisfarne Castle, Northumberland.

TOP RIGHT Seaside gardens, Ramsgate.

ABOVE LEFT Maze at Camelot Castle Hotel, Tintagel, Cornwall.

ABOVE Sign for the sunken garden at Margate.

LEFT Inside the Lawnmower Museum, Southport, Merseyside.

ABOVE The sunken garden on the esplanade at Whitley Bay, Tyne and Wear.

RIGHT Lamplit walk at Southport, Merseyside.

BELOW The Broad Walk yew hedge at Walmer Castle, Kent.

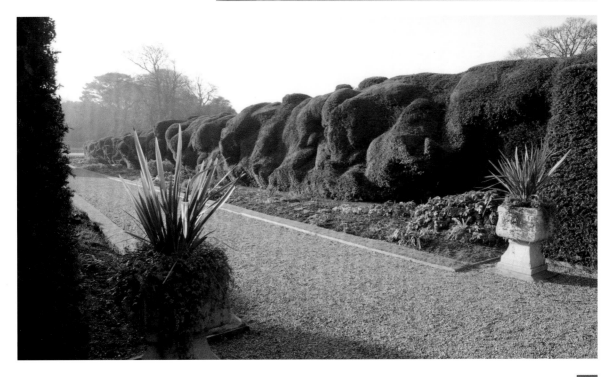

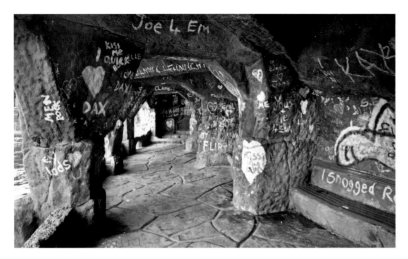

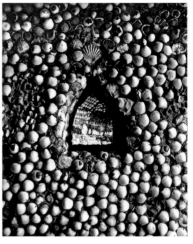

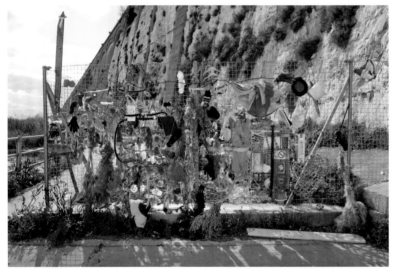

ABOVE LEFT In the 'Axenstrasse' at Skegness, Lincolnshire.

ABOVE The Shell Grotto at Gyllyngdune Gardens, Falmouth, Cornwall.

LEFT Plastic flotsam sea garden, Ramsgate.

BELOW LEFT Pulhamite rockery at Ramsgate.

BELOW A detail in the Shell Grotto, Margate.

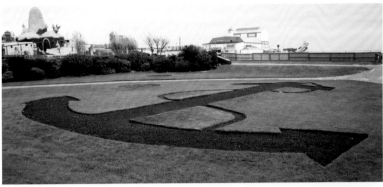

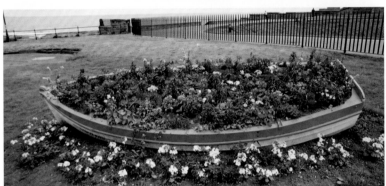

ABOVE Floral display at Skegness, Lincolnshire.

ABOVE RIGHT A giant anchor flower bed at Great Yarmouth.

RIGHT A flower-filled dinghy at Tynemouth, Tyne and Wear.

BELOW Zambezi Tea Room's garden, Bembridge, Isle of Wight.

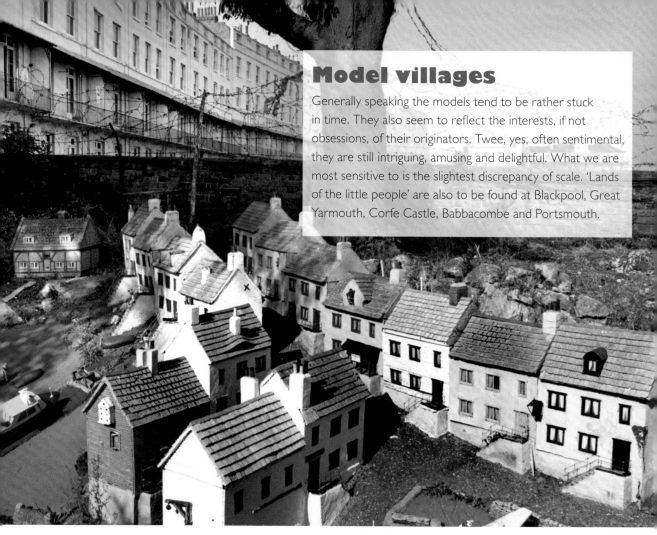

Model villages

Generally speaking the models tend to be rather stuck in time. They also seem to reflect the interests, if not obsessions, of their originators. Twee, yes, often sentimental, they are still intriguing, amusing and delightful. What we are most sensitive to is the slightest discrepancy of scale. 'Lands of the little people' are also to be found at Blackpool, Great Yarmouth, Corfe Castle, Babbacombe and Portsmouth.

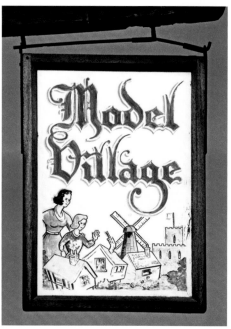

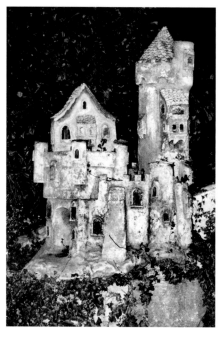

ABOVE Ramsgate Model Village. Built in 1953, it is now sadly closed.

FAR LEFT Sign for the Ramsgate Model Village.

LEFT A dilapidated model castle at Never Never Land, Southend-on-Sea.

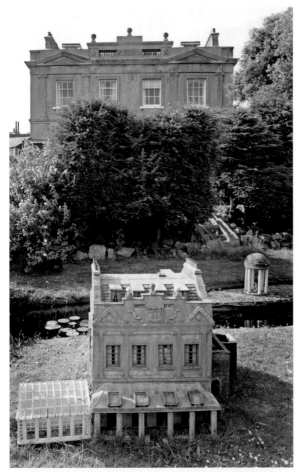

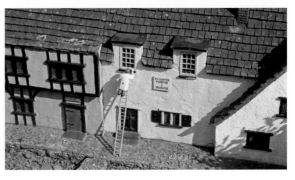

LEFT Little and large at the Ramsgate Model Village.

TOP Semore Clearly and Lucy Lastic at Skegness Model Village, Lincolnshire.

ABOVE W E Slapiton at work in the Skegness Model Village.

BELOW Skegness Model Village.

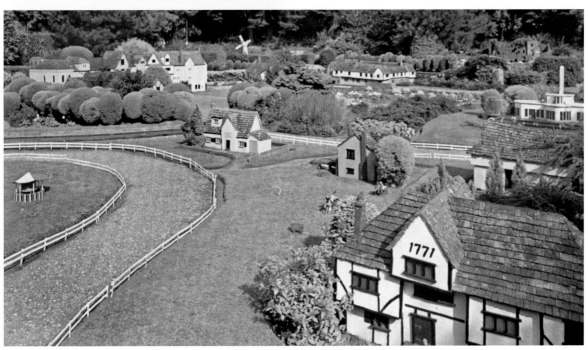

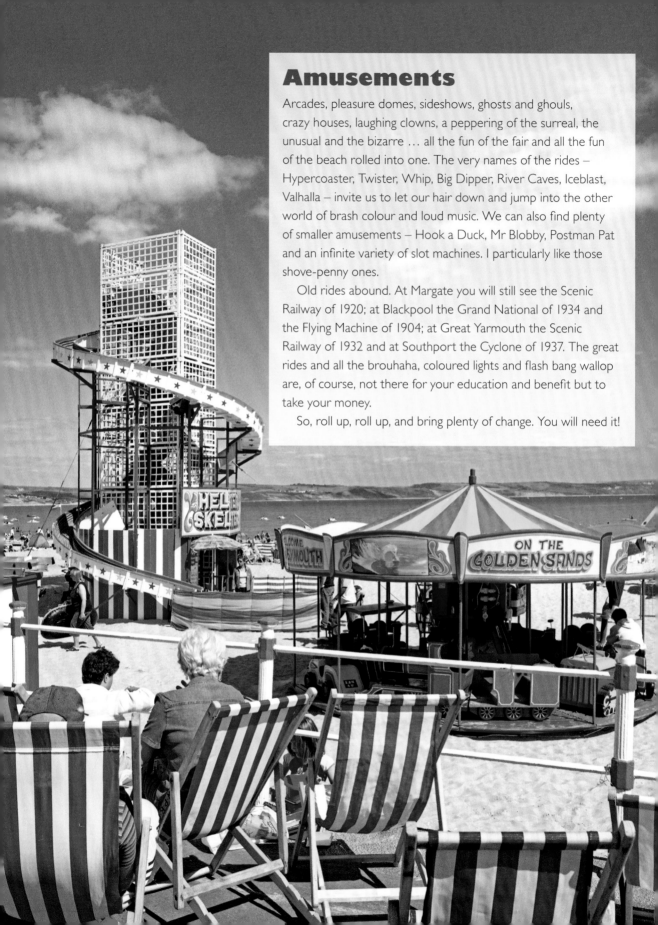

Amusements

Arcades, pleasure domes, sideshows, ghosts and ghouls, crazy houses, laughing clowns, a peppering of the surreal, the unusual and the bizarre … all the fun of the fair and all the fun of the beach rolled into one. The very names of the rides – Hypercoaster, Twister, Whip, Big Dipper, River Caves, Iceblast, Valhalla – invite us to let our hair down and jump into the other world of brash colour and loud music. We can also find plenty of smaller amusements – Hook a Duck, Mr Blobby, Postman Pat and an infinite variety of slot machines. I particularly like those shove-penny ones.

Old rides abound. At Margate you will still see the Scenic Railway of 1920; at Blackpool the Grand National of 1934 and the Flying Machine of 1904; at Great Yarmouth the Scenic Railway of 1932 and at Southport the Cyclone of 1937. The great rides and all the brouhaha, coloured lights and flash bang wallop are, of course, not there for your education and benefit but to take your money.

So, roll up, roll up, and bring plenty of change. You will need it!

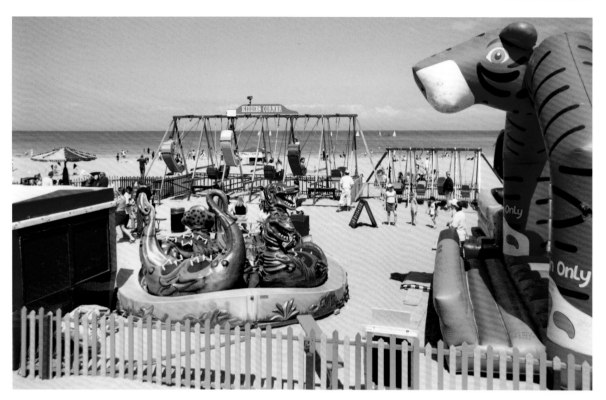

FACING PAGE Weymouth, Dorset. **ABOVE** Amusements on the beach at Margate. **BELOW** The Crazy Clown ride at Brighton.

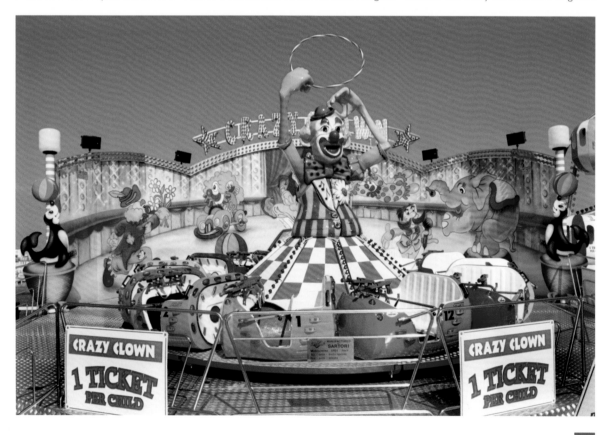

Amusements

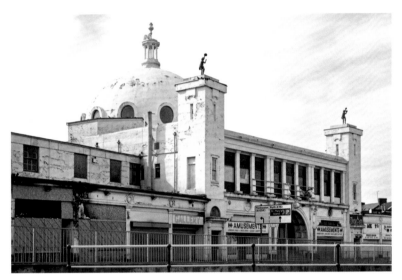

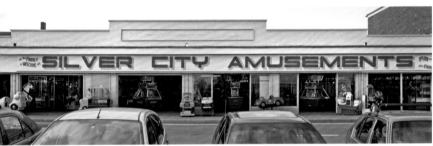

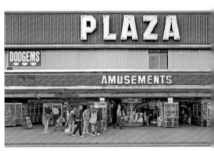

LEFT Spanish City, Whitley Bay, Tyne and Wear, opened in 1910 as a pleasure dome and ballroom.

BELOW LEFT All the family is welcome at Silver City Amusements at Cleethorpes, Lincolnshire.

BELOW The typical 'Plaza' amusements at Skegness, Lincolnshire.

BOTTOM Charles Mannings' Amusements, Felixstowe, Suffolk, 1933.

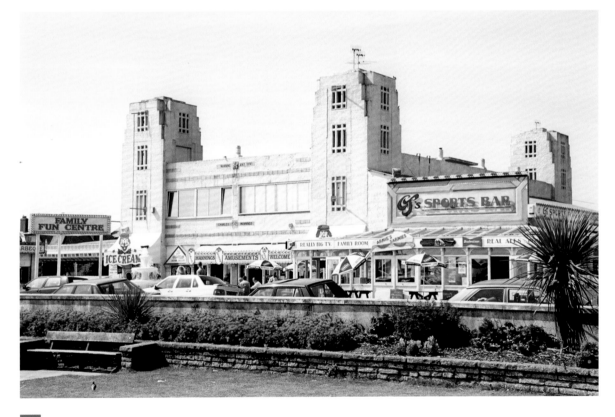

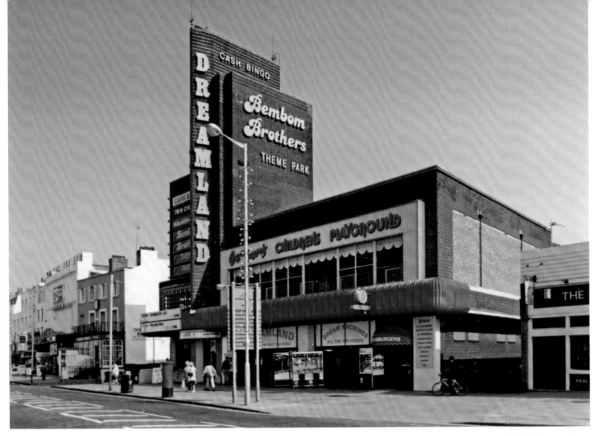

ABOVE Dreamland, Margate, photographed in 1994. Proposed to be redeveloped as a historic-themed amusement park.

BELOW The Kursaal at Southend-on-Sea, 1898–9. Formerly 26 acres of amusements including a menagerie.

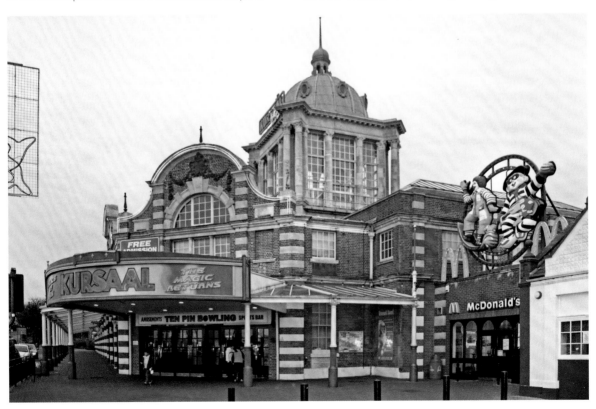

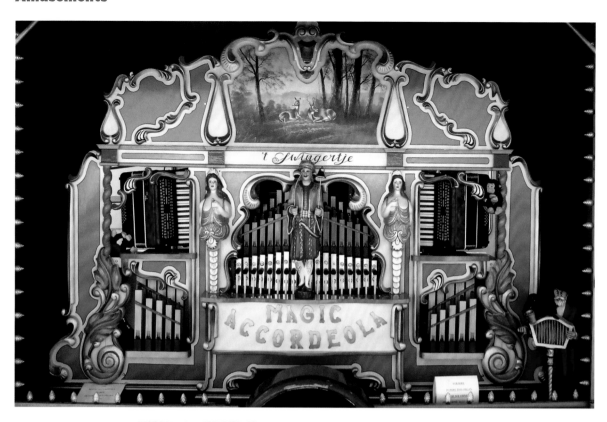

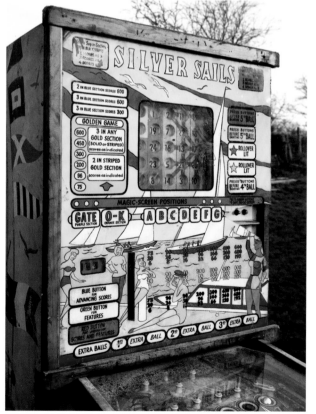

ABOVE The Magic Accordeola, 41-key Dutch Street organ, at Tankerton Slopes, Kent.

LEFT A Silver Sails pinball machine found abandoned in a field near Bristol.

BELOW Detail of the Vintage Old Penny Arcade advertisement on Southport Pier, Merseyside.

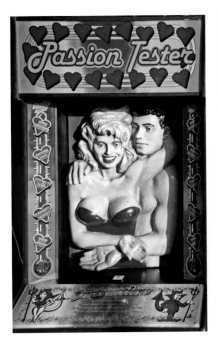

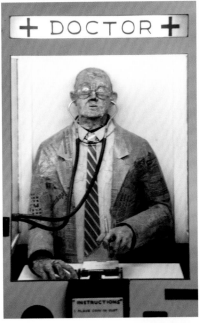

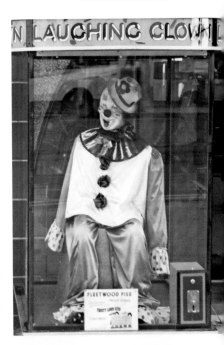

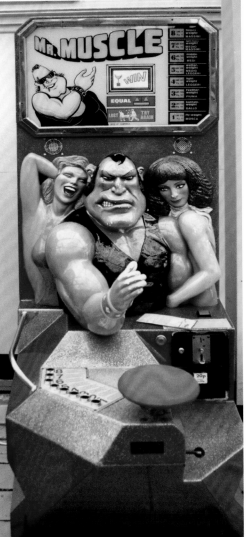

ABOVE LEFT A passion tester machine at Scarborough.

ABOVE CENTRE The Tim Hunkin 'Doctor' machine at Southwold, Suffolk. Scary.

ABOVE RIGHT The laughing clown always has the last laugh. Fleetwood, Lancashire.

RIGHT A Mr Muscle machine at Clacton-on-Sea, Essex.

BELOW Tick-Tock and Fruit-Bowl, two older-style machines at Mablethorpe, Lincolnshire.

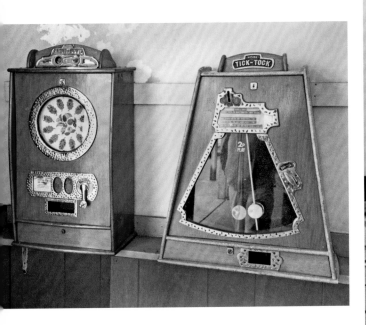

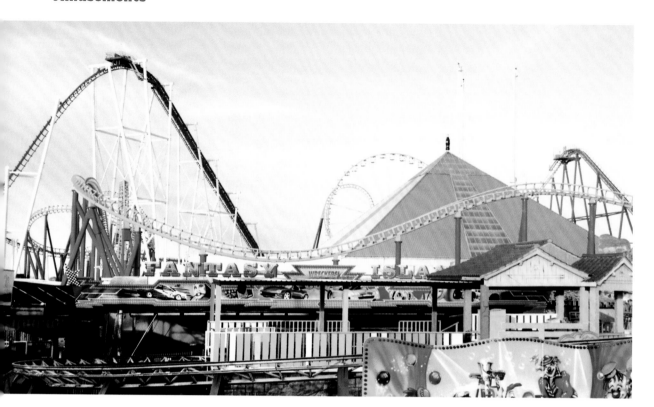

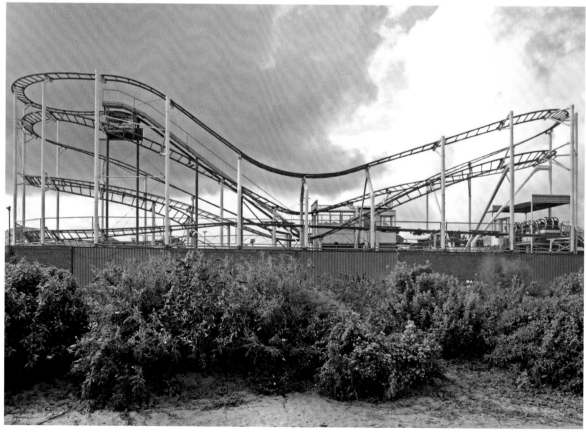

FACING PAGE

TOP Fantasy Island, Skegness, Lincolnshire.

BOTTOM Rollercoaster at Skegness.

RIGHT A rollercoaster of 1934 vintage – The Grand National at Blackpool.

BELOW RIGHT The Cyclone, opened in 1937 at Pleasureland, Southport, Merseyside. It is no longer there.

BELOW AND BOTTOM Dreamland rollercoaster, Margate. Listed Grade II*.

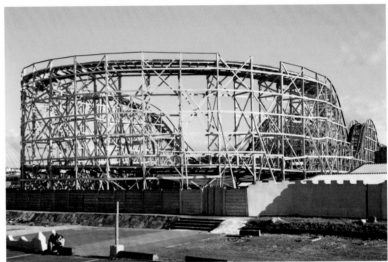

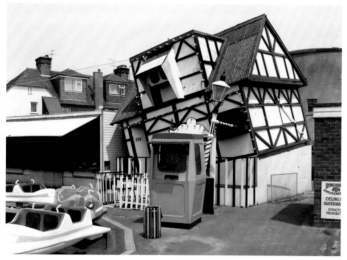

ABOVE LEFT The Crazy House at Dymchurch Amusements, Kent.

ABOVE Alien Base sign, Blackpool seaside.

LEFT The Caterpillar at Pleasureland, Southport, Merseyside, dating from 1914.

BOTTOM The Ghost Train at Pleasureland, Southport.

FACING PAGE

TOP Arcades come into their own at night. Funland Amusements, Blackpool.

BOTTOM Mr B welcomes you to the 'Golden Mile' at Blackpool.

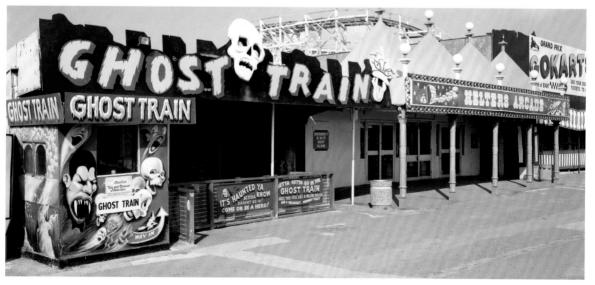

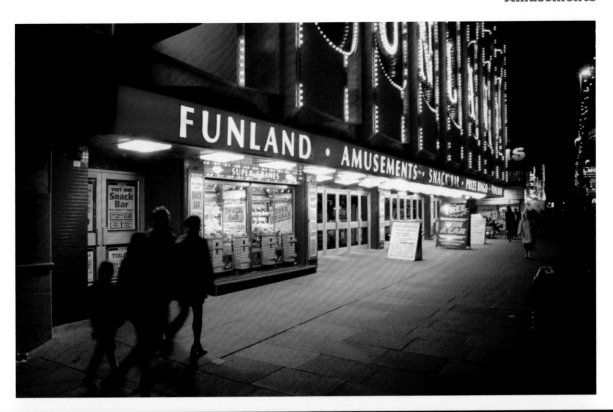

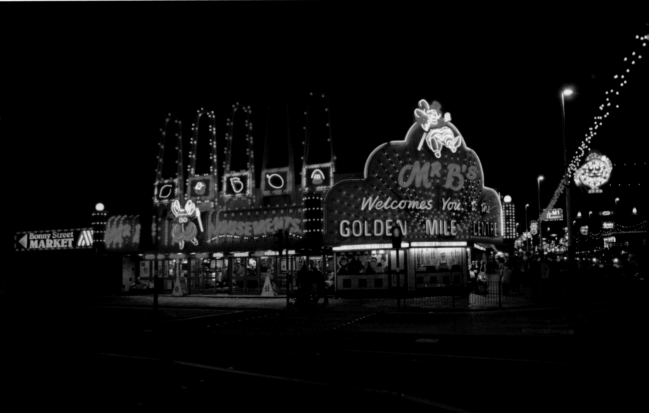

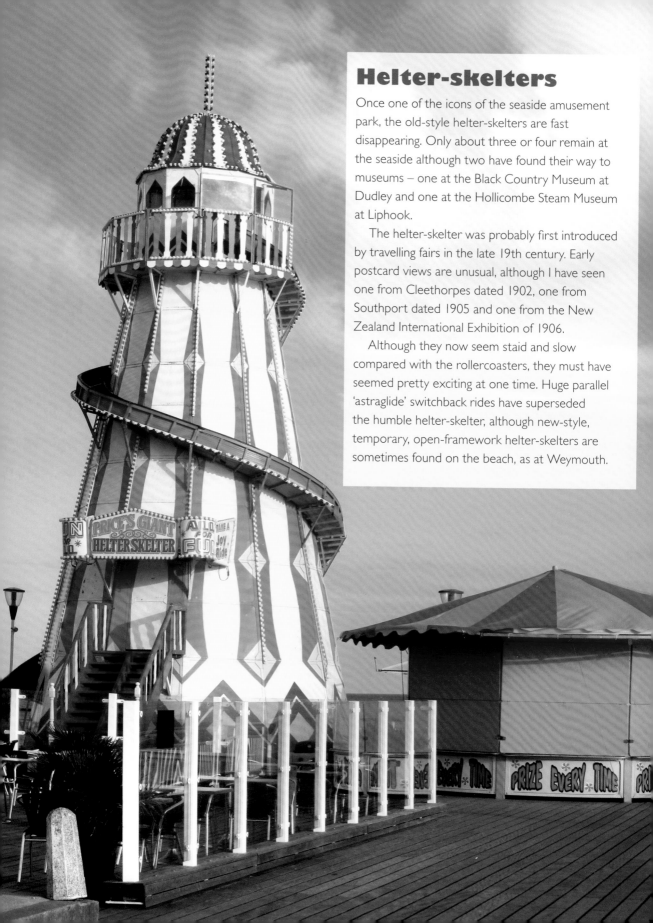

Helter-skelters

Once one of the icons of the seaside amusement park, the old-style helter-skelters are fast disappearing. Only about three or four remain at the seaside although two have found their way to museums – one at the Black Country Museum at Dudley and one at the Hollicombe Steam Museum at Liphook.

The helter-skelter was probably first introduced by travelling fairs in the late 19th century. Early postcard views are unusual, although I have seen one from Cleethorpes dated 1902, one from Southport dated 1905 and one from the New Zealand International Exhibition of 1906.

Although they now seem staid and slow compared with the rollercoasters, they must have seemed pretty exciting at one time. Huge parallel 'astraglide' switchback rides have superseded the humble helter-skelter, although new-style, temporary, open-framework helter-skelters are sometimes found on the beach, as at Weymouth.

FACING PAGE
Helter-skelter,
Bournemouth Pier.

RIGHT On the Palace
Pier, Brighton.

FAR RIGHT
Southend-on-Sea.

BELOW Snake helter-
skelter at Mablethorpe,
Lincolnshire.

BELOW RIGHT
Hunstanton, Norfolk.

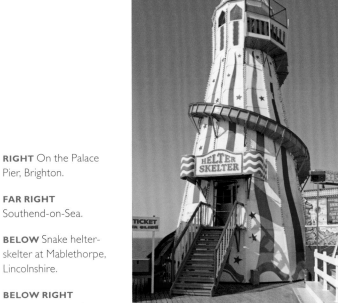

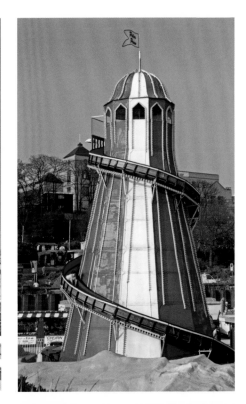

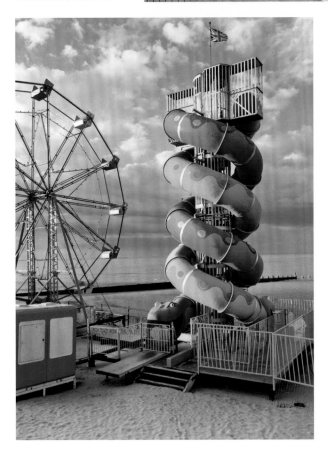

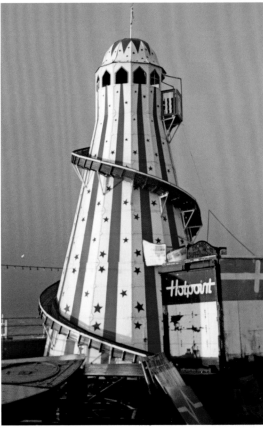

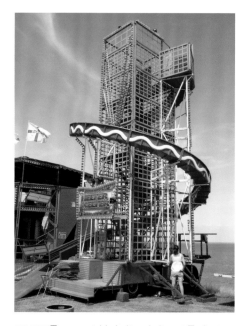

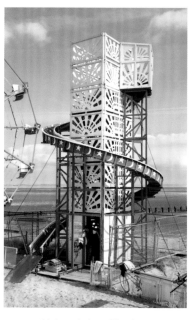

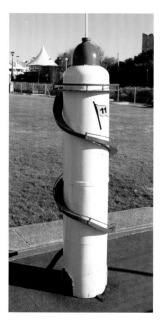

ABOVE Transportable helter-skelter at Tankerton Slopes, Kent.

ABOVE Helter-skelter, Cleethorpes beach, Lincolnshire.

ABOVE Exterior detail of the mini golf helter-skelter at Sefton, Southport, Merseyside.

BELOW The Rotunda Amusement Park at Folkestone, before its closure.

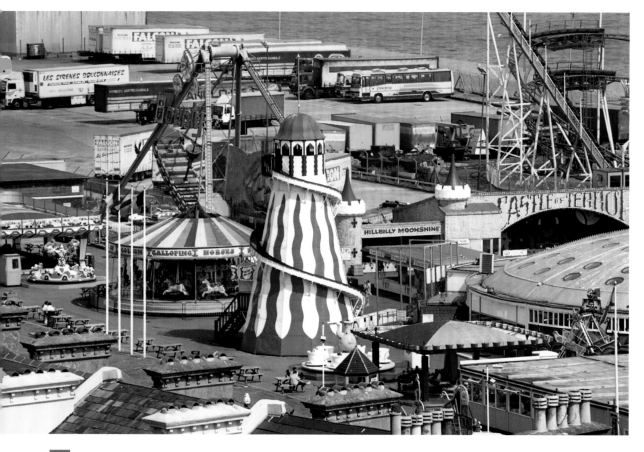

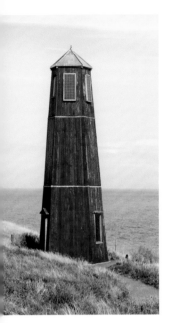

ABOVE The 'Dutch Tutch' at Potter Heigham, Norfolk. Rescued from the Great Yarmouth Pier after a fire in 1914, and re-erected as a house.

ABOVE Blue-painted lookout tower at Samphire Hoe, Dover.

ABOVE Outside Butlins at Minehead, Somerset.

BELOW Urban Beach, The Queens Walk, London.

Carousels

These colourful fairground rides have many names – 'whirligigs', 'roundabouts', 'merry-go-rounds', 'gallopers', '*manèges de chevaux de bois*', and are often found at the seaside. They have their origins in 17th-century French tournaments where horsemen tilted at brass rings. Subsequently, legless wooden horses were attached to a rotating platform and contestants had to ride these and attempt to spear stationary rings. The carousel revolved anti-clockwise to allow the right arm to carry the lance but, as this game never developed in England, English carousels revolve clockwise. By the late 19th century two Englishmen, Frederick Savage and Robert Tidman, developed steam-powered carousels and added to the appeal of the ride with the introduction of an up-and-down galloping motion. Early steam carousels can sometimes be recognised by their chimneys.

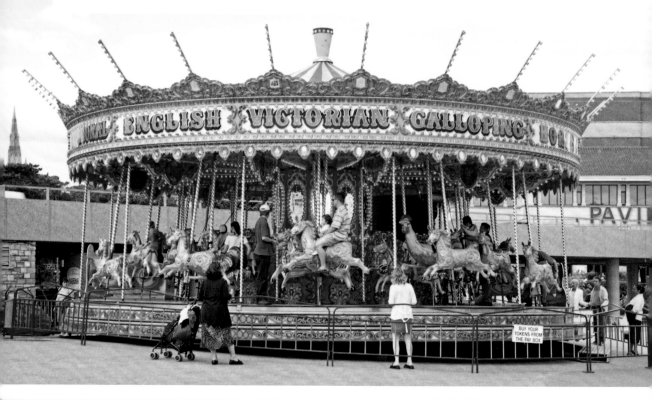

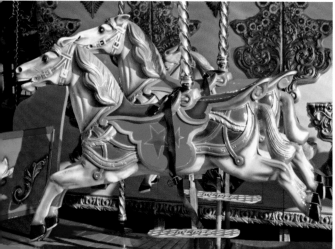

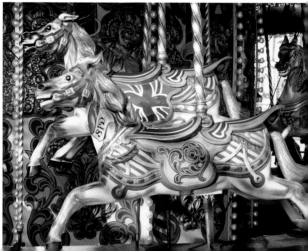

FACING PAGE

TOP English Victorian Galloping Horses at Bournemouth.

BOTTOM LEFT Carousel horses at Butlins, Minehead, Somerset.

BOTTOM RIGHT June, Ela and Sid gallop around the carousel at Folkestone.

RIGHT The Venetian Carousel on North Pier, Blackpool. Notice that the horses go anti-clockwise.

BELOW The magnificent Tommy Matthews Galloping Horses on the beach at Brighton.

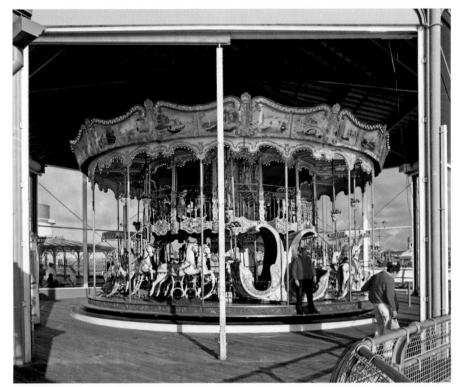

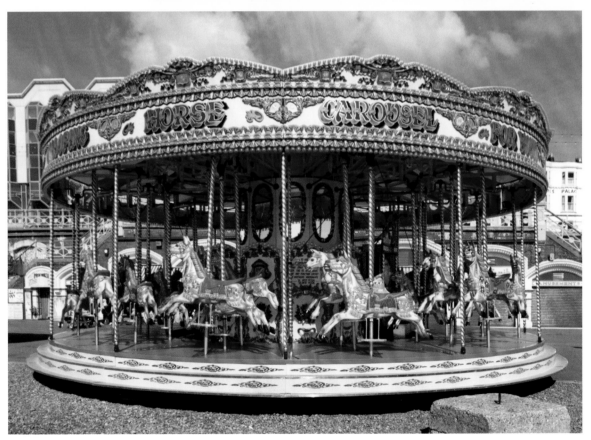

Golf

The world-famous golf course at St Andrews in Scotland was reputedly formed by sheep closely cropping the fairways and developing handy bunkers in which to shelter from the wind. It is thought that the word 'golf' is derived from the German word '*kolbe*', meaning 'club'. The names of many of the clubs used by the players sound strange to the ear: 'brassies', 'spoons', 'cleeks', 'mashies' and 'niblicks'. To non-golfers, the rest of the terminology is well nigh incomprehensible: 'par', 'birdie', 'triple bogey'. There seems to be a difference between 'golf courses' and 'golf links'. Links are found beside the sea and are basically sand dunes with long-rooted short grass. Links courses are well drained and you don't get your feet muddy.

Crazy golf is another iconic seaside resort amusement. It also comes with a wide range of names and rules. There is a difference between 'crazy golf' and 'adventure golf' and between 'miniature golf' and 'minigolf'. Crazy golf seems to originate with the game of 'golfstacle', a form of 'garden golf' popular around 1910. There is also 'clock golf' and 'pitch and putt'.

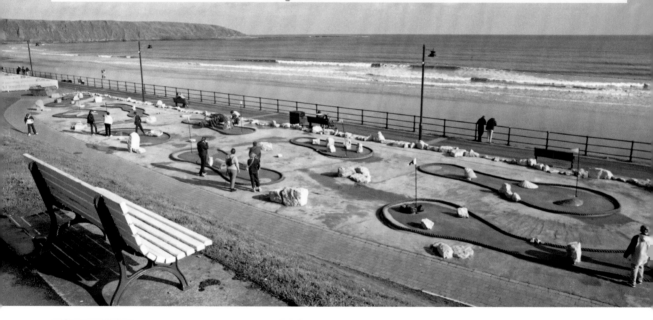

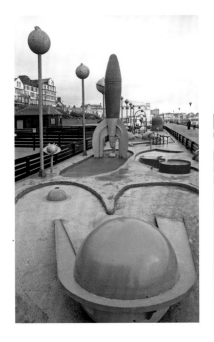

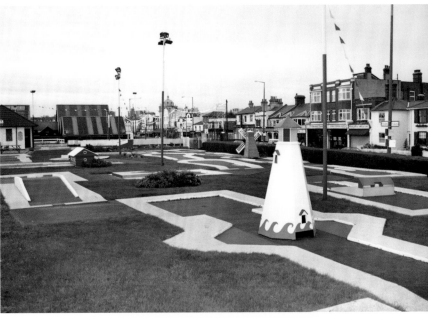

FACING PAGE

TOP Pitch and putt at Filey, North Yorkshire.

BOTTOM LEFT Living Postcards crazy golf, Brighton.

BOTTOM RIGHT Crazy golf on Weymouth beach, Dorset.

ABOVE Interplanetary golf at Bridlington, East Yorkshire.

ABOVE RIGHT Crazy golf at Eastern Esplanade, Southend-on-Sea.

RIGHT One of the thatched shelters at Royal St George's Golf Club, Sandwich, Kent.

BELOW A naïve oil painting of Royal St George's Golf Club.

BELOW RIGHT 'Linkscape' at Royal St George's.

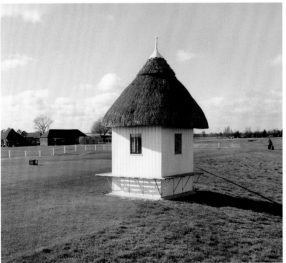

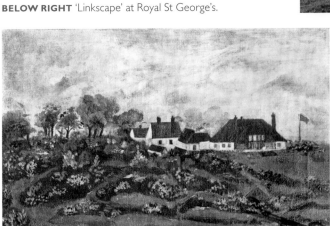

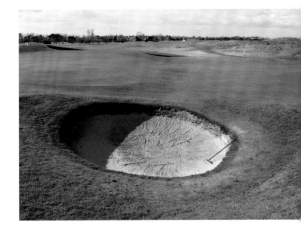

Food

A typical meal at the seaside will consist of fish and chips and a pot of tea followed by apple pie and custard. For a bit of a change, you could go for the all-day breakfast or something simple like sausage, egg and chips or beans on toast (incidentally, the 'full English breakfast' of the Yorkshire coast includes nine items!). Nearer to London, you might find eel pie and mash. 'Local' seafood can be enjoyed all round the coast: Cromer crabs, Whitstable oysters, Morecambe Bay shrimps…. Alternatively, you might decide to go for a 'Chinese', an 'Indian' or an 'Italian'. Some seaside towns aspire to haute cuisine and cordon bleu designer bistros in Mediterranean style, with patio heaters and London prices. We are lucky that there is such diversity of food on offer in such amazing surroundings. However, we must lament the loss of so many Formica, Bakelite and chrome 1950s and 1960s 'coffee bars', especially the York Gate Café interior at Broadstairs. It's also a shame that the candyfloss machines seem to have disappeared. You can still buy candyfloss but it comes in a plastic bag with no stick and it's just not the same.

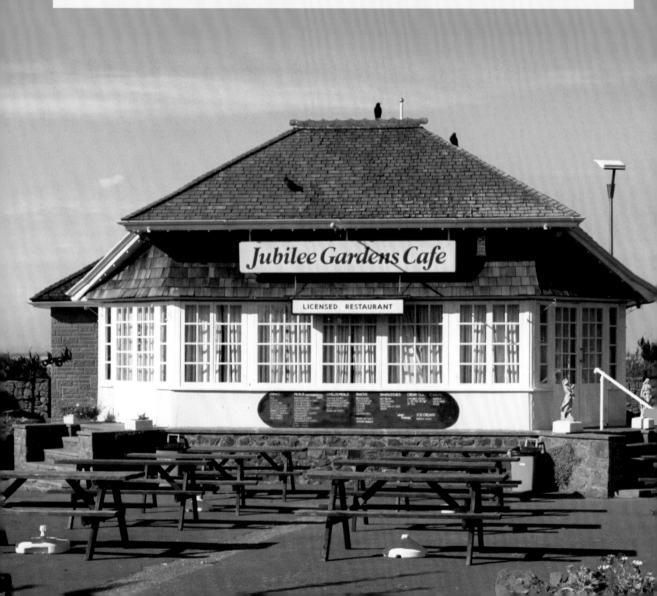

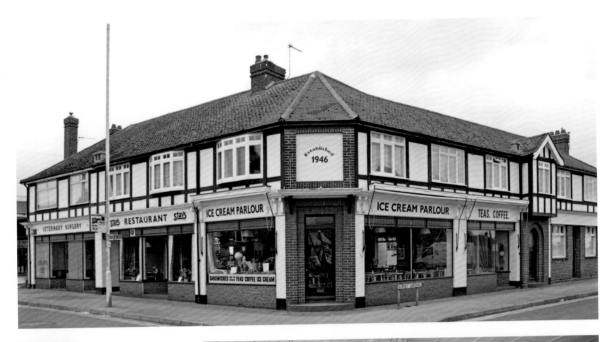

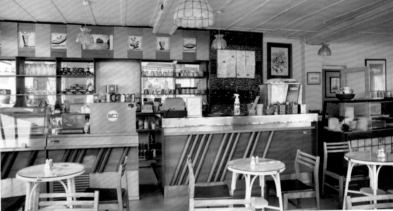

TOP Ice-cream parlour at Birchington, Kent. Ice-cream parlours are few and far between.

ABOVE Sign at Blackpool.

ABOVE RIGHT Interior of the ice-cream parlour at Birchington.

RIGHT Breakfast at Culver Lodge Hotel, Sandown, Isle of Wight.

FACING PAGE One of the larger cafés at Minehead, Somerset.

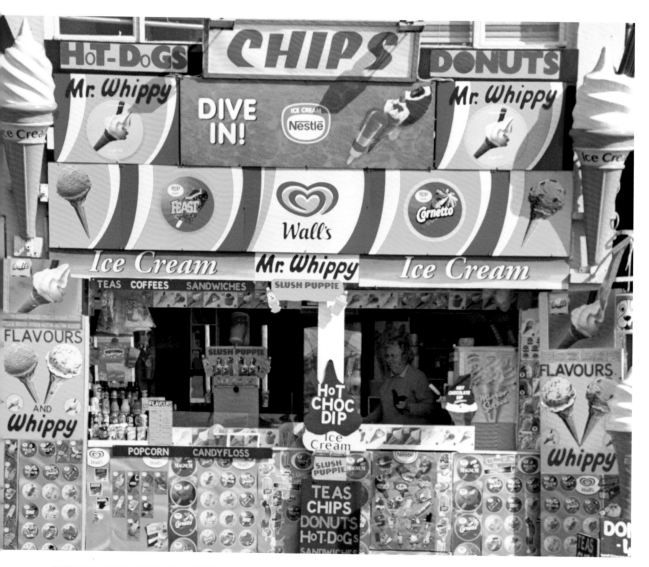

ABOVE Henry's Beach Shop at Sandown, Isle of Wight.

LEFT Breakfast at the Dalmary Guest House, Paignton, Devon.

RIGHT Field Café at Bognor Regis, West Sussex.

BELOW Interior of the Pantrinis Café at Whitley Bay, Tyne and Wear.

BELOW RIGHT Burger bar at Skegness, Lincolnshire.

BOTTOM Restaurant advertisement, Southend-on-Sea.

BOTTOM RIGHT Breakfast at the Harbour Lodge Guest House, Looe, Cornwall.

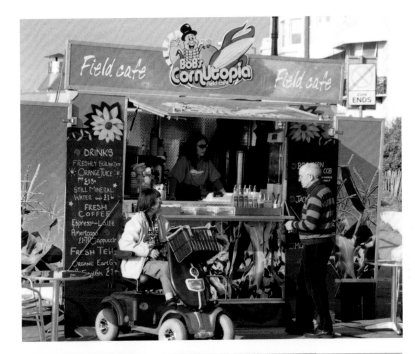

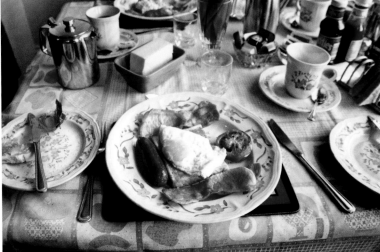

LEFT Sign at Scarborough.

BELOW Traditional fish and chips at Blackpool.

BOTTOM The Leaking Boot Restaurant and Chippie at Cleethorpes, Lincolnshire. Notice the fibreglass pugilistic chef.

ABOVE Jellied eel bar at Hastings.

BELOW A long-established fish and chip shop at Blackpool. Despite its 1950s exterior, inside it has the feel of the 1930s.

FACING PAGE A fish and chips shop at Broadstairs, Kent, with an eye-catching fisherman painting on the wall.

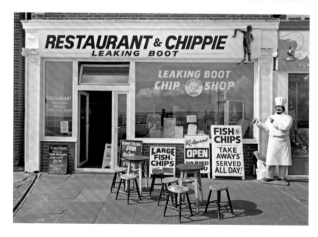

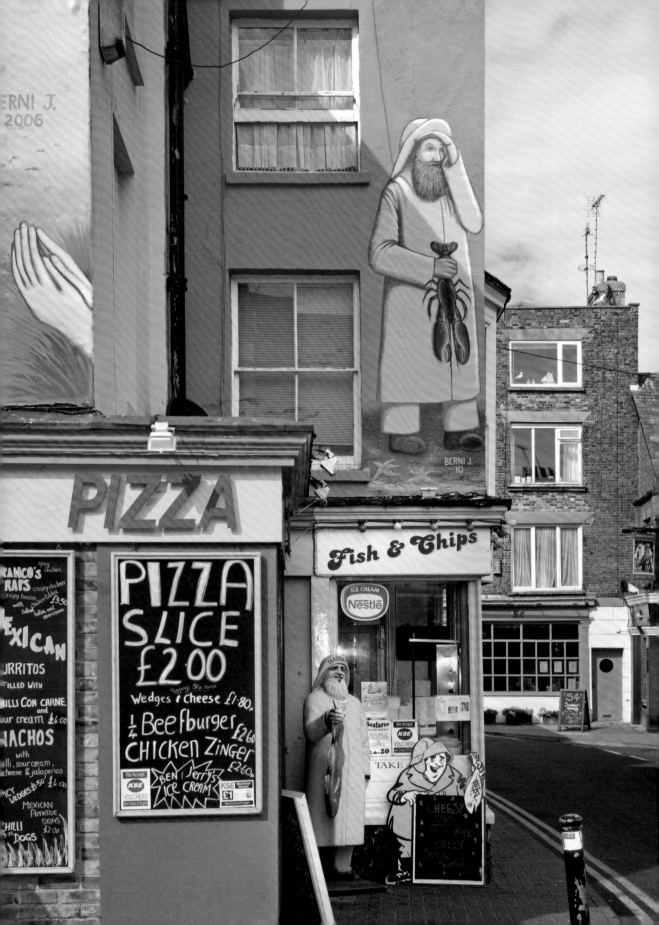

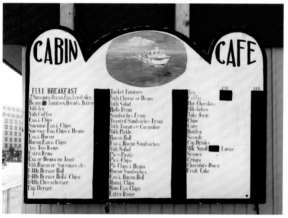

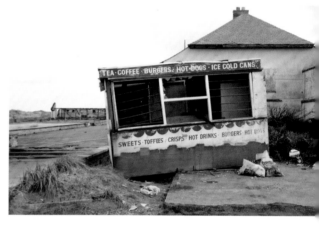

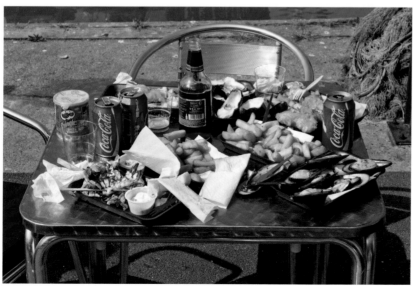

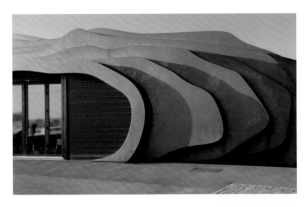

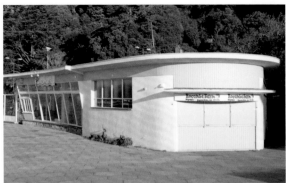

FACING PAGE

TOP Fast food at Minehead, Somerset.

CENTRE LEFT Cabin Café Sign, former Folkestone Harbour Railway Station.

CENTRE RIGHT The ruined burger bar at Ainsdale beach, Merseyside.

BOTTOM LEFT Lunch at Whitstable Harbour, Kent.

BELOW RIGHT Sunset Lounge sign at West Kirby in the Wirral.

BOTTOM RIGHT Fish and chips sign at Bognor Regis, West Sussex.

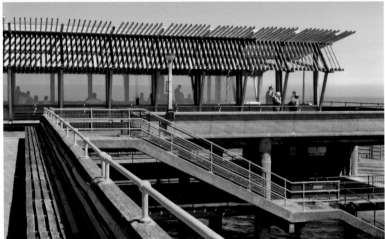

TOP LEFT East Beach Café, Littlehampton, West Sussex designed by Thomas Heatherwick 2007.

TOP RIGHT Café at Torquay.

CENTRE RIGHT Jasins Resaurant on Deal Pier, Kent.

RIGHT Turner Contemporary Art Gallery, Margate.

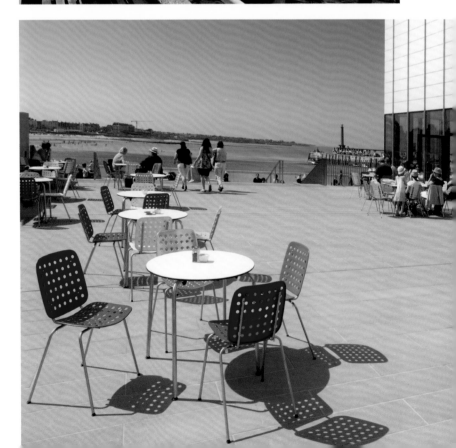

ABOVE LEFT Macaris Italian Restaurant, established 1958, Torquay.

ABOVE A tempting array of cakes on display in the window of Bothams Bakers, Whitby, North Yorkshire.

LEFT The Intrepid Bun at Southsea, Hampshire.

BELOW Breakfast at the Anchorage Hotel, Whitby, North Yorkshire.

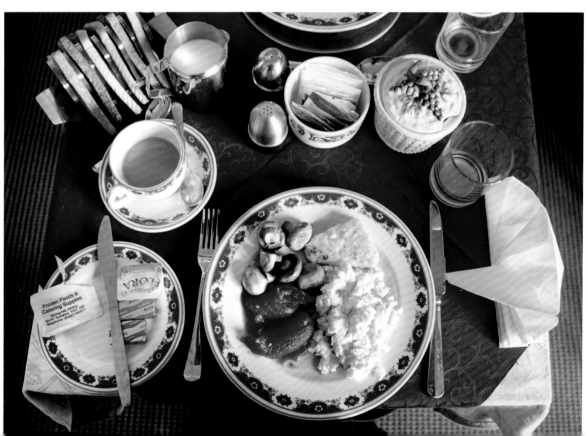

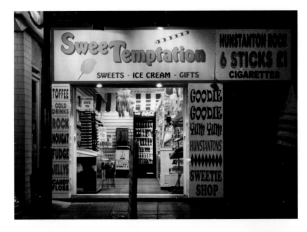

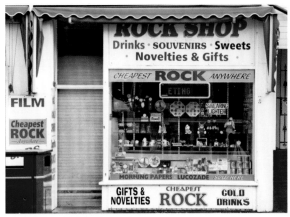

TOP Sweet Temptations at Hunstanton, Norfolk.

TOP RIGHT The cheapest rock anywhere, Blackpool.

ABOVE Rock of all sizes and shapes at Blackpool.

ABOVE RIGHT The Great Wall of Ramsgate – seaside art project.

BELOW LEFT John Bull rock makers, Scarborough.

BELOW An ice-cream parlour at Scarborough, bearing the famous name of the Pacitto family. The Italian connection with ice cream goes back to the mid-19th century when Italian ice-cream vendors known as 'Hokey Pokey' men toured major cities. The name derives from their cry of *'Oche poco'* meaning 'Oh so cheap'.

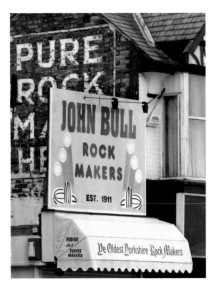

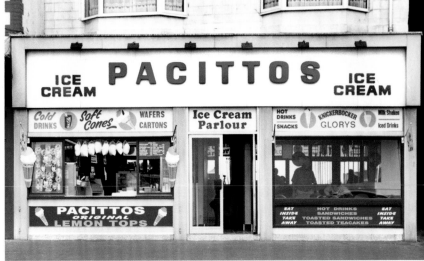

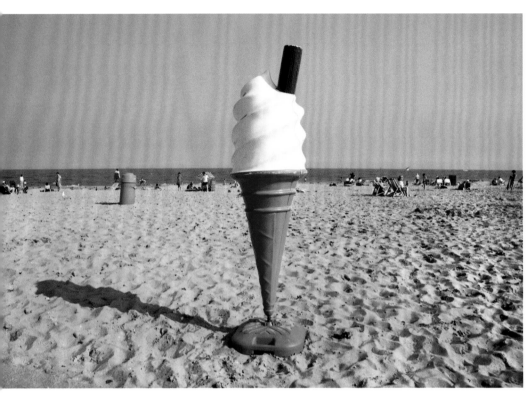

LEFT A large '99' cone on the beach at Ramsgate.

BELOW LEFT Mick's Super Softy ice-cream van at Canvey Island, Essex.

BELOW RIGHT Carlo's ice-cream van at Tynemouth, Tyne and Wear.

BOTTOM LEFT The Scooby and Shaggy ice-cream van at Margate.

BOTTOM RIGHT Mister Softee ice-cream van at Silloth, Cumbria.

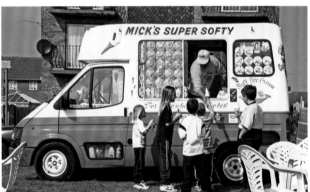

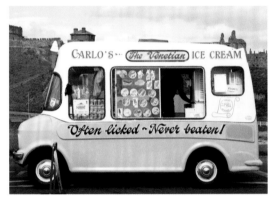

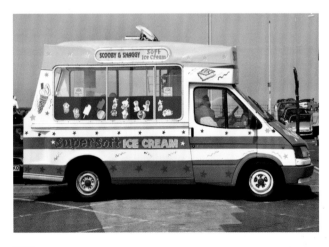

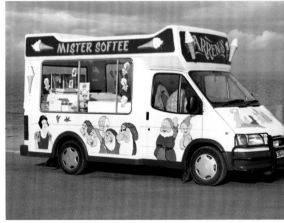

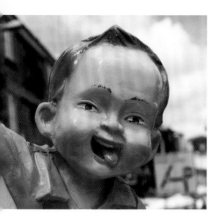

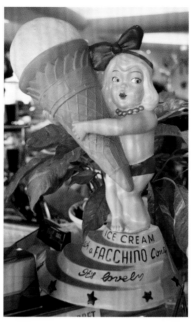

ABOVE Ice-Cream Boy – an advertising figure at Penzance.

BELOW Two ice-cream cones thrown into the harbour gently dissolve, Whitehaven, Cumbria.

ABOVE The Facchino ice-cream cone girl at Fusciardi's Ice Cream Tea and Coffee Lounge at Eastbourne.

ABOVE The Askeys' ice-cream cone girl in the window of an ice-cream parlour at Birchington, Kent.

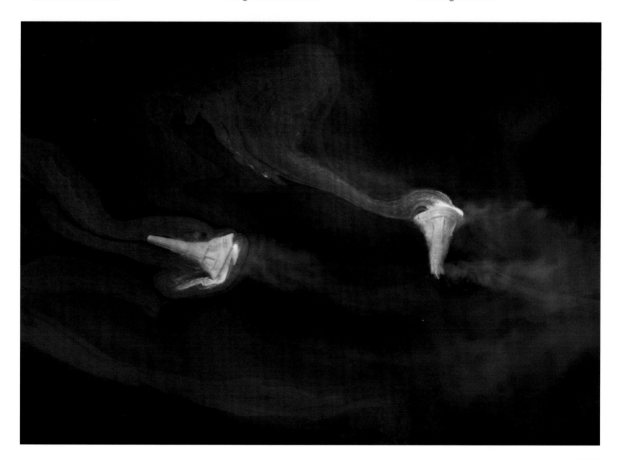

Famous people

During the height of 'sculpturemania' in the early years of the 20th century, many statues were erected at the seaside. Queen Victoria seems to have been the favourite. Other contenders were local people but it seems a bit of a lottery whether they warranted a monument, a bust, a blue plaque or nothing at all. For instance, at Sandgate near Folkestone, there is a memorial to Lieutenant General Sir John Moore who was killed at Corunna in 1809, but not one to H G Wells who wrote *Kipps* there. Those to whom statues have been erected include General Gordon at Gravesend, Sir Charles Palmer at Jarrow, William Harvey at Folkestone, Captain Lewis Tregonwell at Bournemouth, Snooks the dog at Aldeburgh and Dan Dare at Southport. Blue plaques abound: Benjamin Britten at Lowestoft, Ladies Nelson and Byron at Exmouth, and Peter Cushing at Whitstable. A list of the great and the good associated with the seaside would soon reach telephone directory length, but we mustn't forget Lowry at Berwick-upon-Tweed, Logie Baird at Hastings and John Betjeman at the little church of St Enodoc, Trebetherick, Cornwall.

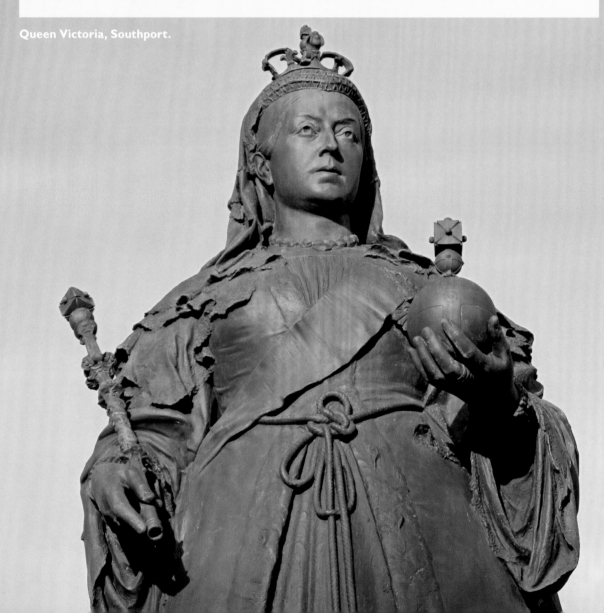

Queen Victoria, Southport.

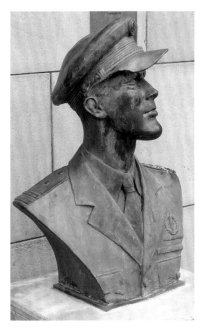

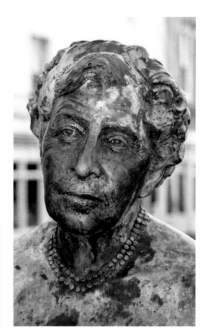

ABOVE Bust of Dan Dare at Southport, Merseyside.

ABOVE CENTRE Statue of Captain James Cook (1728–79) at Whitby, North Yorkshire, the place where he began his seafaring career and from where he set off on many of his famous voyages.

ABOVE RIGHT Bust of Dame Agatha Christie (1890–1976), at Torquay. She was born in the town and spent much of her life in the area.

RIGHT Statue of Eric Morecambe (1926–84) in his familiar pose on the front at Morecambe. Sculpted by Graham Ibbeson, it was unveiled by the Queen in 1999.

BELOW Blue plaque on the house lived in by H G Wells at Sandgate, Folkestone.

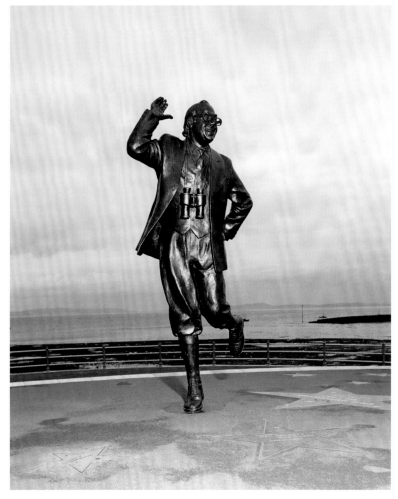

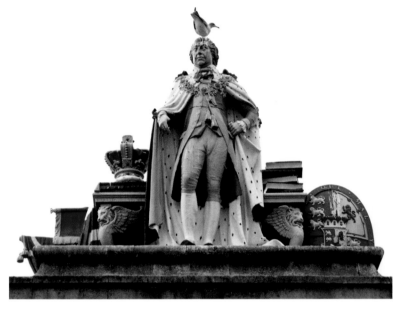

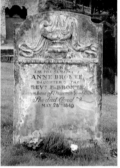

TOP Statue of George III at Weymouth, Dorset.

LEFT The Pilgrim Fathers Memorial, Southampton.

BELOW LEFT The last resting place of Dante Gabriel Rossetti (1828–82) at Birchington, Kent.

ABOVE LEFT The gravestone of John Betjeman (1906–84) at St Enodoc's, Trebetherick, Cornwall.

ABOVE Anne Brontë's gravestone, Scarborough.

ABOVE RIGHT Barnoon Cemetery, St Ives, Cornwall. Alfred Wallis (1855–1942) was a mariner and naïve painter; his gravestone was designed by the potter Bernard Leach.

BELOW Memorial to Louis Bleriot (1872–1936) at Dover. In 1909, he was the first person to fly across the English Channel.

ABOVE A sign on a house in Broadstairs, Kent.

RIGHT A bust of Charles Dickens at Bleak House Museum, Broadstairs. This was his seaside holiday home and the inspiration for his famous novel *Bleak House*.

ABOVE CENTRE RIGHT The statue of Captain Robert Falcon Scott, 'Scott of the Antarctic' (1868–1912), at Portsmouth Naval Dockyard.

ABOVE FAR RIGHT Statue of Princess Pocahontas (1595–1617), at St George's Church, Gravesend, Kent, where she is reputedly buried.

RIGHT Statue of William Prince of Orange, Brixham Harbour, Devon.

BELOW Captain Mannerings public house sign, Campfield Road, Shoeburyness, Southend-on-Sea [should be spelt Mainwaring].

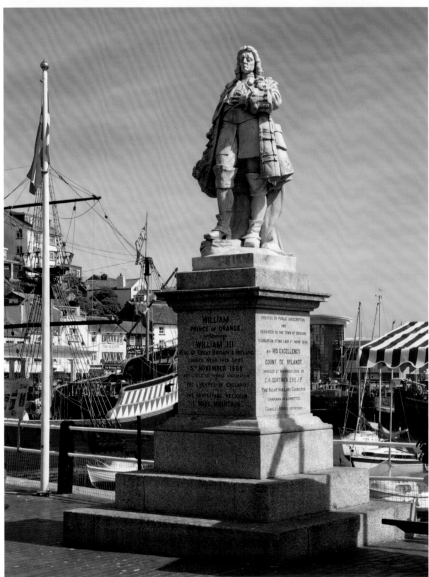

Palmists and clairvoyants

Oracles, soothsayers, readers of the runes, seers, prophets, cheiromancers – all say they can reveal our destiny. Mind reading and fortune telling has always been popular at the seaside, but is it all a bit of fun with crystal balls and tea leaves, or is there some dark arcane truth behind it?

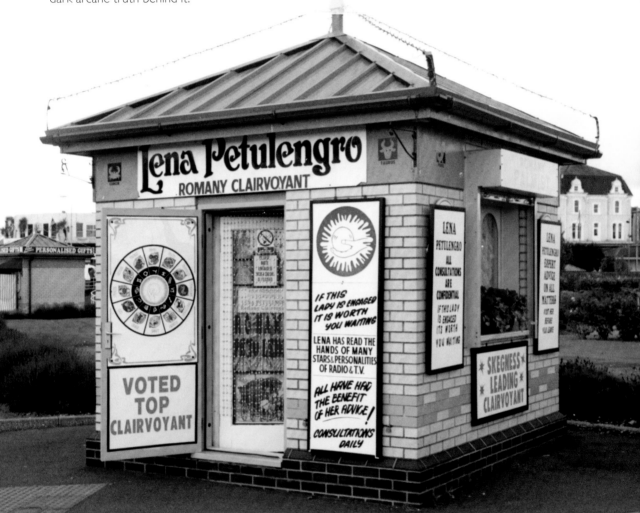

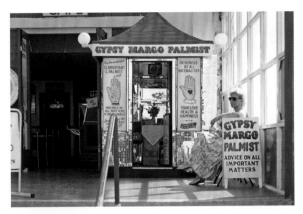

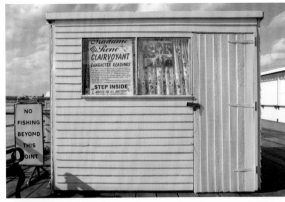

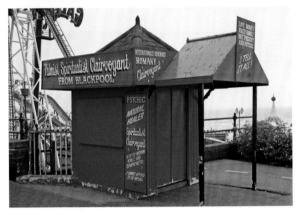

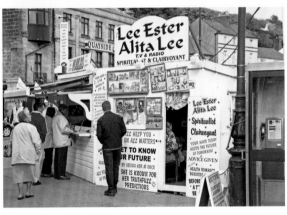

TOP Gypsy Margo, clairvoyant and palmist at Felixstowe, Suffolk.

ABOVE Palmist's kiosk at Bridlington, East Yorkshire.

RIGHT Lynn Petulengro, palmist and clairvoyant at Skegness, Lincolnshire. The name Petulengro is thought to be of Egyptian origin and to mean blacksmith.

FAR RIGHT A machine has taken over at Margate. The 'Lucky Lady' made by R S Coin outside the Royal Amusement Arcade.

TOP RIGHT Madame Rene's hut, Southend-on-Sea.

ABOVE Lee Ester Alita Lee, true-born Romany clairvoyant and spiritualist at Whitby, North Yorkshire.

FACING PAGE

TOP Lena Petulengro kiosk, Skegness, Lincolnshire. Romany clairvoyant.

BOTTOM LEFT Sign opposite the pier at Bognor Regis, West Sussex.

BOTTOM RIGHT An old sign at Southend-on-Sea.

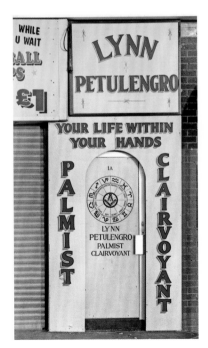

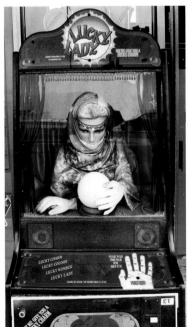

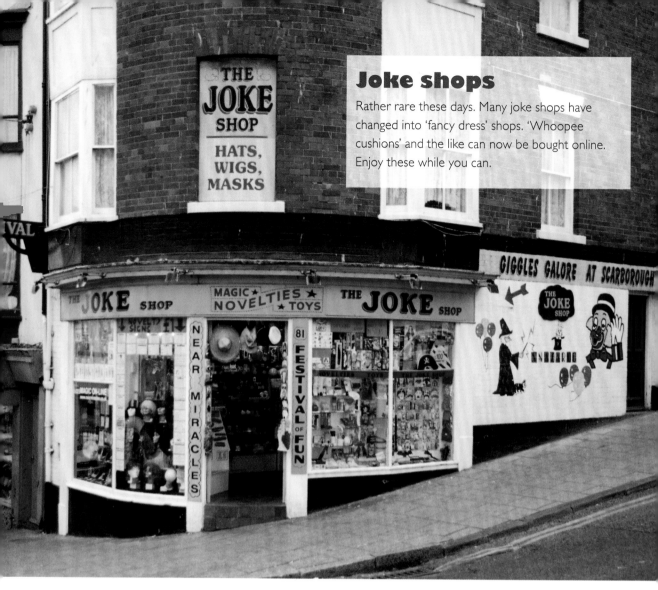

Joke shops

Rather rare these days. Many joke shops have changed into 'fancy dress' shops. 'Whoopee cushions' and the like can now be bought online. Enjoy these while you can.

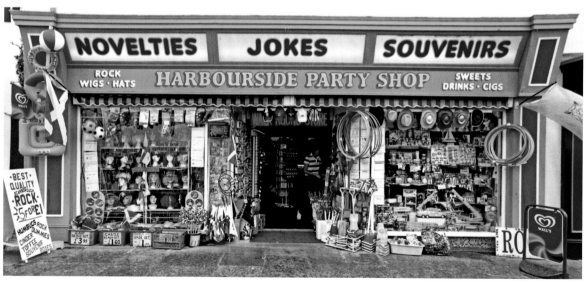

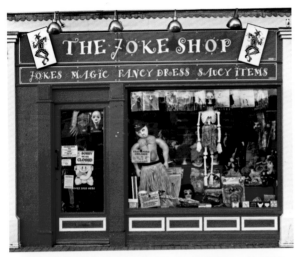

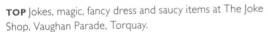

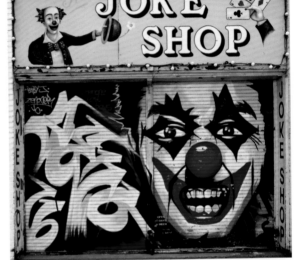

TOP Jokes, magic, fancy dress and saucy items at The Joke Shop, Vaughan Parade, Torquay.

TOP RIGHT The Joke Shop, Southport, Merseyside.

ABOVE Inflatable (and real!) cats at Minehead, Somerset.

ABOVE RIGHT The Joke Shop in the Arlington Tower precinct at Margate.

RIGHT Old faithfuls – the squirting lighter, itching powder and frothing blood.

FACING PAGE

TOP Giggles galore at The Joke Shop, Scarborough. Not only hats, wigs and masks, but also magic and 'near miracles' are on offer.

BOTTOM The Harbourside Party Shop, Scarborough.

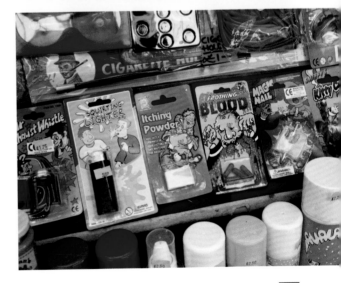

Pirates, smugglers and wreckers

Pirates wield cutlasses, have eye-patches, say 'arrh' a lot, operate a 'piratical code', like a tame parrot, bury treasure, wear stripy clothes, drink rum, have a hook for a hand, sing about dead men's chests, dislike receiving notes with black spots on, like cheese and are very likely to have large black beards. They end up being hanged. There are many theories about the origin of the 'Jolly Roger' pirate flag. Perhaps it is a corruption of the French '*Joli rouge*' but this does not explain why or when the flag changed from red to black. Early prints and pictures show pirate flags with hourglasses and skeletons stabbing hearts.

Hastings has a large summer pirate festival where you could ask the experts. Smugglers are more ordinary folk, if a bit more devious, and used to operate by night from their secret caves and cellars. They are now more associated with drug running and people trafficking.

Wrecking is the legitimate acquisition of valuables from shipwrecks close to or on-shore. It is now known as marine salvage. Wreckers are often confused with 'false lighters' who (supposedly) shine lights from rocky coastlines to lure ships onto rocks. This is, obviously, nonsense as sea captains would naturally assume that a fixed light would indicate land and sail away from it. Donkeys with lights attached are also said to have been used to mimic ships at anchor – also nonsense.

All the above contribute to the growing commercialisation of seaside folklore.

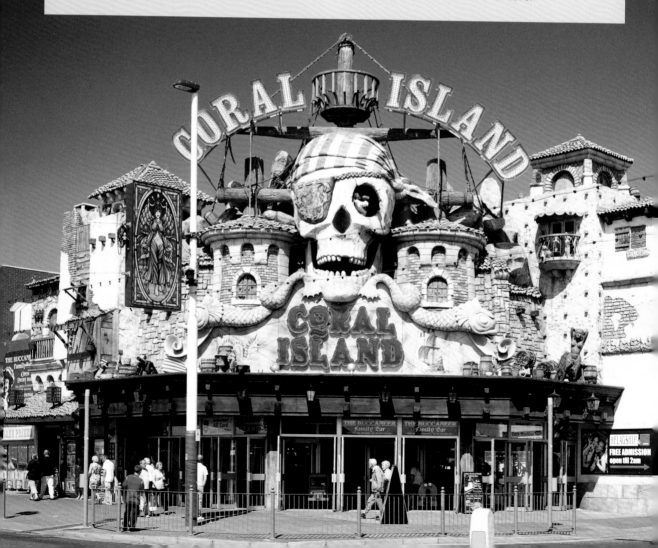

FACING PAGE The giant piratical skull, Coral Island, Blackpool.

ABOVE LEFT Pirate posing opportunity on the pier at Weston-super-Mare, Somerset.

ABOVE CENTRE Pirate golf at Whitby, North Yorkshire.

BELOW This painting at Branwells Mill Meadery in Penzance is thought to represent local people.

RIGHT The Bo-Peep public house sign, Grosvenor Crescent, St Leonards-on-Sea, East Sussex. This is a metaphorical sign. The nursery rhyme refers to the excise men (peeping) and the smugglers with their 'tails' or barrels. Incidentally, Keats is reputed to have composed his poem *Endymion* ('A thing of beauty is a joy for ever') whilst staying at this pub in 1717.

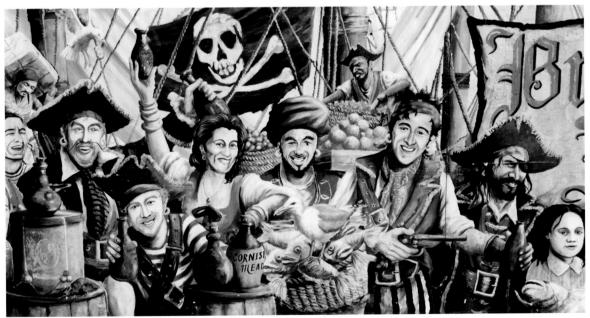

Signage

Hardly a page in this book does not feature signage and there are examples from amusement parks to guest houses and to Punch and Judy. Shown here are some examples of the ubiquitous 'finger post'. Many localities have clearly been influenced by the 1963 Worboys road sign committee, who introduced the present day 'Transport' sans serif typeface. The fingerpost signs come with triangular, curved and straight ends or, indeed, fingers. Some have incised lettering, some with metal letters and once in a while hand-painted lettering.

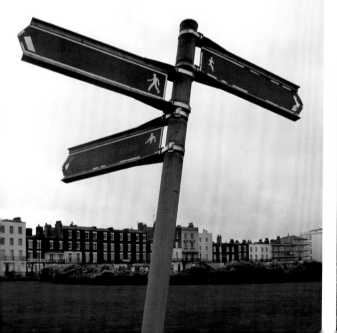

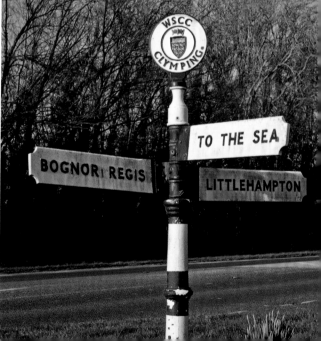

FACING PAGE

TOP A complicated sign at Southsea, Hampshire.

BOTTOM LEFT An 'unreadable' sign at Margate. Wherever it may be they want you to go, you are encouraged to walk.

BOTTOM RIGHT A sign on the A259 at Clymping, near Littlehampton.

ABOVE TOP A typical example of 'do it yourself' signage.

ABOVE CENTRE LEFT At Fairlight near Hastings. Many roads in the vicinity discourage visitors from trying to access the beach.

ABOVE CENTRE RIGHT Naughty Novelties sign at Blackpool.

ABOVE A sign at the entrance to the 'Tunnelsbeaches' at Ilfracombe, Devon. The tunnels date from 1823.

RIGHT TOP Fingerpost at Bude, Cornwall.

RIGHT BOTTOM The author at Land's End beside the iconic signpost dating to the 1950s.

BELOW National Trust style at Brixham, Devon.

BOTTOM Road sign at St Leonards-on-Sea, East Sussex. This road borders the site of the former Hastings Bathing Pool or Lido.

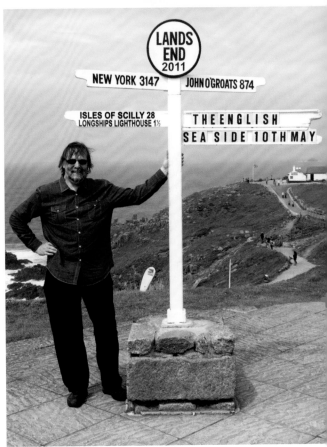

Wind farms

The first onshore wind farm was constructed 1991 at Delabole in Cornwall. Ten years were to pass before the first offshore turbine was commissioned at Blyth in Northumberland. The UK is the world leader in offshore wind farm installed capacity, with the world's largest farm at Walney in Cumberland. The Crown Estate, being the managers of the seabed to 12 NM, licence and approve developments. Much of the design, construction and operation of the wind farms lies in the hands of a multiplicity of European companies. Without wanting to baffle and bewilder with complex electro technical stuff, the main points of general concern appear to lie in the areas of visual impact, danger to wildlife, construction costs (in terms of the power consumed to make the metal parts of the turbines) and decommissioning costs. Advances are being made with tidal and wave power.

FACING PAGE

TOP Offshore turbine, Blyth, Northumberland.

BOTTOM Offshore windfarm, Kentish Flats.

RIGHT Offshore windfarm, Thanet, Kent.

BELOW The Great Wall of Ramsgate – seaside art project.

BOTTOM Blyth, Northumberland.

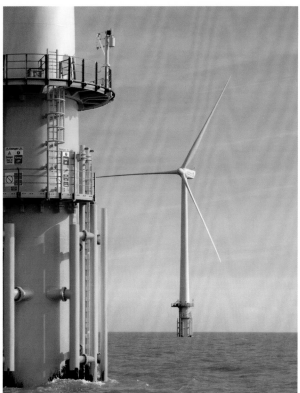

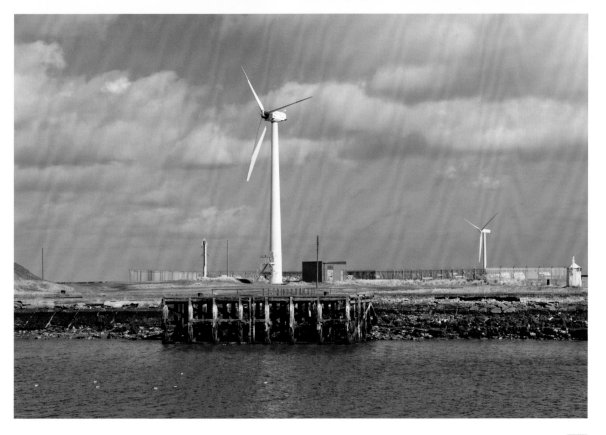

Art galleries and museums

If you build a new art gallery your seaside town will be revitalised, regenerated and thousands more tourists will visit and spend heaps more money. Your gallery must be 'cutting edge architecture' preferably right on the beach and have an excellent café. Follow the example of St Ives and Bilbao.

This is all probably true, but not all seaside towns have the money, the location, the art to fill the gallery. Compromises can begin to creep in and enthusiasm become dampened, but try and persevere. Any gallery is better than none.

FACING PAGE Baltic Centre for Contemporary Art, Gateshead. Built in 1950 for Rank Hovis as a flour mill, it became an art gallery in 2002.

ABOVE Museum of Liverpool, on the Waterfront next to the 'Three Graces'. Designed by Danish architects 3XN, it opened in 2011.

BELOW Turner Contemporary, Margate. The original design by Norwegian architect Snohetta led to controversy over the placing of the gallery partly in the sea, and the present building was designed by David Chipperfield. It opened in 2011.

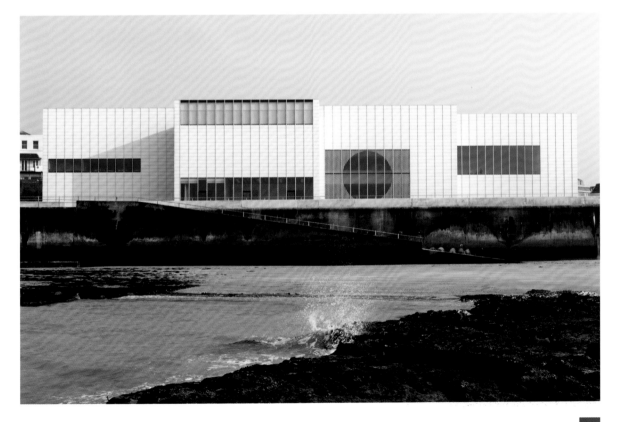

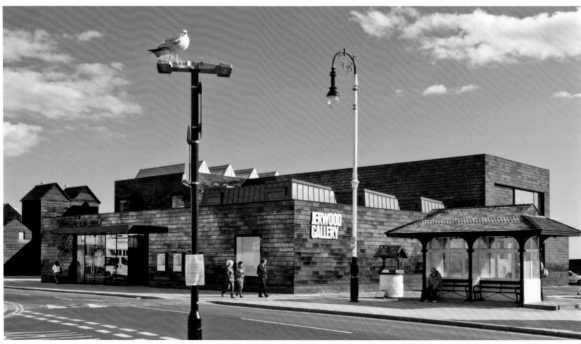

LEFT The Beacon, Whitehaven, Cumbria.

CENTRE Teign Heritage Centre, Teignmouth, Devon, which opened in 2011.

BOTTOM Jerwood Gallery, The Stade, Hastings. Probably the most successful of the new post-Tate St Ives art galleries, it opened in 2012. The café overlooks the fishing boats, the exterior reflects the adjacent net shops and the art is wonderful. Architects HAT Projects.

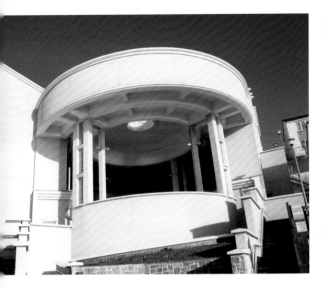

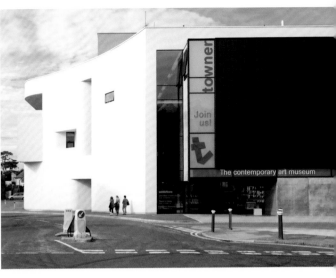

ABOVE Tate St Ives, Cornwall. On the site of the former gas holder, it opened in 1993. Architects Evans and Shalev.

ABOVE The Towner Art Gallery, Eastbourne. It opened in 2009 rehousing the original collections donated by Alderman Towner in 1920. Architect Rick Mather.

BELOW National Maritime Museum, Falmouth, Cornwall, which opened in 2003. Architect MJ Long.

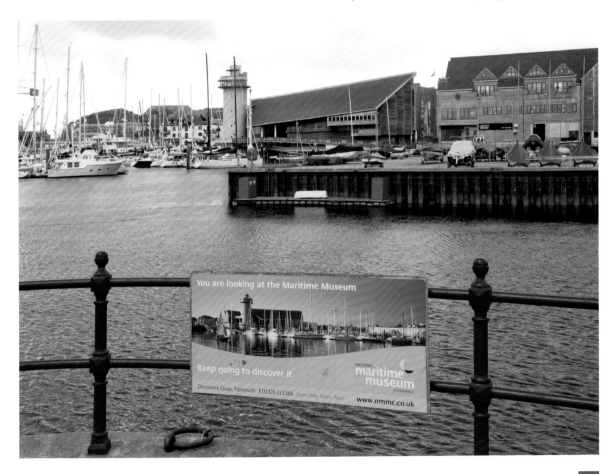

Contemporary buildings

New-build art galleries, museums, commercial buildings and esplanade improvements all help to entice the visitors, but people also need somewhere to live. Often it is the incomers who kick start change and improvements. The second home owners and downsizing retirees have money to spend and not only require sea views, parking, golf courses, marinas, restaurants and all the leisure and retail conveniences but also they want unchanged local character. There is a great deal of cheap and dreary new building (the school of 'two bricks and a tin can') which seems to be built on every corner site. Many architects have given in to the double glazing men, the breeze-block merchants and the white-paint suppliers. There are, however, many good things to be seen.

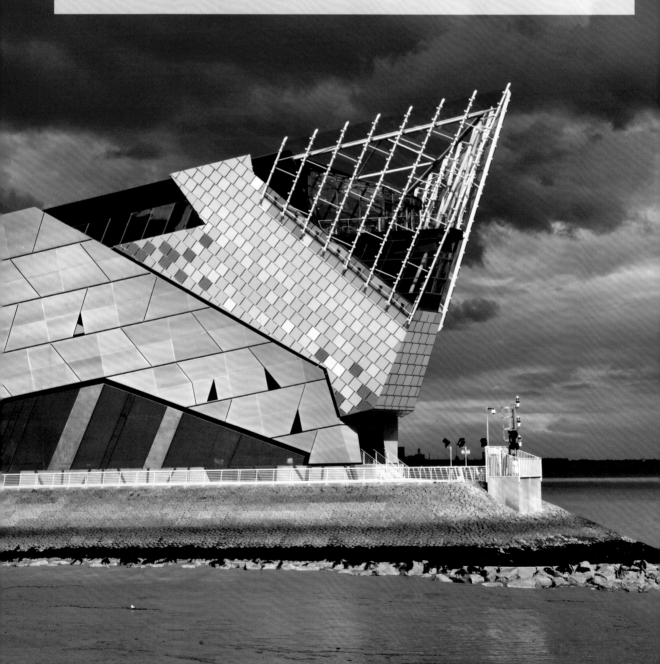

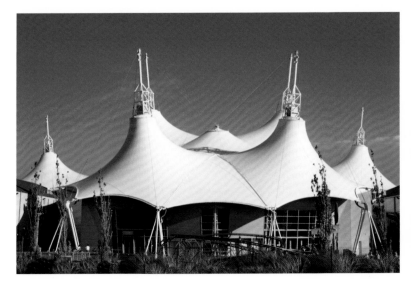

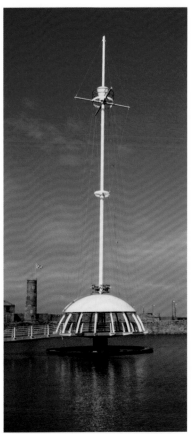

ABOVE The tented structure of the Skyline Pavilion at Butlins holiday camp at Minehead, Somerset. This was the largest post-war camp built 1961 and now has over 9,000 beds.

RIGHT The Lime Tongue Millenium Mast, or Crow's Nest, at Whitehaven, Cumbria.

BELOW The new build martello-type house at Sandgate, Folkestone, with Sandgate Castle beyond with its stainless-steel roof.

FACING PAGE The Deep, Submarium, Tower Street, Hull.

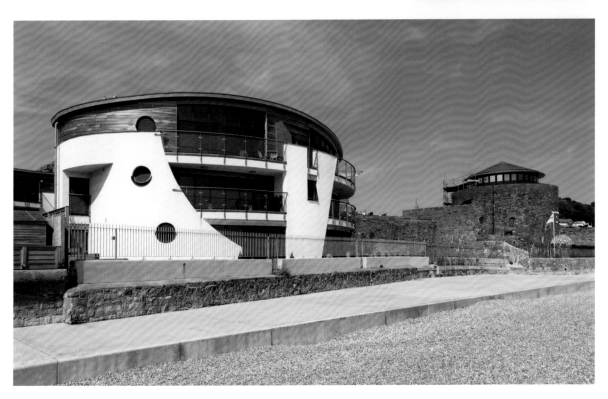

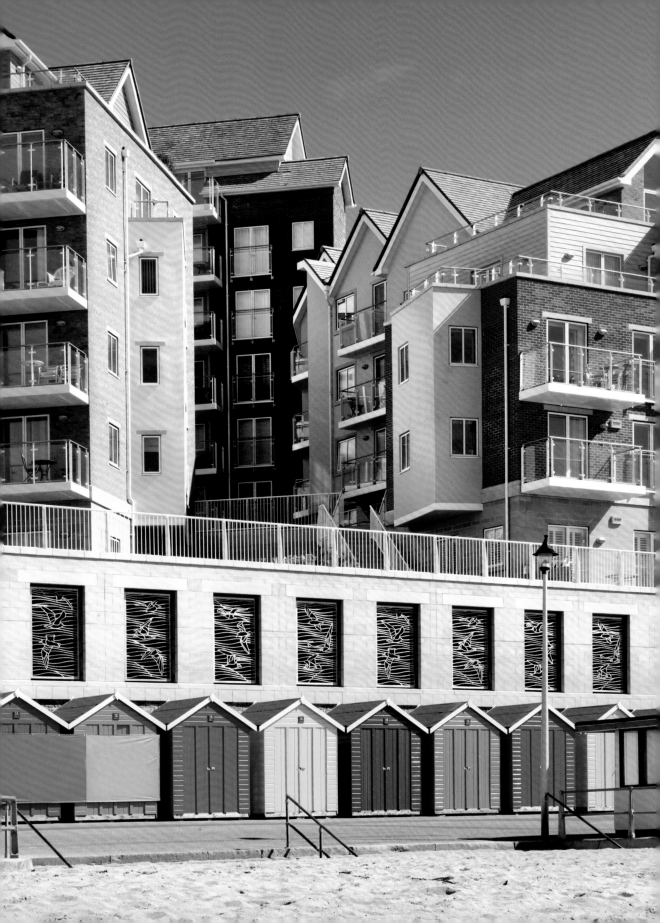

ABOVE Marine Way Bridge, Southport, Merseyside. Often referred to as the Millenium Bridge built to connect the town with new leisure and retail developments.

ABOVE RIGHT Brixham Fish Market, Devon, an award-winning £17m redevelopment by Stride Treglown in 2011.

RIGHT Spinnaker Tower and Gunwharf Quay, Portsmouth. Opened in 2005, it is 170 metres high, has the largest glass-viewing floor in Europe and is visible 23 miles away. Architects HGP.

BELOW The Big White House, Pett Level, East Sussex. Featured on the TV programme *Grand Designs*.

FACING PAGE Honeycombe Chine Beach development at Boscombe, Dorset. Sometimes referred to as 'Bos Vegas' Boscombe has some great 1930s buildings and, of course, the pier.

A nice cup of tea

There's a lot of walking up and down the prom. We have
seen the sights and the tearoom is conveniently placed just
where you can see there's no point in walking any further.
It's only sensible to stop for a cuppa.

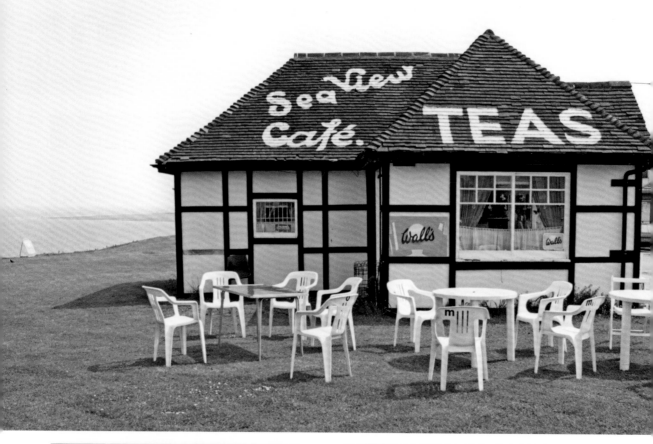

FACING PAGE

TOP Sea View Café at Tankerton, Kent.

BOTTOM LEFT Tudor Tea Rooms sign at Whitstable, Kent.

BOTTOM RIGHT Chalkboard sign at the Café Latino, Herne Bay, Kent.

RIGHT A teapot sign hangs in the window of the Manor Tea Rooms, Sand Bay, Kewstoke, Somerset.

BELOW Tea for two at the Tudor Tea Rooms, Whitstable, Kent. Favourite café of the late Peter Cushing.

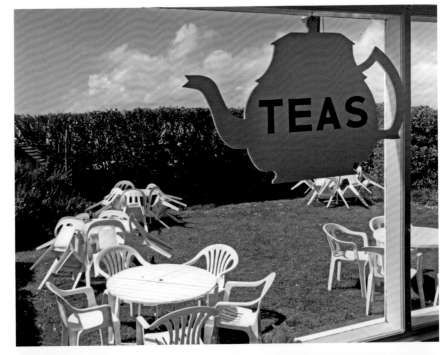

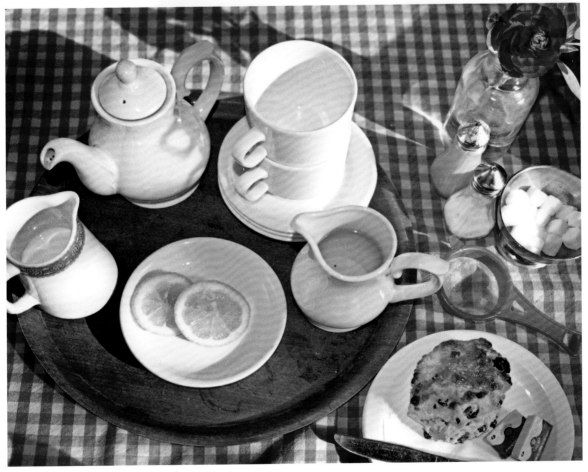

Staring out to sea

Many sea watchers are clearly oblivious to their surroundings. They sit motionless sometimes on beaches, sometimes in cars absorbing the vastness of the natural world and the smallness of a man. They watch for 'the Green ray'. They search for the horizon, for inspirations, for meaning. They gaze into the future.

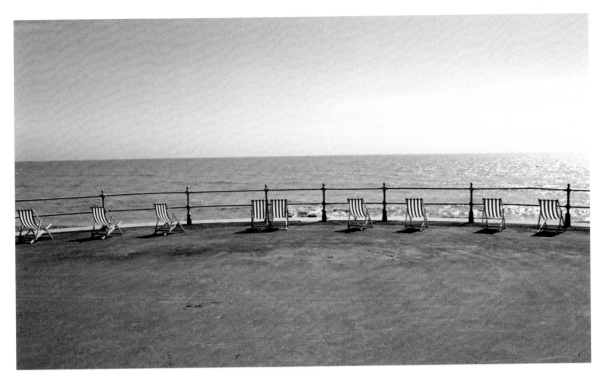

FACING PAGE Near the Tyneside coast, Tyne and Wear.

ABOVE Bexhill-on-Sea, East Sussex.

BELOW Staring out to sea at Felixstowe.

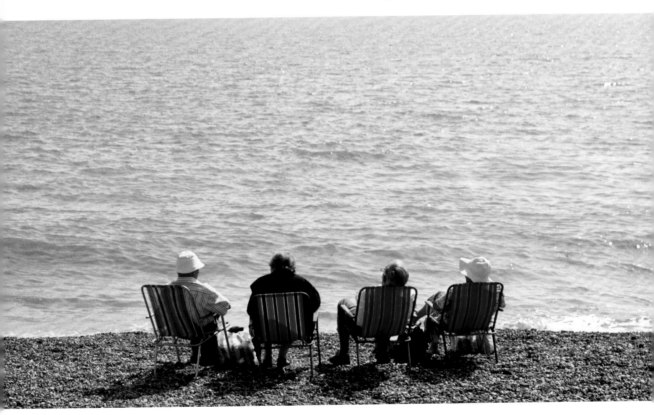

Acknowledgements

Thanks must go to the many people who have helped me during ten years of snapping away at the seaside. Particular thanks to my former colleagues Mike Hesketh-Roberts, James O Davies, Ian Leonard, Shaun Watts, and Jonathan Proudman. To Anne Williams who has been a constant help and to Lisa Williams who accompanied me around the Kent coast. Extensive help and advice has been given by Allan Brodie, Gary Winter, Ursula Dugard-Craig, Robert Dickinson and Andrew Sargent. Thanks also to John Walton, Val Horsler, Sue Kelleher and Rod Teasdale. This new edition could not have happened without the help and encouragement of John Hudson, Robin Taylor and particularly project manager Jess Ward and designer Pauline Hull.

Sandcastle on Berrow beach, Somerset.

Index of places illustrated

Index of places illustrated